MORTON COLLEGE

VERITAS

1924

LIBRARY

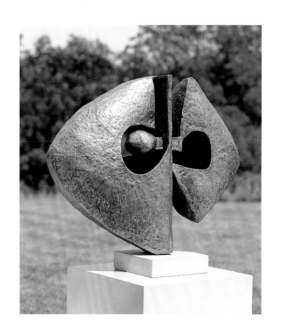

SEYMOUR LIPTON

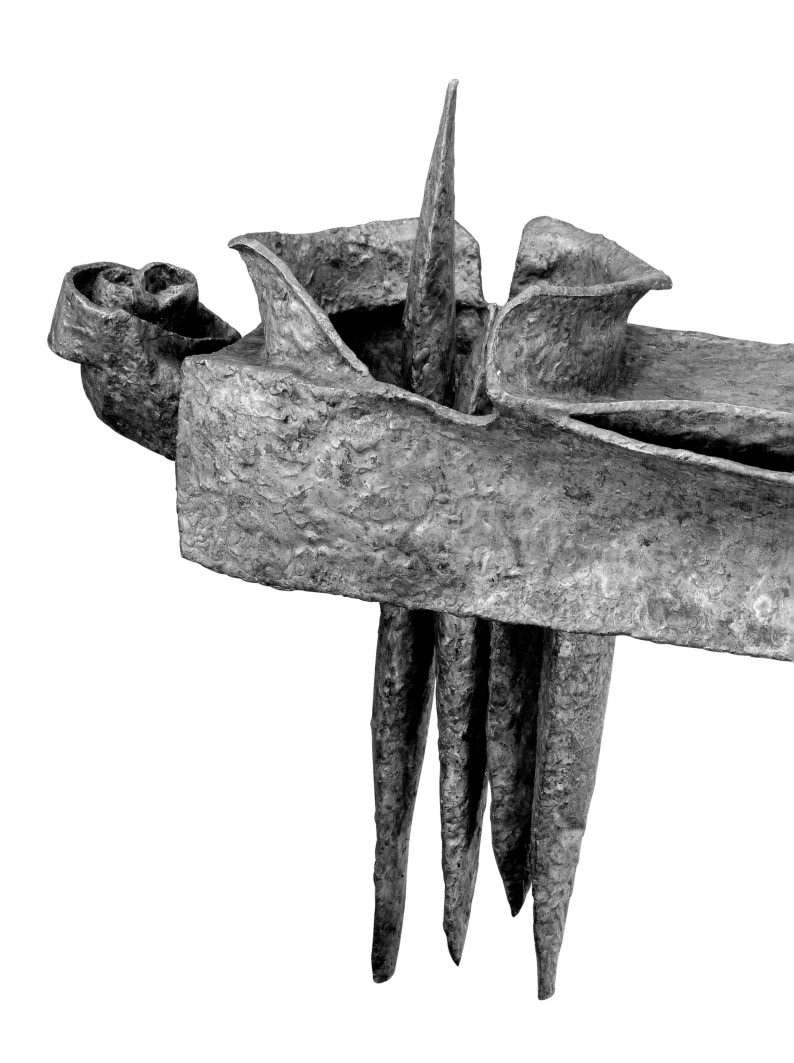

PALMER MUSEUM OF ART
THE PENNSYLVANIA STATE UNIVERSITY

DISTRIBUTED BY HUDSON HILLS PRESS, NEW YORK

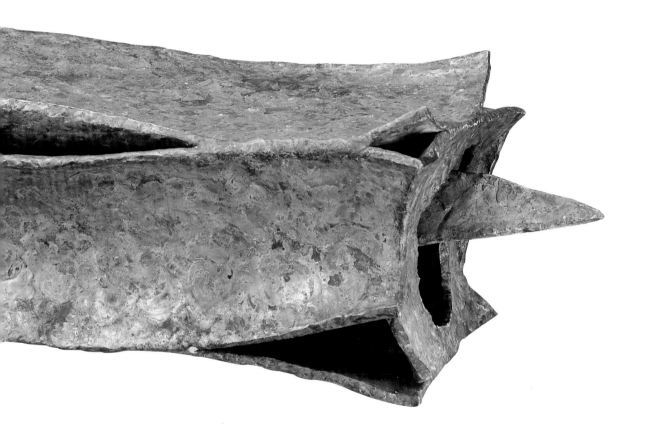

AN AMERICAN SCULPTOR

SEYMOUR
LIPTON

LORI VERDERAME

WITH AN INTRODUCTION BY
IRVING SANDLER

This book is published in conjunction with *An American Sculptor: Seymour Lipton,* a traveling exhibition co-organized by the Palmer Museum of Art and the Marion Koogler McNay Art Museum beginning January 20, 2000.

Copyright © 1999 by the Palmer Museum of Art. All rights reserved. No portion of this book may be reproduced in any form or by any means without the permission of the copyright holder.

Library of Congress Catalog Card Number: 99-75215

ISBN: 1-55595-190-2

Distributed by Hudson Hills Press, Inc.

122 East 25th Street, 5th Floor

New York, NY 10010-2936

President: Paul Anbinder

Distributed in the United States, its territories and possessions, and Canada through National Book Network. Distributed in the United Kingdom, Eire, and Europe through Art Books International, Ltd.

Page 1: *Winterseed,* 1968–74, Collection of James R. and Barbara R. Palmer (cat. no. 32)

Frontispiece: *Séance,* 1961, Estate of the artist, New York (cat. no. 27)

Project Management by Jan Muhlert

Edited by Carolyn Vaughan and Patricia Draher

Designed by John Hubbard with assistance by Susan E. Kelly

Produced by Marquand Books, Inc.

Printed and bound by C & C Offset Printing Co., Ltd., Hong Kong

This publication is available in alternative media on request.

The Pennsylvania State University is committed to the policy that all persons have equal access to programs, facilities, admission, and employment without regard to personal characteristics not related to ability, performance, or qualifications as determined by University policy or by state or federal authorities. The Pennsylvania State University does not discriminate against any person because of age, ancestry, color, disability or handicap, national origin, race, religious creed, sex, sexual orientation, or veteran status. Direct all inquiries regarding the nondiscrimination policy to the Affirmative Action Director, The Pennsylvania State University, 201 Willard Building, University Park PA 16802-2801;tel.(814) 865-4700/V, (814) 863-1150/TTY. U. Ed. ARC 00-16

PENNSTATE

College of Arts and Architecture

CONTENTS

DIRECTORS' ACKNOWLEDGMENTS

This exhibition and accompanying publication had their genesis in 1991 when James R. and Barbara R. Palmer acquired a comprehensive collection of sculptures, maquettes, and drawings by Seymour Lipton (1903–1986). They encouraged scholars, students, and curators to visit them and study Lipton's work. The Palmers also made their collection readily available to museums for exhibitions and extended loans. Their enthusiasm for Lipton's work is unabashed and communicable. We are deeply grateful to them for their most generous support in all aspects of this project.

Probably no other American sculptor of his generation was more widely collected than Lipton from the mid-1940s through the 1970s. His works were acquired by nearly every major museum that included contemporary American sculpture in its scope. However, by 1980 Lipton's popularity and critical reputation were in decline, a fate he shared with most of his colleagues except for David Smith. Furthermore, no major study of Lipton's work has been published since Albert Elsen's monograph of 1974. It is now our distinct pleasure to offer this critical reevaluation of Lipton's artistic production, which spanned six decades.

We wish to thank Irving Sandler for providing the introduction to this publication. His thoughtful essay places Lipton in context with his fellow artists and within the prevailing social milieu.

Lori Verderame worked diligently to illuminate the recurring themes in Lipton's work and to present his working methods. Her essays and catalogue entries add fresh insights into Lipton's prolific career.

We also extend our sincere gratitude to all the lenders to the exhibition, who are listed with the reproductions of their works. In addition, a number of individuals provided invaluable assistance with locating sculptures and securing photographs: Cynthia Altman, The Rockefeller Archive Center; Tom Behrens and Stephanie Mendelson, Chase Manhattan Bank; Robin Dettre and George Gurney, National Museum of American Art; John Driscoll, Babcock Galleries; Drs. Thomas and Marika Herskovic; Wendy Hurlock, Archives of American Art; Achim Moeller, Achim Moeller Fine Art; Mrs. Rodman C. Rockefeller; and Gene Shapiro, Sotheby's.

This exhibition would not have been possible without the cooperation and generosity of Alan and Michael Lipton. We are privileged to be able to share their pride in their father's work. Maxwell Davidson of Maxwell Davidson Gallery also provided invaluable assistance.

The staffs of the Palmer Museum of Art and the Marion Koogler McNay Art Museum had significant roles in the project represented by this exhibition and catalogue. Beverly Balger, Rachel Cervin, Richard Hall, Ron Hand, Jennifer Noonan, Barbara Weaver, and Betsy Warner from the Palmer should be especially recognized for their skillful attention to every detail. At the McNay, Edward Hepner, Melissa Lara, and Heather Lammers are also acknowledged for the care they devoted to each aspect of the project.

Thanks also are due to the photographers cited throughout the publication. We especially want to single out Peter Harholdt, who provided all but one of the photographs of the sculptures from James and Barbara Palmer's collection and the estate of the artist. His appreciation for Lipton's work is apparent in the quality of his photographs. We further acknowledge Richard Ackley and University Photo/Graphics for the photographs of Lipton's drawings.

Finally, we wish to acknowledge the expert work by the staff at Marquand Books, Inc. John Hubbard, Susan Kelly, Ed Marquand, and Marie Weiler could not have been more helpful. It was a pleasure to work with them and with our diligent editors, Patricia Draher and Carolyn Vaughan.

Jan Keene Muhlert
Director
Palmer Museum of Art

William J. Chiego
Director
Marion Koogler McNay
Art Museum

AUTHOR'S ACKNOWLEDGMENTS

As an alumna of the university and a former staff member of the Palmer Museum of Art, I am proud to return to Penn State for this exhibition dedicated to the work of Seymour Lipton. Lipton's sculpture has a special place on the Penn State campus and at the Palmer Museum. Many members of the university community and museum patrons enjoy the works on a regular basis. It is my pleasure to share Lipton's fine and thought-provoking work with both old friends and new admirers of this significant American artist.

My interest in the history of postwar America began many years ago, as I listened to my parents' recollections of their experiences during the 1940s and 1950s. My father, who served in the Pacific theater, provided me with stirring images of the Second World War, the period of occupation, and the war's aftermath. My mother offered a wealth of information about the home-front war effort and the growth of suburban America.

While my parents initially sparked my study of the postwar era, Jim and Barbara Palmer afforded me the opportunity to study American painting and sculpture of this period. Throughout my career at Penn State, the Palmers shared with me not only their private collection, but also their high standards, good cheer, and wisdom. They provided me so many opportunities—too many to recount— including access to an extensive collection of the sculpture of Seymour Lipton. This project would not have been possible without the interest, vision, and genuine goodness of the Palmers. As a Penn Stater, I can attest that the Palmers personify the characteristics that make Happy Valley a very special place. I extend my most heartfelt thanks to them.

I would like to thank my friends from the Palmer Museum of Art, many of whom I hold very dear to my heart. Dr. Kahren Arbitman deserves my special thanks and my deepest gratitude. As my mentor, Kahren consistently offered me support, direction, and so much of her time. She taught me to strive for excellence and to share my enthusiasm for art with others. I thank Dr. Mary Linda, whom I miss a great deal, for teaching me the joys of museum work. Of course, I share my pride with my lovely friends Betsy Warner, Barbara Weaver, and Jill Hoffman. Thanks also to the Palmer staff who taught me so much: Ok Hi Lee, Glenn Willumson, Ron Hand, Patrick McGrady, Jennifer Piskorik, Bob Fry, Beverly Balger, and Jan Muhlert.

I extend my sincere thanks to the members of the art community who provided me with information about Lipton's work as I conducted research: Will Barnet, John Driscoll, Albert Elsen, Luis Jimenez, Alan Lipton, Michael Lipton, Stephen Polcari, and Craig Zabel. I owe a debt of gratitude to my colleagues at Muhlenberg College and to the members of my staff at the Martin Art Gallery, Masterpiece Technologies Inc., and Masterpiece Galleries. I would like to thank my sisters for their interest in my work, Mike for his patience and understanding, and my parents for all of their love and support.

Lori Verderame
Director, Martin Art Gallery
Muhlenberg College

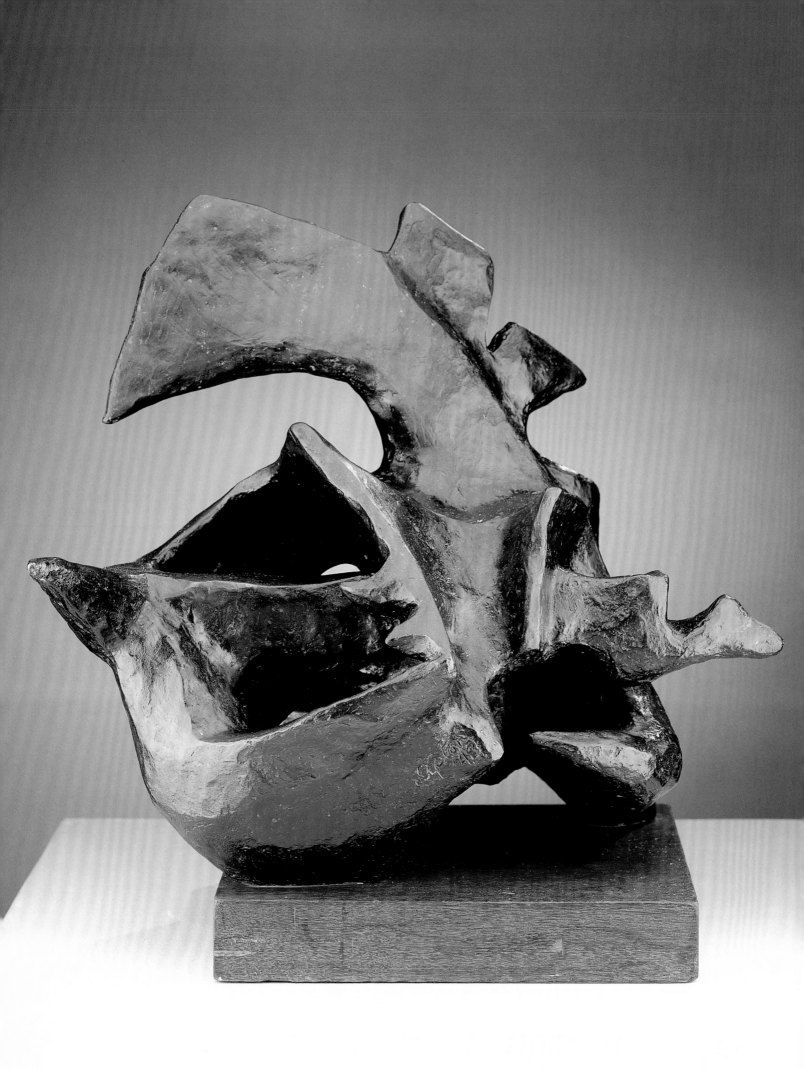

INTRODUCTION

by Irving Sandler

Seymour Lipton achieved art-world recognition in the 1950s as one of a small number of avant-garde construction sculptors. But he did not begin as a vanguard artist. From 1933 to 1945, he carved stone and wood sculptures in the then-popular Social Realist manner. Like many artists during the Great Depression of the thirties, he wanted to reveal the evils of capitalism. His themes were racism, in *Lynched;* poverty, in *Breadline* and *Subway Beggars;* child labor, in *Shoeshine;* and class struggle, in *Strike.* The figures were simplified and distorted for expressive purposes and in this sense his style could be termed modernist.

Lipton's stylization suggests that although committed to the revelation of social injustice, he wanted to avoid the generally backward-looking academicism of Social Realist art. Nevertheless, the manner in which he worked was a common one, related to that of a number of figurative stone- and wood-carvers in the 1930s who commanded more art-world attention than he did, among them José de Creeft, John Flannagan, Chaim Gross, Gaston Lachaise, Robert Laurent, Elie Nadelman, Hugo Robus, and William Zorach. Lipton's sculpture was highly accomplished, but he himself recognized that "If only my work to 1945 survived, I feel it would be viewed as that of a personal, expressive craftsman with no special originality that I can see now."[1]

With the outbreak of World War II in 1939, Lipton's sculptures referred increasingly to the conflict, as in *Refugee* and *Wounded Soldier* (both of 1940), and *Air Raid* (1941). The change in subject matter proved critical in Lipton's development. As the war continued, and after the entry of the United States, he experienced a profound sense of anguish about the human condition, which could no longer be conveyed by the topical themes and the sculptural limitations of his Social Realism. He now wanted to express "the sense of the dark inside, the evil of things,"[2] as he said: "The iceberg character of human personality: evil, unconscious drives, selfish and animal needs that may exist below the level of consciousness."[3]

Lipton searched for new motifs that might convey "the dark inside," and found them in tusks and horns, teeth, claws, beaks, and thorns, and the sculls, pelvic bones, and mouths of fearsome primordial beasts and birds. The sculptures' surfaces were no longer smooth but scarred, erupting into space. Lipton evidently recognized that representing dinosaurs and great bird-lizards would not have conveyed the horrors of global war. He would need

opposite
Moby Dick #2, 1948, bronze with wood base, 16¾ × 18⅜ × 14 in. (42.6 × 46.7 × 35.6 cm), *cat. no. 8*

9

to adopt modernist abstraction. So urgent was his need to confront current atrocities that as early as 1942, in *Ominous Directions,* he made the leap from realism into abstraction without having experienced the modernist art of the 1930s, as did Mark Rothko and Adolph Gottlieb, who were members of The Ten, a group of avant-garde Expressionists, or Arshile Gorky, Willem de Kooning, and David Smith, who were part of an informal group that looked mainly to Picasso for inspiration.

Lipton's growing concern with inner reality led him to look toward Surrealism for inspiration. And in New York there were a considerable number of Surrealist artists who had fled Paris when France was conquered by the Germans, among them André Breton, Max Ernst, Yves Tanguy, Matta, and André Masson. Lipton did not meet any of them, but he probably was aware of their activities since the émigrés possessed a flair for promotion and a knack for generating excitement. They became a lively force on the New York art scene. In 1942, they organized a major show, *First Papers of Surrealism,* for which Marcel Duchamp crisscrossed the exhibition space with sixteen miles of white string, a maze that gave rise to a great deal of media coverage. The exhibition included not only Europeans but Americans, among them William Baziotes, Alexander Calder, and Robert Motherwell. Also in 1942, Peggy Guggenheim, then Ernst's wife, opened the Art of This Century Gallery and gave one-person shows to a number of avant-garde Americans, among them Baziotes, Jackson Pollock, Richard Pousette-Dart, Rothko, and Clyfford Still. These artists and Gottlieb constituted a loose group that Rothko labeled the Mythmakers.[4] Lipton claims not to have known their works until 1948, but beginning in 1943, their ideas were in the air. Their shows were reviewed and their work elicited a controversy in *The New York Times* that commanded art-world attention.

The Mythmakers, like Lipton, were disturbed by the war's violence, destruction, bestiality, and suffering. They were in thrall to an "imagination of disaster," to borrow a phrase from Henry James, a fearful and anxious state of mind that persisted and grew even more acute with the dropping of atom bombs on Hiroshima and Nagasaki, the revelations of the Holocaust, the cold war, and the ever-present threat of nuclear devastation. The war and its aftermath brought into sharp relief the irrational side of humankind as inherent to its being, a side that had to be addressed in any art that aspired to be relevant. Confronted with a world that seemed to have lost its reason, the Mythmakers asked: What was responsible? Their answer: irrational drives whose source was in the unconscious. Their search would have to be inward, into their *own* selves. The way was shown by Surrealist art, because it proposed to explore the deeper levels of the psyche.

Inspired by Freud, the Surrealists considered the unconscious to be the domain of humankind's true nature. But entry into this hidden realm of repressed memories and obscure impulses was blocked by conscious censors, which had to be bypassed. To unlock the unconscious, Freud had devised the technique of free association, requiring an analysand to blurt out whatever came to mind. The Surrealists invented an artistic counterpart, automatic drawing and painting or, as they termed it, "pure psychic automatism," in which the artist employed spontaneous doodling—inspired doodling, it was to be hoped—to gain access to the secret recesses of the unconscious; to encounter images, symbols, and signs there; and to externalize them.

In his own desire to work more improvisationally, Lipton was attracted to the practice of automatism. However, as a sculptor, particularly as a carver, he could not use automatism as freely as painters could. But he could in his drawing, and he relied increasingly on preparatory sketches. As he gave automatism freer rein, Lipton's imagery became increasingly abstract. He continued to cast his pieces in bronze, but in his desire for directness, he began to make maquettes by modeling in plasticene or plaster, or soldering lead sheets, and then translating them into bronze. Next, he produced larger lead constructions, the first of which was *Moby Dick #1* (1946). Increasingly, Lipton's process would be to make quick preliminary drawings, translate them into small working models, and then turn these models into larger, more "finished" constructions. However, his process remained sufficiently improvisational to transform a work in progress at any stage.

———————

Lipton's turn to "thorns, bones (ancient and modern), . . . tusks, teeth, and harsh forms [that evoked the] meaning of modern man"[5] was inspired by "primitive" art. As he recalled: "Around 1945 I became interested in Mayan and Aztec death ritual sculptures, Molochs, and other historical deadly devouring imagery [exemplifying] the hidden

destructive forces below the surface in man."[6] He also began to base his imagery on primordial creatures and birds of prey which for him became metaphors for the bestial side of humankind. Moreover, predatory birds made allegorical references to warplanes that devastated cities from Guernica to Nagasaki. Lipton's *Prehistoric Birds #1* (1946) and *Birds of Prometheus* (1947) are two such sculptures, and the title of the latter also indicates an interest in myth. It is significant that three other pieces of 1945–46 are each titled *Moloch* after a god of human sacrifice.

Faced with what they repeatedly referred to as "a crisis in subject matter," the Mythmakers were in a quandary. What were they to paint? How could they depict the tragic condition of humankind? Like Lipton, they looked for inspiration to "primitive" art and myth. Gottlieb, Barnett Newman, and Rothko, who spoke for their colleagues, declared that the modern world was essentially as barbaric as the "primitive" world was, or so they imagined. Human beings, both aboriginal and modern, were in thrall to apocalyptic external forces and irrational inner instincts and impulses, which they were powerless to control and which caused an overwhelming feeling of anxiety.[7] The Mythmakers felt compelled to express terror, fear, aggression, and anguish in their art. Consequently, "primitive" cultures assumed a particular relevance for them. As Gottlieb said in 1943:

> If we profess kinship to the art of primitive man, it is because the feelings they expressed have a particular pertinence today. In times of violence, personal predilections for niceties of color and form seem irrelevant. All primitive expression reveals the constant awareness of powerful forces, the immediate presence of terror and fear, a recognition of the brutality of the natural world as well as the eternal insecurities of life. That these feelings are being experienced by many people throughout the world today is an unfortunate fact and to us an art that glosses over and evades these feelings is superficial and meaningless.[8]

Rothko discovered in primitive art and myth universal psychological truths, in his words,

> . . . eternal symbols upon which we must fall back to express basic psychological ideas. . . . symbols of man's primitive fears and motivations, no matter in which land or what time, changing only in detail, but

never in substance, be they Greek, Aztec, Icelandic or Egyptian. And modern psychology finds them persisting still in our dreams, our vernacular, and our art, for all the changes in the outward conditions of life.[9]

Rothko's statement was influenced by his reading of Carl Jung's psychoanalytic writings. As Jung saw it, during humankind's primordial past images, symbols, and signs were embedded in the "collective unconscious," a realm shared by all people. These universal and timeless archetypes continue to "live" in the psyche, and it was the mission of artists to recollect them. Jung's ideas were much in the air in the 1940s, and Lipton was very taken with them.

Mythmaking was attractive to the avant-garde painters in New York during World War II because they believed that myths had always been invented by people to contend with the terrors of the unknown. Moreover, the primitivistic and mythic subjects they chose, which as Rothko and Gottlieb claimed were "tragic and timeless,"[10] expressed the contemporary human condition with greater truth and relevance than the images of class struggle contrived by the Social Realists. Thus the Mythmakers emulated the Social Realists' social commitment and urge to communicate while rejecting their messages as limited and banal. As Gottlieb summed it up:

> Different times require different images. Today, when our aspirations have been reduced to a desperate attempt to escape from evil, and times are out of joint, our obsessive, subterranean . . . images are the expression of a neurosis which is our reality. To my mind, certain so-called abstraction is not abstraction at all. On the contrary, it is the realism of our time.[11]

Lipton's works were the sculptural counterpart of primitivistic and mythmaking painting. His *Moby Dick #2* (1948) is representative of his abstractions of the mid-forties. He chose the great white whale as his subject because he viewed it as a "symbol of destruction and . . . evil."[12] *Moby Dick #2* is a voracious open maw. In its gaping interior a great tooth-tusk-horn, the back of which is armored like some fearsome dinosaur, is poised to clamp down or impale itself in a violent sado-masochistic self-destructive act. It is noteworthy that in 1943 Jackson Pollock chose Moby Dick

as his subject (he later changed the title to *Pasiphae*—but not the content). Both Ahab's whale and Pasiphae's bull were engaged in violent bestial activity. However, whereas Pollock's Moby Dick is orgiastic, Lipton's is ferocious. Indeed, Lipton's sculpture from 1945 to 1949 is more monstrous than that of any of his contemporaries.

Lipton and Pollock were not the only artists who chose grotesque animals and birds as subjects in the 1940s. Theodore Roszak created *Spectre of Kitty Hawk* (1946–47) and *Raven* (1947); and David Smith, *Jurassic Bird* (1945) and *Royal Bird* (1948), both based on the skeleton of a birdlike creature in the American Museum of Natural History.[13] Herbert Ferber's *Act of Aggression* (1946) and *Hazardous Encounter* (1947) are composed of aggressive bonelike elements. In painting, there was Baziotes' *Dwarf* (1947), inspired by a photograph of a mutilated World War II veteran as well as dinosaurs and great bird-lizards. His *Cyclops* (1947) was suggested by a rhinoceros, eyes slung low, at the Bronx Zoo. At the same time, Baziotes thought of the rhinoceros as the living kin of primordial beasts and as a metaphor for the one-eyed giants of Greek legends, all of them symbolizing primal evil.[14]

Albert Elsen commented that Lipton's works of the 1940s reveal an "uneasy coexistence of order and disorder in man and nature."[15] So do the postwar paintings of Pollock, de Kooning, Franz Kline, and other Abstract Expressionists. They lack fixity or repose and exhibit signs of anxiety, irrationality, and at times violence. Their color is disquieting more often than not, and their formal design is threatened with dislocation and dissolution. Clement Greenberg suggested that the tension between order and chaos was inherent to the American sensibility at the time.[16] He wrote that Pollock was able "to create a genuinely violent and extravagant art without losing stylistic control."[17] So was Lipton.

In 1948, Lipton created cagelike constructions that he titled *Prisoner* and *Imprisoned Figure*. Mazelike images also appear in the sculptures of Lipton's contemporaries, e.g., Peter Grippe's *Symbolic Figure #4* (1946). Internment was a gripping subject at the time. In 1952, London's Institute of Contemporary Art sponsored an international sculpture competition on the theme of *The Unknown Political Prisoner*, which attracted thirty-five hundred entries from fifty-seven countries. Comparable images of webs, nets, tangles, mazes, and labyrinths appeared frequently in Abstract Ex-

pressionist paintings, for example, Pousette-Dart's *Figure* (1945); Baziotes' *Web* (1946); Pollock's *Out of the Web* (1949); and Gottlieb's labyrinthine images (1950–55). These images call to mind the mythic Minotaur, on the one hand, and on the other, the entrapment of despairing, helpless, and frustrated individuals in prisoner-of-war compounds, death camps, and gulags. Or perhaps, more generally, as the art historian Michael Leja suggested, webs evoke "modern man entangled in forces beyond his ability to understand or control—webs woven of fate, past actions, and unconscious and primitive impulses."[18]

Even when Lipton's sculptures were violent and brutal without any apparent redemptive edge, his statements were hopeful. Understandably, in time, he would search for an optimistic counterbalance to his pessimism, and by 1949, he found it. As he recalled, "tragic horrors had reached a point of no return." He now desired to reveal "a new hope" manifest in "biologic life cycles"—a rebirth.[19] Savage thorns, teeth, tusks, and claws—to which Lipton added aggressive screws and other machine forms—are joined by seeds, pods, buds, and cocoons—often forming composite or hybrid seed-thorns, suggesting "double meanings and feelings," as he commented.[20]

Lipton's subjects became the regenerative cycles of life, death, and rebirth. His sculptures' abstract forms are based on biological and botanical organisms, notably plants, that call to mind the psychosexual, the social, and the metaphysical. For example, at the core of *Sanctuary* (1953) is the seed, surrounded by a protective sheath or cloak, yet open to the world. The germinative kernel is also a vertebra, malevolent symbol of death. The polarity between life and death is carried through in the interaction of tranquil sheathlike planes, unfolding in concave and convex layers, with belligerent cutting and piercing details. The seed may be viewed as struggling for life, and by implication, as a metaphor for the struggle to renew and rebuild society after Auschwitz and Hiroshima.

As the fifties progressed, Lipton's works became more figurative and epic. A series of vertical figures are heroes, signifying the heroic in Everyman, as Lori Verderame comments here.[21] *Prophet* (1959), for example, is a striding figure just short of eight feet tall whose face and leg sprout plant forms. He raises his prayer shawl or bent

arms heavenward in a gesture that at once supplicates and wards off evil. In a sense, Lipton had circled back to the humanism that motivated his Social Realist carved wood and stone sculpture of the 1930s and early 1940s, but now his constructions evoke a survivor humanism.[22]

In the 1950s, Lipton began to weld Monel metal planes and braze them with nickel silver or bronze. At this time, he became identified with a group of welders that achieved prominence during that decade, namely Herbert Ferber, David Hare, Ibram Lassaw, and Theodore Roszak. This group was considered the sculptural counterpart of Abstract Expressionism. Just as the painters used the direct process of painting to encounter new motifs, so the sculptors used the direct process of welding. The welding medium enabled them to improvise relatively freely with structure and with the molten crust that activated the unconscious imagination and suggested biomorphic images. There were degrees of improvisation, Lassaw relying more on "action," Lipton more on preliminary sketches. Despite certain similarities in approach, the differences in the styles of these welders is much more pronounced, since each had achieved a singularly independent style. Lipton's work is unique because it deals with life cycles and tends to be less linear and more volumetric than the others'.[23] But mass had always been Lipton's forte, beginning with his early wood and stone carvings of the 1930s and early 1940s.

Lipton's fame was at its greatest in the 1950s. In 1956, for example, he was included in the prestigious *12 Americans* at The Museum of Modern Art. In 1958, the critics of *Art News* voted his show one of the twenty best that year.[24] Ferber, Hare, Lassaw, and Roszak were equally esteemed. Then in the 1960s, their reputations fell off precipitously. Why? One might say that it was because the art world of the 1960s turned its attention to new art. True, but David Smith continued to command art-world interest. Perhaps then, the sixties art-conscious audience concluded that their work was lacking in quality. But not according to the taste of the 1950s. Are we then to assume that the "eye" of the 1960s was superior to that of the 1950s? On what grounds? One might say aesthetic distance. But does distance in time enable us to see quality in art with greater clarity? I am not

convinced that it does. Is it not as reasonable to assert that sensibility, expectations, and taste had changed—changed, rather than improved? Perhaps, too, considerations of quality were not the only forces at work on taste. If so, what might they have been and how would they explain the decline of Lipton's reputation and that of his fellow metal sculptors?

During the sixties, two sculptural tendencies came to dominate art-world discourse. One was the Formalist welded construction of the progeny of David Smith, notably that of Anthony Caro and his numerous followers. The other was the Minimal sculpture of Donald Judd, Robert Morris, Sol LeWitt, and Dan Flavin. Now, the emergence of these sculptural tendencies in themselves need not have caused the decline of fifties welded construction. But Formalists and Minimalists issued statements that aggressively attacked fifties welded construction as passé. Although Formalist and Minimalist rationales were both rooted in Clement Greenberg's aesthetics, they were nonetheless opposed to each other. However, they were agreed that fifties welded construction ought to be relegated to the dustbin of history. In sum, the reputations of Lipton, Ferber, Hare, Lassaw, and Roszak declined because their work did not meet the requirements of the two dominant aesthetic dogmas of the 1960s.

How powerful were the Formalist and Minimalist camps? A list of the names of the art critics involved is a sufficient indicator. In the cause of Formalism were Greenberg, Michael Fried, Rosalind Krauss, Barbara Rose, William Rubin, and Eugene Goossen. The Minimalist critics were Lucy Lippard, and artists Judd, Morris, Robert Smithson, and again Goossen, Krauss, and Rose. This was indeed a formidable array.

Underlying both Formalist and Minimalist aesthetics was the conviction advanced by Greenberg that each of the arts was—or ought to be—occupied with what was unique and irreducible in the medium of each. The Minimalists claimed that sculpture should be concerned with what made sculpture sculpture, and they decided it was its "objecthood." Morris insisted that the concerns of sculpture were not only distinct but hostile to those of painting. The one was essentially "tactile," the other, "optical." Sculpture had to focus on its physical properties and approach what it was essentially—a thing of "obdurate literal mass."[25] The most physical of masses was the single or unitary, monolithic

abstract object, that is, an object without parts, since the parts would call attention to their relationships and away from its thingness. If the sculpture did have parts they were required to be modular. Welded construction in space with its diverse parts did not fit that bill and was dismissed as retarded and outworn.

Like the Minimalists, the Formalists insisted that each of the arts confine itself to what was distinctive or limited to its particular medium. They applied the dogma to painting, but not to sculpture. Making an exception of sculpture, they required that it not be sculptural but "pictorial," like that of Caro. In direct opposition to Minimalist claims, Greenberg asserted in 1958 that modernist sculpture should be "almost as exclusively visual in its essence as painting itself. It has been 'liberated' from the monolith."[26]

But what painting did Greenberg have in mind? In the late forties and early fifties, he had written favorably about the action or gestural or painterly tendency in Abstract Expressionism, exemplified by the painting of de Kooning, Kline, and Philip Guston. However, in the middle 1950s, he turned against it, and instead championed Color-Field Abstraction in which the painterly "touch" of the artist was suppressed or eliminated.

Like the painting he admired, Greenberg acclaimed the "pictorial" in welded construction, but only when its sur-faces and contours were clean, like Caro's. He rejected the works of Lipton, Lassaw, Ferber, Roszak, and Hare, because their bubbled, fretted, and pitted surfaces were "painterly" as well as "pictorial." Transferring his distaste from the "painterly" in painting to sculpture in which the oxyacetylene torch was used like a brush, he condemned both. Moreover, with Smith and Caro in mind, Greenberg wrote that it was permissible for construction sculpture to "suggest recognizable images, at least schematically" but it must "refrain from imitating . . . organic substance or texture," such as that found in fifties welded sculpture, presumably because the latter was less abstract.[27]

Lipton, Lassaw, Ferber, Roszak, and Hare got both barrels—from the Minimalists and the Formalists. I can only conclude that the decline in the reputations of these construction sculptors was caused by considerations other than the quality of their works. Linda Nochlin once commented that the mission of contemporary art critics and historians is not only to teach people to *see* art but to *see through* it as well, that is, to make them aware of what it is that conditions their seeing: the psychological, social, and other pressures that shape our tastes, ideologies, and discriminations.[28] Is it not time to reevaluate Lipton and his fellow construction sculptors?

Notes

1. Albert Elsen, *Seymour Lipton* (New York: Harry N. Abrams, Inc., 1970), 20.

2. Elsen, *Seymour Lipton,* 20.

3. Elsen, *Seymour Lipton,* 21.

4. Mark Rothko, *Clyfford Still* (exh. cat., Art of This Century Gallery, New York, 1946), n.p.

5. Seymour Lipton, "Some Notes on My Work," *Magazine of Art* 40 (November 1947), 264.

6. Elsen, *Seymour Lipton,* 27.

7. See Michael Leja, *Reframing Abstract Expressionism: Subjectivity and Painting in the 1940s* (New Haven: Yale University Press, 1993), 72. The idea that primitive man was essentially fear-ridden was frequently expounded in popular literature but was denied by the leading anthropologists at the time. Anthropologists also disagreed with the idea that there was a generic primitive man. The Mythmakers did recognize the *élan vital,* communality, and spirituality of primitive societies, but they tended to minimize these qualities.

8. Adolph Gottlieb and Mark Rothko, *The Portrait and the Modern Artist* (mimeographed typescript of a radio broadcast on "Art in New York," WNYC, New York, October 13, 1943), n.p.

9. Gottlieb and Rothko, *The Portrait and the Modern Artist,* n.p.

10. Adolph Gottlieb and Mark Rothko (in collaboration with Barnett Newman), "Letter to the Editor," *The New York Times,* June 13, 1943, II:9.

11. Adolph Gottlieb, "The Ides of Art," *The Tiger's Eye* 2 (December 1947), 42.

12. Elsen, *Seymour Lipton,* 28.

13. Kirk Varnedoe, "Abstract Expressionism," *'Primitivism' in 20th Century Culture* (exh. cat., The Museum of Modern Art, New York, 1984), vol. 2, 652–53.

14. See Mona Hadler, "William Baziotes: Contemporary Poet-Painter," *Arts Magazine* 51 (June 1977), 102–10.

15. Elsen, *Seymour Lipton,* 21.

16. See Leja, *Reframing Abstract Expressionism,* chapter 5.

17. Clement Greenberg, "Art," *The Nation,* April 13, 1946, 445.

18. Leja, *Reframing Abstract Expressionism,* 283–84.

19. Elsen, *Seymour Lipton,* 30.

20. Seymour Lipton, Statement, in *12 Americans* (exh. cat., Museum of Modern Art, New York, 1952), 72.

21. See below, p. 45.

22. Kirk Varnedoe first used this expression with regard to the bonelike sculpture of Henry Moore.

23. In the late 1950s, David Hare began to create bulky figures by welding slender metal rods, but his imagery and technique did not at all resemble Lipton's.

24. "The Year's Best: 1958," *Art News* 57 (January 1959), 45.

25. Robert Morris, "Notes on Sculpture: Part 1," *Artforum* 4 (February 1966), 44.

26. Clement Greenberg, "Sculpture in Our Time," *Arts Magazine* 32 (June 1958), 23.

27. Greenberg, "Sculpture in Our Time," 23.

28. Linda Nochlin, Convocation Address to the American Section of the International Association of Art Critics, Solomon R. Guggenheim Museum, New York, 1983.

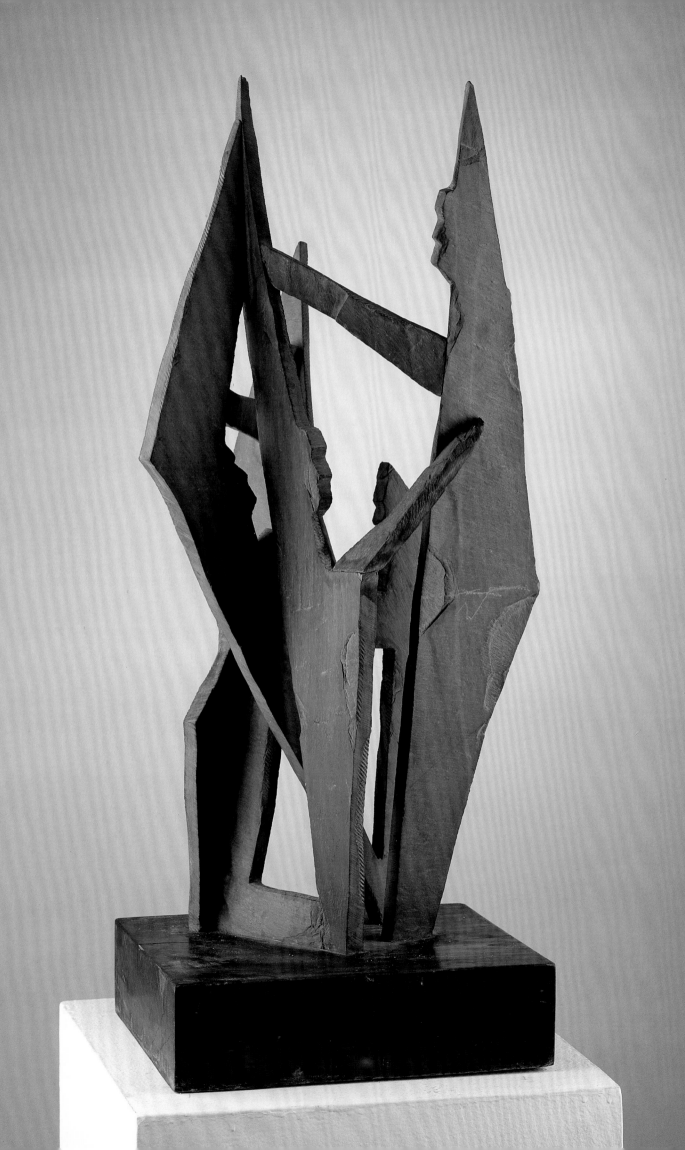

ONE

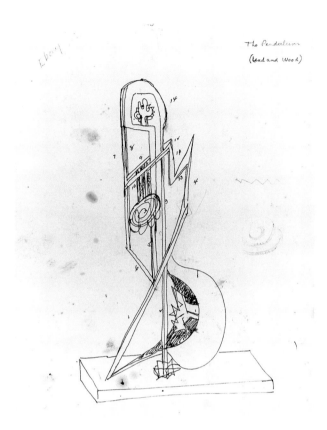

Seymour Lipton and Postwar American Sculpture

above

Study for Pendulum, ca. 1949, black ink
and pencil, 11⅟₁₆ × 8½ in. (28.3 × 21.6 cm),
cat. no. 57

opposite

City, 1947, slate, 26 in. high (66.1 cm),
cat. no. 7

Abstract Expressionism, the major modern art movement in the
United States after the Second World War, catapulted American
artists to the forefront of the art world. New York replaced Paris as
the world art center, and the Abstract Expressionist artists who
lived and worked in the city were often referred to as members of the
New York School. Among them was the sculptor Seymour Lipton.

Lipton (1903–1986) has been viewed primarily as a technical
innovator for his employment of the rustproof alloy called Monel.
The best known scholarly investigations of Lipton and his work de-
vote attention to his studio practices and his innovative method of
constructing large-scale metal sculpture. Such studies ignored for
the most part Lipton's themes and subject matter to concentrate on
his sculpture-making process. Recently, however, scholars have
defied the notion that Lipton's contributions to the history of
American art were merely technical. In addition to their innovative
construction and interesting forms, his works, in fact, reflect the
broader context of postwar society and, in particular, the concerns
of Abstract Expressionism.

Although the movement's painters have received more critical
and popular notice, the ideas and subject matter of Abstract Ex-
pressionism also categorized the works of inventive sculptors such
as David Smith, Ibram Lassaw, Herbert Ferber, Theodore Roszak,

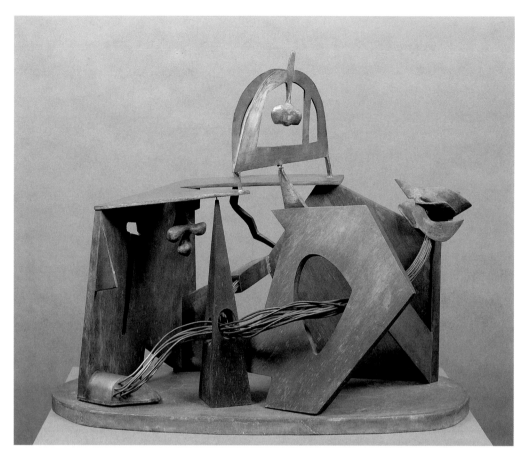

Pavilion, 1948, wood, copper, and lead, 22 × 24 × 14 in. (55.9 × 61 × 35.6 cm), *cat. no. 10*

and Lipton. Lassaw described the art climate for sculptors in New York in the 1950s:

> *There is an idea that sculptors have been influenced by Abstract Expressionist painters, or that painting happened first and then a form of Abstract Expressionism came into being in sculpture. In all those years we had been talking together and having the same ideas as these movements were produced, and they were produced by both painters and sculptors.*[1]

According to the art historian Stephen Polcari, the artists of the postwar period concentrated on the following themes: the elemental forces of life and history, the historic continuum or life cycle, the quest for harmony through chaos, and life-affirming optimism.[2] These ideas were explored by the Abstract Expressionists through their studies of history, prehistory, life cycles, mythology, cultural ceremonies, philosophy, and nature. Such themes were fundamental for Lipton. He had a strong aesthetic and contextual link to the intellectual world of New York during the 1940s and 1950s. His intellectual nature, diverse interests, and broad-based subject matter closely paralleled those of the "giants" of Abstract Expressionist painting such Jackson Pollock, Adolph Gottlieb, Willem de Kooning, Mark Rothko, Barnett Newman, and Robert Motherwell.

An examination of prominent and recurring postwar themes demonstrates that Lipton's ideas paralleled those of America's painters, writers, sociologists, anthropolo-

gists, and philosophers at mid-century. The ideas expressed by Lipton place his art firmly within an intelligent postwar context. As Lipton stated, "each image for me is a variety of life with man and his spirit which has a central suggestive reality whether the image is . . . a man, a bird or a flower."[3] This exhibition concentrates on Lipton's career, and his place within this seminal movement, by focusing on three major themes: nature, avian images, and the hero.

Born and raised in New York City, Lipton was a member of a strong and supportive Jewish family. He grew up on Charlotte Street in the Bronx, in tenement buildings first constructed at the turn of the century. Although the neighborhood would have been considered rural at that time, the tenements in which Lipton was raised represented some of the first signs of urbanization in that area. Charlotte Street was a hardworking, career-oriented, lower-middle-class community where many professionals were reared.

As an adolescent, Lipton was interested in art, and he shared this interest with his siblings. His sister worked as a textile artist and ceramist, and his other siblings had creative tendencies as well. Although his high-school teachers wanted Lipton to pursue art, his parents encouraged him in his decision to study electrical engineering at the Brooklyn Polytechnic Institute and later to pursue a course of study in the liberal arts at New York's City College. After college, Lipton continued his education in the field of dentistry. In 1927, he graduated from Columbia University's

dental school and shortly thereafter established a success-
ful practice in his native New York City.

In the late 1920s, Lipton became interested in sculp-
ture, and he embarked upon "a period of intense self-
training in sculpture."[4] By 1932, Lipton had achieved
expertise in the medium and, working primarily in carved
wood, he produced many pieces. Although his dental-
school training would later provide him with a basis for
making metal sculpture in his characteristic and mature
style, his early wood pieces showed similarities to the work
of the American direct carvers. Lipton's sculptures de-
picted the struggles of the common man and other Social
Realist themes common to the period. With a command of
abstraction and emotion, Lipton offered powerful sculp-
tural interpretations of the working-class experience.

With much experimentation, Lipton refined his tech-
nique, and his sculptures became more abstract. For themes
he looked to the war and its impact. Eventually, Lipton
rejected traditional carving techniques and employed the
tools and materials of the modern era. Quite simply, he
developed an unprecedented technique for creating his
sculpture: brazing nickel-silver rods onto joined sheets of
Monel metal.

By the early 1940s he was working almost exclusively
with metal, producing cast bronze pieces from plaster and
plasticene models. By 1946 he created his first sheet-metal
constructions using lead. He chose to abandon bronze
casting to "overcome the expense of casting as well as to
permit a more direct contact with the metal,"[5] and he turned
to a type of expressionist construction. Eventually, he de-
veloped the method he would use throughout his career. He
cut sheet metal, manipulated it to the desired shapes, then
joined, soldered, or welded the pieces together. Next, he
brazed a metal coating to the outside to produce a uniform
texture.

As he worked with various materials, he tried combin-
ing different types of metal. *Genie* (1948, cat. no. 9), for ex-
ample, combines copper and lead. In some cases he even
juxtaposed metal, wood, glass, and other materials. From
about 1947 through 1952, he experimented extensively with
different metals, assessing their usefulness, and tried sol-
dering, direct welding, and other joining systems. By 1952
he had achieved his mature style. He used Monel metal for
the shell of his sculptures, and brazed bronze or nickel sil-
ver onto the constructed sheets. This process resulted in a
uniform surface texture and color, enhancing the metallic
shell forms. This unprecedented technique, which Lipton
employed until the end of his career, was known throughout
the art community. He pioneered the use of Monel, a new
material known for its rustproof qualities.[6] He explained
that the technique "emerged as a craft adequate to my
needs, as a personal fulfillment."[7] Consisting as they did of

Genie, 1948, copper, lead solder with steel base, 22¼ × 21½ × 13 in.
(56.5 × 54.6 × 33 cm), *cat. no. 9*

thin, hollow, metal shells, Lipton's sculptures were light-
weight and transportable. And his innovative use of nickel
silver and Monel meant that his constructed metal works
could be placed outside without fear of weather damage
or rust.[8]

In the 1950s, technical and stylistic breakthroughs and
a new thematic approach occurred almost simultaneously.
The New York School sculptors made great strides in
American art as "sculpture in the 1950s broke free of tradi-
tional carving techniques and extended its aesthetic and
technical boundaries into the modern age."[9] New technol-
ogy, materials, and processes paralleled the new means of
expression for the New York School sculptors. According to
Herbert Read, the sculptural capabilities of metal were at-
tractive to these artists: "In general, metal is so docile that
it will submit to any formal conception the sculptor may
have, and it is this adaptability that explains its present
general use."[10] Sculptors created dramatic forms using
dripped, spattered, and molten metal, with highly textured
results. The introduction into sculptors' studios of the oxy-
acetylene torch, perfected during World War II, opened up
vast technical possibilities. Portable and inexpensive, this
torch burned hotter than any preexisting one, and it was re-
sponsible for producing highly textured surfaces in metal.
Additionally, the war had presented many Americans with
industrial jobs, and sculptors often applied such experi-
ence to their own artistic work. David Smith, for example,
along with Lipton and Harry Bertoia, incorporated skills ac-
quired as a factory worker into his working method.

The innovative pieces created during this period re-
flected the concerns of postwar American society. The

Sentinel, 1959, nickel silver on Monel metal, 89¾ in. high
(228 cm), *cat. no. 24*

sculptors had experienced a world filled with chaos from
the late 1930s to the mid-1940s; they chose manipulated
metal as a means of expression. The powerful heat of the
oxyacetylene torch was described as relating to the vio-
lence of the war years: Lisa Phillips characterizes artists'
desire to control the uncontrollable—in this case, fire—as
an attribute of the wartime psyche.[11] And sculptures based
on predatory forms, raptors, mutant plants and other or-
ganisms, as well as the heroic figure derived from a war-
torn world.[12]

This decade of the 1950s was pivotal for many of the
New York School sculptors. David Smith continuously con-
structed sculpture from found objects. Roszak made aes-
thetic breakthroughs, and Lassaw produced his first
dripped metal pieces in 1951. Ferber turned to welding
metal in 1954. This period was critical to Lipton's artistic
development, too, as he arrived at his signature style of
metal working in the early fifties. He continued to experi-
ment with various media and techniques, producing many
works. His process innovations brought him widespread at-
tention, and throughout the decade, Lipton was an impor-
tant and well-known figure in New York's art circles. He
taught sculpture at the New School for Social Research and

exhibited his own work extensively, at the Betty Parsons
Gallery, the Marlborough-Gerson Gallery, and New York's
museums. Along with strong market popularity, he enjoyed
corporate patronage, receiving commissions from archi-
tects such as Max Abramowitz and Skidmore, Owings, and
Merrill and from large corporations including the Rand Cor-
poration, the Inland Steel Company, and IBM. In 1955, he
retired from his successful dental practice to devote him-
self to sculpture full time.

In addition to achieving commercial success, Lipton
was viewed as an important figure in the development of
modern sculpture. He was praised by critics and "recog-
nized as a major force in American art."[13] *Art News* regarded
his one-man show at the Betty Parsons Gallery in 1954 as
one of the ten best shows of the year.[14] By 1958, 150 muse-
ums owned sculptures by Seymour Lipton,[15] and in that
same year, his works adorned the United States Pavilion at
the prestigious Venice Biennale. His participation at Venice
established his international reputation and solidified the
1950s as a decade filled with major accomplishments.

Despite Lipton's successes of the 1950s, he fell out of
favor in the coming decades. With the influx of such new
movements as Minimalism and Conceptualism in the 1960s
and 1970s, Lipton's popularity declined. He continued pro-
ducing thematic works, but fell prey to an art market and
community that rejected his pieces as passé. By this time, a
sculpture's critical acceptance was judged largely on its
formal or aesthetic qualities. With an art market devoted to
Formalism, the thematically based works by such sculptors
as Ferber, David Hare, Lassaw, Roszak, and Lipton, were
not embraced. The change in contemporary taste, as well as
the imposing scale of Abstract Expressionist sculpture
constituted reasons for a lack of collectors interested in
purchasing these works. In addition, the closing of many
of New York's most prominent galleries impacted the sale of
Abstract Expressionist sculpture.[16]

In light of Lipton's popularity in the 1950s, his unex-
pected journey into obscurity is intriguing. According to the
art historian Harry Rand, the artist's "progress has not
been greeted by any single voice of strong critical acclaim,
though Lipton's work has a large and knowledgeable audi-
ence."[17] Albert Elsen concurred that Lipton's work only "re-
ceived modest attention from the major art magazines and
critics in New York."[18] Lipton himself was very disappointed
about his lack of acceptance after 1960, and he was vocal
about his personal feelings concerning the art world and
critics.

Though he shared their artistic concerns, Lipton was
not a member of the core group of Abstract Expressionists
and he did not achieve their celebrity. According to his
friend the artist Will Barnet, Lipton's demeanor also played
a significant role in his status in the art world, for he had

difficulty in social situations. He did not frequent the Abstract Expressionist "hang-outs," and he did not consider many of the Abstract Expressionist artists close friends. He was acquainted with William Baziotes, Gottlieb, and Richard Pousette-Dart, and along with Barnet, he socialized with them more frequently than with the other members of the New York School. He knew the major figures of the period and was one of the "Irascible 18,"[19] but he was essentially a loner. Barnet contended that Lipton's severe personality contributed to his falling out of favor in New York's prominent art circles:

> *Sy was not very social. He had very little patience with people and he basically was very self involved. In the first place, he was not a drinker and during [this time] liquor was important to social behavior. People who drank a lot and enjoyed each other over drinks had a better position socially in the art world. Drinking wasn't Lipton's way. He was strictly a family man, a serious artist and up until the time he gave up dentistry, a serious dentist. He was totally committed to his work.*[20]

Although he did not join them socially, Lipton's sculptural themes and artistic concerns place him firmly within the circle of the Abstract Expressionists. Issues that reflected the attitudes of a generation of postwar Americans were vital to him, and his work characterized the cultural, historical, and social feelings of postwar society. Through a study of his works and the ideas and influences that underlie them, this exhibition reveals that despite the scholarship that narrowly defines him as a skilled technician, Lipton helped to define the prominent themes of Abstract Expressionism.

Untitled drawing (possibly related to *Diadem*), ca. 1945, black ink and graphite, 11 × 8⅞ in. (27.9 × 22.5 cm), *cat. no. 54*

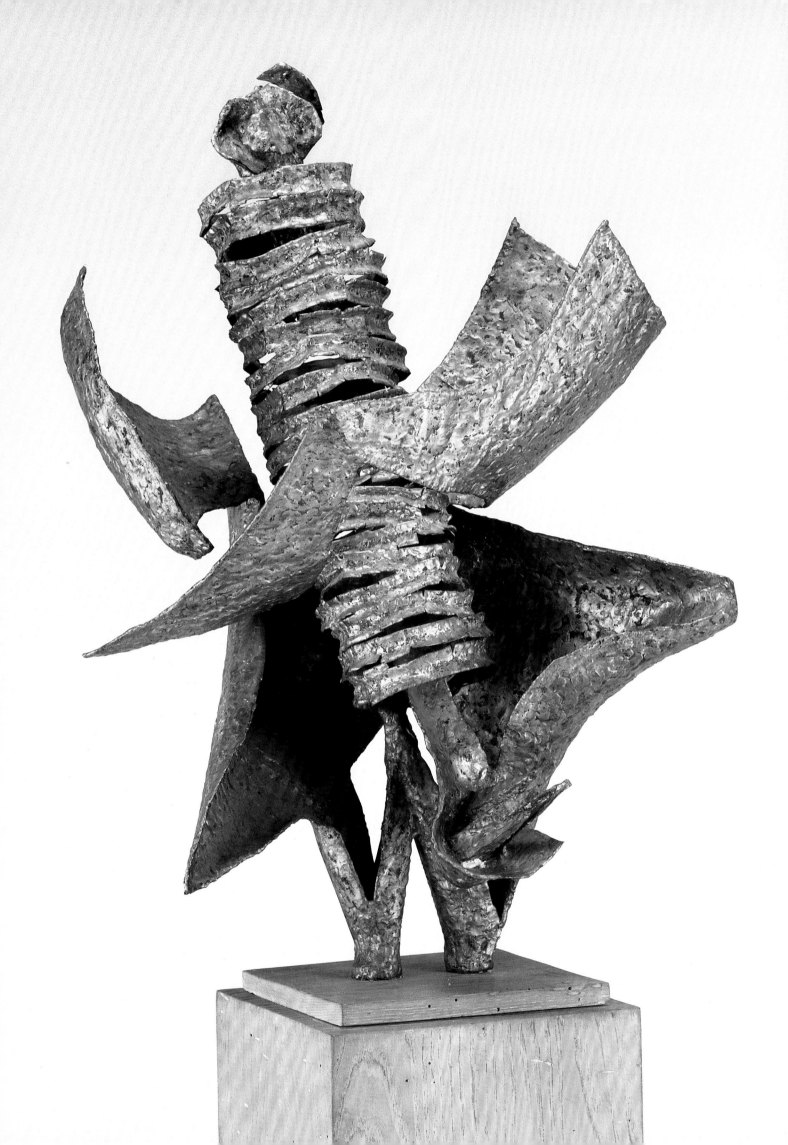

TWO

Nature's Forms

The art of Abstract Expressionism grew out of the tragedies of World War II. In short, "the general assessment that modern western civilization is in a state of crisis was the starting point from which the Abstract Expressionists approached their time and their art."[1] The artists of the New York School, having experienced the social changes that resulted in a negative societal mood that was prevalent from about 1914 through 1945, then matured during the war years. The events of this period sparked the "nihilism and negativism [that] the Abstract Expressionists grew up with."[2] The horrors of the Second World War remained a fundamental influence on and subject for the Abstract Expressionist painters and sculptors. Other subjects also evolved from the war and its aftermath.

In the postwar period, Americans looked to the future and tried to rebuild society. This mentality found a parallel in nature. Nature's ability to emerge anew each spring after a somber winter became symbolic of the postwar period. The artists of the New York School in particular were influenced and inspired by nature's growth, sustaining capabilities, and cyclical processes.

Nature as Subject for the New York School

When Hans Hofmann asked Jackson Pollock if he drew from nature, Pollock replied confidently, "I am nature."[3] Indeed, nature

above

Study for Sanctuary, 1951, pencil, 10¹⁵⁄₁₆ × 8½ in. (27.8 × 21.6 cm), *cat. no. 62*

opposite

Glowworm, 1957, nickel silver on Monel metal, 32 × 22 in. (81.3 × 55.9 cm), *cat. no. 21*

David Smith, American (1906–1965), *Hudson River Landscape,* 1951, welded painted steel and stainless steel, 49$\frac{15}{16}$ × 73$\frac{3}{4}$ × 16$\frac{9}{16}$ in. (126.8 × 187.3 × 42.1 cm). Collection of Whitney Museum of American Art, New York. Purchase, 54.14. © Estate of David Smith/Licensed by VAGA, New York, NY

served as an influential and prominent theme for the majority of artists of the New York School. They felt that "nature was synonymous with evolution, struggle, process, change and the internal psychic life, a symbol of the continuity of life."[4] They found in nature a means to express their connection to and outlook on the postwar era in America. The importance of nature as a theme for the Abstract Expressionists reigned supreme. An exhibition dedicated to the topic, *Nature in Abstraction,* premiered at the Whitney Museum of American Art in 1958. In the catalogue, painters and sculptors featured in the show discussed their work and its relationship to nature. Richard Pousette-Dart described his painting *Golden Dawn* (1952, oil on canvas) as "defining my relationship to nature." Adolph Gottlieb indicated that his *Red Sky* (1956, oil on canvas) was based on nature, as he often demonstrated some "connection with nature in painting." Lipton's comments for the *Nature in Abstraction* show relate to those of his colleagues: "My own areas of derivation are largely biologic nature, technological forms, and aspects of past art traditions. The manner in which I use forms from nature developed from my attitudes towards life, in general and sculpture, in particular."[5]

The Abstract Expressionists looked to nature for sources for their work. Barnett Newman studied botany and produced numerous works relating to it; Theodoros Stamos' paintings *Moon Flower and Surf* (1946, oil on canvas) and *Movement of Plants* (1945, oil on canvas) may have been inspired by his reading of Charles Darwin's book *The Power and Movement of Plants* (1881).[6] Gottlieb's *Omens of Spring* (1950, oil on canvas) and William Baziotes' *Dusk* (1958, oil on canvas), among other works, give evidence of their inception in nature. Also, the abstract landscapes of Franz Kline such as *New York, New York* (1953, oil on canvas) and Willem de Kooning's *Gotham News* (1955, oil on canvas) react to nature in the highly expressive and famed gestural style.

Nature's impetus was felt even in sculptures of constructed metal. Many of David Smith's compositions related to drawing in space as evidenced by the landscape-inspired works *Australia* (1951, painted steel) and *Hudson River Landscape* (1951, steel). Works from Smith's "Cubi" and "Hero" series refer to the human figure. Ibram Lassaw, a major figure in postwar American sculpture who created cages and webs of dripped metal as well as sculptural abstractions, commented:

> Nature is not something opposed to or in any way different from man. Man is part of Nature's organic whole. This is never a question of the conquest of nature, but of finding one's place and function in the creation of the world, which is continually taking place, the music that is playing itself eternally before us and within us.[7]

Like Smith, Lassaw, and other Abstract Expressionist sculptors, Lipton found that nature served his objectives both formally and thematically throughout his career. Lipton avowed that his work derived from the inner spirit of nature: "The life of forms is for me, the forms of life."[8] Scholars and critics, too, have recognized that Lipton's work addresses the natural world and its forms. Albert Elsen remarked that Lipton made "nature a full subject of his sculpture,"[9] Andrew Carnduff Ritchie said that Lipton's sculptural repertoire demonstrates his "interest in the regenerative process, nature forms."[10] And the art critic Herman Cherry stated that "sculpture is organic for Lipton."[11] Subjects based on nature appear early in Lipton's career. In the 1930s, he focused on the human figure in a manner consistent with the American direct carvers, and he produced traditional figural groups such as *Man and Woman* (1937, sabicu wood). Other natural forms began to appear in his sculptures of the 1940s: *Thorns* (1941, mahogany), *Thorny Shell* (1946, wood) and *Moon Flower* (1949, brass and lead, cat. no. 14). From the 1950s through the 1980s, natural phenomena continued to inspire Lipton as he produced sculptures based on figures, plant growth, sea life, seasonal change, insects, birds, and the cycles of life.

Influences and Inspirations

Lipton's personal connection with nature began early and remained strong. Growing up in the suburban areas of New York (which he described in his letters as rural), Lipton was drawn to the outdoors; later, his sculptural forms would reveal this childhood experience:

> I knew what a grasshopper was because we used to catch them. And I collected butterflies. So I became very, very close to the fields, like any farm boy. We used to pick jack-in-the-pulpits which had a very big influence on my subsequent forms. I would assume that the actual forms of these flowers in some way gave me a basis, a formal basis for the development of a certain kind of imagery to express certain attitudes toward life. There were city streets but not many houses—they were building while I was a kid. We picked flowers. And I remember clover. On the next block there was a big farm and it had about fifteen cows. The man who owned it had fruit trees and in the fall, kids used to jump the fence to get the pears. There was a park right near us, Katonah Park. So I was brought up in an area which perhaps led later, let's say in the '50s, to my getting involved with botanical forms and animals and insects.[12]

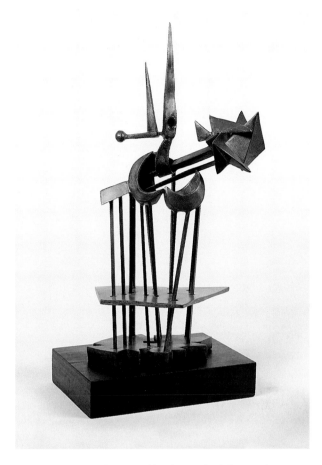

Moon Flower, 1949, brass and lead, 19 in. high (48.3 cm), cat. no. 14

Additionally, Lipton's family often visited art and natural-history museums and botanical and zoological gardens in and around New York City. There Lipton looked at the "plants of the tropics, at plants of the desert, at sea forms, animal forms and flowers of all kinds."[13] In adulthood, he drew upon these experiences to discover interesting and exotic forms to translate into organic sculptural compositions. He recalled:

> I used to go to the Museum of Natural History. It's one of the most fascinating museums in the world to me. The Bronx Botanical Gardens still fascinate me. I'm sure I was influenced by many of the tropical plant forms, particularly in the Bloom series [the flower series of sculptures], that have always interested me. The animals of the zoo, all kinds of root forms always fascinate me.[14]

Lipton's personal inclination toward natural forms coincided with the mainstream of sculptural production for the postwar period. As the critic Herbert Read described it, "nature and the organic mood of sculpture dominated the 1950s."[15] The "organic mood of sculpture" was closely aligned with the modern theory of Vitalism, the view that suggests that in the very materials and processes of art, life is present.[16] Vitalism characterizes a newly found "interest in science . . . a new found faith in the regenerative power of nature."[17] Vitalism reflected the postwar preoccupation with regeneration and further solidified nature as a theme for the Abstract Expressionists.

Any discussion of Vitalism must begin with a review of the influence of Henry Moore and the impact that Vitalist theory had on his work. As Jack Burnham explained, Moore's art shows "the infusion of life into the materials of sculpture."[18] Moore outlined the major tenets of Vitalism and their connection with modern sculpture. The two most important elements are a sculptor's dedication to the observation of nature (or natural objects) and the power of expression. Moore explained these two points:

Observation of Natural Objects

> The observation of nature is part of an artist's life. I have found principles of form and rhythm from the study of natural objects such as pebbles, rocks, bones, trees, plants, etc. Shells show nature's hard but hollow form (metal sculpture) and have a wonderful completeness of single shape.

Vitality and Power of Expression

> A work must first have a vitality of its own. I do not mean a reflection of the vitality of life, of movement, physical action, frisking, dancing figures and so on, but that a work can have in it a pent-up energy, an

intense life of its own, independent of the object it may represent.[19]

Lipton alluded to the Vitalist quality of his work as he discussed the forms that interested him: "forms that are angry, bitter, lovely, searching; that intertwine, that reach out, that close back and inward. These are the stuff of every-day living."[20] Such forms are apparent in organic pieces such as *Carnivorous Flower* (1953, nickel silver on steel), *Jungle Bloom* (1954, bronze on steel, cat. no. 17) and *Dragon Bloom* (1955, nickel silver on Monel metal). He elucidated his interpretation of Vitalism in describing his artistic method based on the metaphor: "Metaphors with varied suggestiveness pulling in several directions keep the experience open. The visceral excitement of suspense evidently forced me to seek formal organizations suggesting 'process' as a never-ending mystery, a never-closing experience."[21] For Lipton, the restrained energies of Vitalism found expression in the natural life process, the process that takes a seed from its dark, protected underground environment to its bursting forth with new life, as he discussed in "The Seed Motif":

> *The germinal force of life is a reality rich in sculptural possibilities. To open up and unfold these dark beginnings, to peer into their interiors that they disclose, themselves as feeling and symbols pointing to the entire process of life, struggle, change, death and rebirth. To activate the quiet seed, to bring out the energy lying dormant within the shell of the seed, my present concern is to bring all these into the realm of active, vital sculpture.*[22]

Lipton's dedication to such ideas is evident in works such as *Jungle Bloom* and *Sanctuary* (1953, nickel silver on steel, cat. no. 16). These works visually explore the simultaneous transformation of the interior and exterior forms and qualities of germination of seeds into plant forms.

Insects also proved to be an attraction for Lipton and other sculptors. For example, David Smith's *Insect* (1948, steel) and Lynn Chadwick's *Chrysalis* (1955, copper) show this common thematic thread. For Lipton, it was again his childhood experience that surfaced as inspiration: "in any event, the acorn, the caterpillar, the various insects that I could see and play with as a child must have crept into my subconscious and came out in many ways later on."[23] Particularly, the larva and pupa stages of insect development reflected Lipton's desire to represent the hidden, mysterious occurrences within nature and the cycle of life. *Chrysalis* (1957, bronze on Monel metal) and *Glowworm* (1957, nickel silver on Monel metal, cat. no. 21) both retain an element of the unknown, of the mysterious, through their intertwined and complex forms. For example, *Chrysalis*

juxtaposes curved forms that indicate growth, internal movement, and activity. The mysterious transformation of a caterpillar into a moth or a butterfly parallels once again the hopeful, transitional, and regenerative aspects of postwar thought. The unexpected light source from a glowworm exemplifies a hidden and enigmatic energy within this strange earthy creature. Lipton viewed the light as the work's most important feature. This is apparent in the work, as the sculpture's most prominent form is the elongated coil that houses the insect's natural lightbulb. Here, Lipton achieves the interior dynamism and activity of Vitalism described by Herbert Read and Henry Moore.

Influence of Jungian Theories

As artists of the New York School searched for a more universal expression of art than the Social Realism of the 1930s, they began to explore the philosophy of Carl Jung.[24] Pollock's and Motherwell's vast knowledge of Jung's work is well documented. Other Abstract Expressionist painters and many of the movement's sculptors also studied Jung and his followers Heinrich Zimmer and Joseph Campbell, who brought Jung's ideas to the attention of the American avant-garde.[25] Jungian thought was a prominent source for the exploration of several leitmotifs of Abstract Expressionism, including the regenerative forces of nature and the issue of process. Renewal myths, too, were important sources for these artists, and Jung elucidated such myths and their connection to the collective unconscious.[26]

Lipton's library included works by Jung and his American disciples, and it was, specifically, Jung's writings about the unconscious that most affected him. In his book *Modern Man in Search of a Soul* (1933), Jung discussed the personification of the unconscious as a living sense of the rhythm of organic growth, flowering. Lipton found this connection to the unconscious in the events of natural development that occurred beneath the ground's surface, such as the evidence of root systems or the germination of seeds.

> *In the flowers, the opening bud, the sense of the hidden in the ground in the winter, what went on in nature below the surface, always below the surface, the unconscious is present all the time with us, as well as what we visibly present in our everyday talking. So my images began to be subtly and strongly influenced by this need for a dynamic interplay between inside and outside forms, between an internal anatomy and an external anatomy so that both together become a single, organized, living sculptural entity.*[27]

This interplay between interior and exterior forms is evident in many of the "Bloom" series sculptures. These works indicate the way the mysterious processes of nature that take place out of sight inevitably affect the outer,

Study for Sanctuary, 1953, pencil, 10¹⁵⁄₁₆ × 8½ in. (27.8 × 21.6 cm), *cat. no. 63*

Study for Sanctuary, ca. 1953, black ink, 10¹⁵⁄₁₆ × 8½ in. (27.8 × 21.6 cm), *cat. no. 64*

visible forms of plants; while at the same time, the external forms protect and shelter the vulnerable interior—much as the unconscious influences human experience. In *Sanctuary,* for instance, the central core seems struggling to emerge, while the protective outer shell contains it, yet also seems to be expanding to allow the center to grow. Lipton said,

> When I made Sanctuary, *for example, I felt among other things a sense of guarding hidden secrets, probably painful ones. We guard these personal things by letting other experiences develop. The work as a whole suggests a flower. Yet botanical nature was of secondary concern. Man was primary.*[28]

In *Dragon Seed* (1954, nickel silver on Monel metal), *Dragon Bloom, Mandrake* (1958, nickel silver on Monel metal, cat. no. 22), and *Dragon* (1966, bronze on Monel metal), Lipton accentuates the connection to Jung's theories. In addition to addressing the natural processes of growth, these works also pertain to dragons. The dragon was especially significant for Jung: He believed that "in mythology, great animals—for instance, a whale, wolf or dragon—represent the unconscious."[29] Lipton's titles for such preeminent works of the postwar years indicate their foundation in Jung's theory of the unconscious.

Additionally, Jung examined the impact of prehistory and natural history on the art world. Lipton's works featuring skeletons of specific creatures not only recall his own interest in objects seen in natural-history museums but also refer to Jung. The skeletal properties of *Dragon Bloom* are reminiscent of prehistoric fossils, while the dragon refers to contemporary issues such as the intellectual interest in the grotesque and the primitive. Lipton described the

work as containing "staccato forms, suggesting vertebrae and gothic bestiary, a total mood of jagged force and primitive ritual."[30]

Similarly, *Mandrake* reveals Lipton's study of the natural world and its association with Jungian thought. A poisonous plant of the nightshade family, mandrake plants possess a short stem, purple and white flowers, and a thick, forked root system. This curious plant form attracted Lipton, as did the origin of its name. The word *mandrake* derives from *man,* meaning "after" and *drake,* meaning "dragon." Jung's notion of the dragon as a representation of the unconscious and Lipton's fascination with prehistory converge in this sculpture. As Jungian psychology commanded the attention of the art world during this period, Lipton frequently related Jung's ideas to his nature sculptures. In his forms of plants, flowers, and images of growth, the mysterious processes of nature signify the workings of the unconscious.

Struggle and Protection

The concept that struggle is required for progress and growth underlies much of Lipton's oeuvre. Lipton viewed struggle as an organizing principle for his work. He encountered the "thought of struggle and strife in the sense of oppositions. Forces oppose each other in the effort for supremacy; creating tensions. The resolution of such forces results in dramatic counterplay of forms and spaces. Usually one line of force wins."[31] Albert Elsen insightfully described Lipton's works as depicting the unrest and struggle of nature, with growth as a product.[32] Many of Lipton's early carvings such as *Lynched* (1933, mahogany, cat. no. 1), *Football Players* (1936, oak, cat. no. 2), and *John Brown and the Fugitive Slave* (1941, sabicu wood with wood base, cat. no. 4)

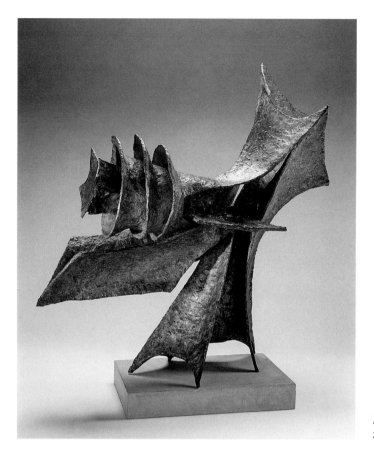

Mandrake, 1958, nickel silver on Monel metal,
36 × 34 × 16½ in. (91.4 × 86.4 × 41.9 cm), *cat. no. 22*

were based on the theme of human struggle. Specific refer-ences to racial struggle, athletic struggle, personal and social struggles are evident, yet Lipton also used formal devices to capture the mood of struggle. He carved partial figures in wood and presented forms that twist and turn.

By using the broad definition of nature's forms as in-cluding both human forms as well as organic (non-human) ones, the viewer achieves an all-encompassing view of Lipton's art and interest in the idea of the living. The theme of struggle evident in the tense, strained, figural composi-tions of Lipton's early career is reconsidered in his sculp-ture based on plant life, notably in the sculptures of his "Bloom" series. Plants—as well as humans—have devel-oped solutions to overcome or mitigate conflict. Protection, or the ability to guard oneself, is one way to foster growth and progress, and protective elements are often apparent in the interior of plants. *Cloak* (1951, bronze on steel), *Car-nivorous Flower, Sanctuary, Germinal #2* (1953, nickel silver on Monel metal), *Jungle Bloom, Jungle Bloom #2* (1956, nickel silver on Monel metal), and *Thorn* (1959, nickel silver on Monel metal) all emphasize protective coverings and demonstrated strength.

Many plants protect their growth by covering or con-cealing vulnerable parts. *Cloak* possesses plantlike proper-ties and other formal elements that relate to botany even though the work is not meant to reference specific plant life. Lipton described the protective nature of this sculp-ture: "*Cloak* with its enclosing forms, symbolizes the fact that for man as well as [for] plant life protection is neces-sary if there is to be growth."[33] This idea that protection is a requirement for growth, progress, and even procreation

parallels the pursuit in postwar and cold-war America of security, stability, and self-defense. Lipton equated the forms of *Cloak* with man's need for protection from a hos-tile world.[34]

Other plants defend themselves by presenting a harm-ful environment for predators, as suggested in Lipton's works *Carnivorous Flower* and *Thorn.* The notion of a car-nivorous flower projects the terror of the unexpected: A beautiful plant disguises an unrelenting meat-eater. For-mally, *Carnivorous Flower* is a bulbous plant shape with little indication of the horror it conceals. *Thorn,* from its title alone, imparts fear and caution, while the construction of the sculpture emphasizes the strength of the plant, with its sharp projecting elements, reminiscent of a clenched fist. In both plants, the expectation of harm and the struggle for survival are apparent; their existence depends upon self-protection.

Some of Lipton's plant forms, such as *Desert Gnome* (1954, nickel silver on Monel metal) and *Desert Briar* (1955, nickel silver on steel), promote the notion of struggle as obligatory to growth. For example, *Desert Briar* exemplifies success over the most severe obstacles. This work makes reference to a beautiful plant that grows in the desert's dry and barren environment, flourishing in spite of the odds against its survival. These two sculptures could be seen to share a kinship with those individuals who suffered brutal and inhumane circumstances in World War II, such as mem-bers of the armed forces, prisoners-of-war, and survivors of the Holocaust.

Like Lipton, other artists employed botanical imagery to address the war. For instance, Theodore Roszak's *Thorn*

Blossom (1948, nickel silver and steel) has been interpreted to refer to "a delicate and lovely flower, which in order to survive, must throw up a shield of thorns which becomes a symbol of those many children whom war and destruction never permitted to develop."[35] Roszak's work shows the ever-changing quality of nature; both its threatening and predatory side as well as its rejuvenating and lively aspects. Specifically, the context for Roszak's piece is hopeful, as it was produced on the eve of his daughter's birth. Many other figures in mid-twentieth-century American sculpture produced works inspired by plants,[36] demonstrating this generation of artists' interest in representations of struggle, quest for survival, elemental forces of life, and hope for the future.[37]

Nature's Mysteries and Unseen Wonders

Like the other visual arts, film of the postwar era adopted nature as a prominent subject. Given his well-established interest in natural history and the arts, Lipton may have been aware of film projects dealing with science and nature's processes. Slow-motion science documentaries and other films that used time-lapse photography to capture plants and flowers blooming were quite a phenomenon at the time. Walt Disney's Academy Award winner *Nature's Half Acre,* released in 1953, examined the mysteries and unique processes of the natural world.[38] Through the work of fifteen photographers, the film demonstrates the continuity of life in birds, plants, and insects over the four seasons. It examines the stages of life, following, for example, the development of a caterpillar into a fully grown butterfly. In addition, the film shows viewers the protective nature of plants such as the Venus's-flytrap.

The text for the film describes the half acre of land as a microcosm: "Nature's half acre is a little spot of ground that might be anywhere. Down in the grasses lies a little land. It has millions of inhabitants. It has crowded cities and quiet hidden homes. It has busy highways with travelers hurrying up and down. It has wars and weddings, factories and farms." This world sounds strikingly similar to postwar America. The parallels are easy to recognize. The 1950s saw the onset of the baby boom, the suburban Levittowns, the rebuilding of cities and towns worldwide, the beginning of the new interstate highway system, the atrocities of war, and the joy of homecomings. *Nature's Half Acre* compared the hectic lifestyle of postwar Americans to the nonstop world of insects. The contextual parallels between America's social structure and this film relate nature's activity with the rebuilding of western civilization after World War II.

Although many of Lipton's plant forms of the 1950s expose the viewer to the life structure and inner occurrences of nature, the unique world that exists beneath the earth's surface was also given special consideration by Lipton.

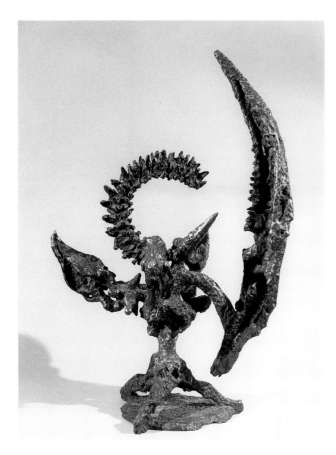

Theodore J. Roszak, American (b. Poland, 1907–1981), *Thorn Blossom,* 1948, steel and nickel silver, 32¾ × 19¼ × 12½ in. (83.2 × 48.9 × 31.8 cm). Collection of Whitney Museum of American Art, New York. Purchase, 48.6. © Estate of Theodore Roszak/Licensed by VAGA, New York, NY

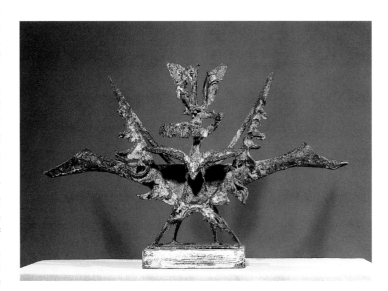

Theodore J. Roszak, American (b. Poland, 1907–1981), *Mandrake,* 1951, steel brazed with copper, 25½ × 40 × 11¾ in. (64.7 × 101.6 × 29.8 cm). © The Cleveland Museum of Art, 1999, Gift of the Cleveland Society for Contemporary Art, 1964.4. © Estate of Theodore Roszak/Licensed by VAGA, New York, NY

Nature's Half Acre surveyed ants and other burrowing creatures as they made their way underground into the unseen world. Lipton was also intrigued by the subterranean world. He was fascinated by the construction of bomb shelters during the postwar period as Americans prepared themselves to live beneath the ground with the threat of air raids.[39] In his compositions *Earth Forge #1* (1953, nickel silver on steel) and *Earth Forge #2* (1955, nickel silver on steel), he examines the unyielding power that lies deep beneath the earth's surface. Lipton described power in the context of his pieces:

> Power is attained thru release and containment; thru spontaneous flow and stop. . . . Power is not attained in art thru symbolism alone, nor physical gesture nor violent or free formal play but thru the drama of tensional irony between polar aspects of the work. . . . The tensional struggle for attention between these equally dominant forces is what creates drama, power, and vitality in a work of sculpture.[40]

The dynamic yet intermingled, repeated forms of *Earth Forge #1* are seemingly on the verge of movement and exposure, yet the piece is actually knotted together and forms a strong and powerful bond within itself. In *Earth Forge #2*, Lipton achieves dynamism through the implementation of concentric ovals of metal that may suggest the earth's core, mantle, and other geological levels. In the center of the sculpture, a screwlike form, which recalls large landscaping equipment or a construction drilling device, projects the feeling of the outward movement as if from within the earth's inner core. Through *Earth Forge #2*, Lipton visually captures the force that creates change and movement at the depths of the earth. He wrote, "this work presents the unfolding of the dark forces at work in the earth, in the insides of man . . . towards birth and light."[41]

Dynamism is also created through the juxtaposition of the natural and the mechanical—the concentric levels of the earth and the rototilling machine form. Lipton commented on the organic sources for *Earth Forge #2:*

> This work evidently drew together in a fairly closed shape from such varied moods as giant, twisted, cacti, gnarled root shapes such as in Van Gogh's drawings, clenched fists and its knotted struggle, volcanic forces below the earth's surface struggling to be free but strangely impotent, the human aspiration to flower, to grow from the many seen and hidden forces shaping his destiny.[42]

A similar energy and a similar theme appear in *Earth Loom* (1958–59, bronze on Monel metal, cat. no. 21). The work's horizontal extensions coupled with the repeated springlike coils at the sculpture's peak seem to extend and retract simultaneously. Again, for Lipton, the botanical imagery was secondary to an expression of human experience and the life force. He said *Earth Loom* "involves the forces of energy, of potential, of the subconscious, operating and weaving patterns of experience that may later become overt and conscious."[43] The sculpture's intertwined forms, circular elements, and biomorphic aspects refer to the energy of nature and its complex patterns.

Lipton's sculptures inspired by botanical forms, insects, and the earth's structure demonstrate vital aspects of his artistic philosophy. In them we see the artist exploring the tension created by polarities, the relationship of interior and exterior forms, the potential of seed forms, the innate drive to move upward, whether of plants or of forces within the earth. And all of these concepts refer, ultimately, to humankind: to man's and society's struggles to grow.

The Ocean and Mysteries of the Deep

The ocean and its mysteries grew prominent in American popular culture during this period. There was a great interest in the films *Twenty Thousand Leagues Under the Sea,* which was released in 1954, and Jacques Cousteau's 1956 underwater classic, *The Silent World.* Many sculptors, too, looked to the ocean for subject matter. The critic Thomas Hess commented on artists' attraction to the mystery of the sea and the transformation of ocean forms into metal sculpture: "the sea is a common subject for sculptors . . . sea shells, sea's motion, sea flowers."[44]

Lipton worked with forms related to the world's seas and seafarers throughout his career. He addressed the theme early in masterpieces such as *Moby Dick #1* (1946, lead construction) and *Moby Dick #2* (1948, bronze with wood base, cat. no. 8) and revisited the subjects in late works such as *Pirate* (1970, nickel silver on Monel metal) and *Sailing* (1976, nickel silver on Monel metal).[45] In his writings, he discussed his longstanding fascination with the sea: "the ocean has the deepest appeal. I have to create everything with my imagination. It is a sense of identification with nature. Some things will be creatures of the sea."[46] Works from the 1950s based on the undersea world include *Sargasso* (1948, nickel silver on steel), *Sea Gnome* (1951, bronze on steel), *Sea Bloom* (1952, bronze on steel), *Sea King* (1955, nickel silver on Monel metal, cat. no. 18), *Sea Loom* (1959, nickel silver on Monel metal), and *Seafarer* (1959, bronze on Monel metal). He described these pieces as showing "the dark side of things, the unseen aspects of reality; the internal anatomy as hidden truths, these things need a sculptural explanation. Such things as an opening bud, or the x-ray skeleton of a fish recorded a basis for a

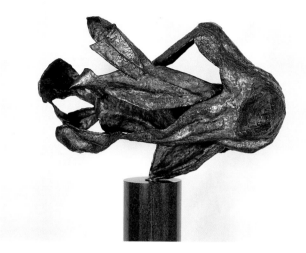

Sea Bloom, 1952, bronze on steel, 25 in. long (63.6 cm). Collection of the Chase Manhattan Bank. Photo by Fredrika Stjärne

solution."[47] Through these constructed metal works, he exposed the internal intricacies of the marine world. Lipton further mentioned that "the openness and the emptiness of the ocean—there is nothing there but there is everything there. If you have imagination you feel this, and it is a religious feeling also."[48]

Sargasso is based on the life cycles of plant growth. The inspiration for the sculpture is the genus of floating, brown seaweeds found in warm waters of the Atlantic near the West Indies. The weed's main stem has a flattened leaf-like series of outgrowths with branches that support air sacs. Transformed into nickel silver and steel, Sargasso possesses dynamic forms showing the tension and slow movement of the sea plant.

Sea Gnome, Sea Bloom, and Sea Loom suggest the inner structure of aquatic plants, showing protective aspects similar to those of the "Bloom" series. Within these sea-inspired works, Lipton remained dedicated to the bud form for its suggestion of struggle, growth, and beauty. The germinal form is the main emphasis of Sea Gnome and Sea Bloom, but these sculptures also have a sinuous, undersea quality that reminds the viewer of the calm yet continuous motion of the sea. In Sea Bloom, the curved metal forms recall the effortless but powerful movement that occurs underwater, the strength and power of the ocean.

Like these sea flower works, Sea King features a plant-like bud form at its back section. This form is joined together with angular forms that demonstrate a prominent forward-moving thrust. Lipton referred to this form as "the gesture of a ship,"[49] and Sea King suggests a powerful machine moving through water. Sea King exemplifies the strength that can be found within the realm of the sea. A related work, Seafarer revisits the theme of protection evident in Lipton's floral pieces. Its innate shield form and large, jutting spikes act as instruments of self-preservation, and the work's dynamism stems from the juxtaposition of curved, protective portions, sinuous forms, and projecting spikes.

Cycles of Nature, Life, and the Seasons

The overall negative feeling that permeated the art and literature of the 1930s and 1940s is probably best demonstrated by Oswald Spengler's book The Decline of the West, which, despite its pessimistic diagnosis of American culture, remained popular through the 1950s. Spengler proposed a "cultural life cycle": He maintained that all cultures experience a progression of birth, maturity, death, and rebirth. And he claimed that Western civilization was in the phase of decay. Many postwar artists, writers, and performing artists used Spengler's theory as a point of reference. For example, the work of the dancer and choreographer

Martha Graham, often based on life cycles, renewal, and rebirth, was admired and supported by painters and sculptors of the period. Graham's strong interest in fertility rites and cyclical rebirth is evident in a statement about her innovative modern dance "Dark Meadow of the Soul" of 1946:

> I search for the power of the Spirit, to bring about a better condition—a health of the land, the world . . . Perhaps a kind of fertility ritual. Not for rain but for growth, on a waste land—after a war. Could I make a drama of resurrection?[50]

In keeping with his colleagues in other fields within the arts and humanities, Lipton made sculptures that denote the dominance of cycles in postwar society. Lipton described this aspect of postwar thought as it related to his own work:

> The essence of sculpture, is for me the perception of space, the continuum of our existence. . . . Since our experiences of space are however limited to momentary segments of time, growth must be the core of existence. We are reborn, and so in art as in nature there is growth, by which I mean change attuned to the living. Thus growth can only be new, for awareness is the ever changing adjustment of the human psyche to chaos.[51]

In his writing entitled "The Metaphor in Sculpture," Lipton wrote of his sculptural adaptations of such cyclical processes:

> I've been preoccupied with the life cycle and its renewal—with birth, struggle, death and rebirth in an evolving process of reality. The dark inside of things, germination, the seed, the womb, the internal anatomy of things, the winter earth, etc. . . . have suggested forms with unfolding layers, with sharp cleavages, with struggling emergent forces.[52]

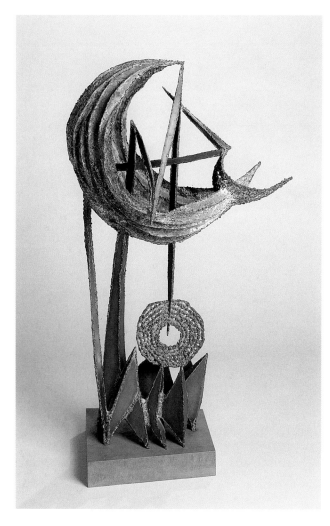

Equinox, 1949; bronze, lead, and wood; 32 × 19¼ × 11 in. (81.4 × 48.9 × 28 cm); *cat. no. 13*

Once again, imagery of nature proved to be an appropriate vehicle for the Abstract Expressionists, and Lipton, to demonstrate their interest in cycles. Although many of the botanical pieces fit into the cyclical category, the works based on the seasons closely relate to nature's cycles; for example *Equinox* (1949; bronze, lead, and wood; cat. no. 13), *Spring Ceremonial* (1951, bronze and steel, cat. no. 15), *Spring Rite* (1951, bronze on steel), *Sundial* (1954, nickel silver on steel), *Winter Solstice* (1954, nickel silver on Monel metal), and *Winter Solstice #2* (1957, nickel silver on Monel metal, cat. no. 20). Regarding seasonal cycles in his sculptural oeuvre, Lipton said,

> There are cycles of the year, of the day, the period of the life and death of stars and so forth. I think there is some kind of order and I'm led to believe not through mystical religious notions in the occult sense, but from science, from the astronomers, from the physicists, from the chemists. I believe that there is order.[53]

The works that represent the seasonal cycles range from the late 1940s through the 1950s and demonstrate different aspects of Lipton's interest in this theme. For example, in *Equinox,* Lipton employed title, context, and rec-

ognizable forms that remind the viewer of this transitional time of the year. The sculpture comprises forms commonly associated with planetary change, such as the craters of the moon's surface, the sun's form, and the life cycle of the stars. Related imagery of cycles and the universe is evident in the work of other New York sculptors. For instance, Lassaw's *Nebula in Orion* (1951, welded bronze) and Ferber's *The Sun, the Moon, and the Stars II* (1956, brass) share with *Equinox* the artists' interest in recurrent celestial activity that relates to the postwar search for elemental life forces.

Spring Ceremonial recalls the season associated with hope and new life. Within its dominant vertical or triumphant rising form reminiscent of a maypole or a blooming tree, *Spring Ceremonial* captures the season's joy and majestic power through change. *Equinox* and *Spring Ceremonial,* early works that address the seasonal theme, both project a vertical emphasis. In contrast, works that follow these two pieces, such as *Sundial* and *Winter Solstice,* are more closely related to the contained floral forms of Lipton's other organic pieces of the mid to late 1950s. *Sundial* incorporates the curved forms of pieces like *Sanctuary.* These dynamic shapes offer the feelings of movement associated with an instrument used to indicate change.[54] An evident representation of the seasonal cycle, *Winter Solstice* also possesses forms reminiscent of the budding floral sculptures of the mid to late 1950s, yet it portrays the sense of the unknown, the hidden characteristics of nature and the astrological movements.

Lipton summarized the varied interests that sparked the production of his natural forms. He found inspiration through ". . . death and rebirth in the cyclic renewal process. I sought to make a thing, a sculpture as an evolving entity; to make a thing suggesting a process. I felt the rightness of curved, convoluted forms, outgrowing but not fully spread, as a new phraseology. . . ."[55]

Late Work

The prevalent themes of Abstract Expressionism remained in the artists' minds as they matured. As other art movements were ushered in through the 1960s, 1970s, and 1980s, the horror of the Second World War continued to affect the Abstract Expressionists and specifically, Lipton. Lipton never abandoned his interest in the war and its aftermath as a theme for his sculpture. As Polcari explains,

> The truth of the matter is that Lipton never left this tragic horror of war. He went on with it throughout his career, throughout the 1980s. It became the human condition. [Lee] Krasner was the same way, nothing ever changes, this stuff moves on about growth and flowering, emergence, vitality, the new,

Ibram Lassaw, American (b. 1913), *Nebula in Orion*, 1951, welded bronze, 28¾ × 34 × 20 in. (73 × 86.1 × 50.7 cm). The Museum of Modern Art, New York, Gift of Mrs. John D. Rockefeller 3rd. Photo © 1999 The Museum of Modern Art, New York

Herbert Ferber, American (1906–1991), *The Sun, the Moon, and the Stars II*, 1956, brass, 71 × 46 × 10¼ in. (180.3 × 116.8 × 26 cm). Collection of Whitney Museum of American Art, New York, Gift of the Howard and Jean Lipman Foundation, Inc., 65.74. Photo © 1999 Whitney Museum of American Art

renewal. That became their way, death and renewal. That's what Lipton's sculpture came to be.[56]

In the early years of Lipton's production, ideas sparked by the war and its imagery were widespread. Yet these themes continued to surface as his career progressed. In the early part of the 1940s, Lipton offered the monster forms of the Moloch from ancient mythology and Moby Dick from literature. These works gave way to predatory pieces in the 1950s; later, the same horrific forms appeared in pieces like *Apocalypse* (1978, nickel silver on Monel metal) and *Scream* (1981, nickel silver on Monel metal).

Apocalypse and *Scream* refer to World War II and the threat of the end of the world. These pieces derived from the fear surrounding technological advances such as the testing, production, and ultimate use of the atomic bomb. The atomic threat continued throughout the cold-war period and during the production period of these pieces. Lipton's "work is essentially work of darkness and a search for hope,"[57] and the persistence of the war coexists with the optimism of nature.

Organic motifs, specifically the seed motif, also recurred in his late-career works. The floral and germinal qualities of the "Bloom" series were resurrected from 1960 through 1986, for example, in *Winterseed* (1968–74, nickel silver on Monel metal, cat. no. 32) and *Dragonseed* (1981,

nickel silver on Monel metal). In a review, Tracy Atkinson described *Winterseed:* "*Winterseed* represents itself as two conjoined triangular masses enclosing within an ovoid stemmed form. It suggests a quality of containment and protection, then moves on to thoughts of replication and growth—the beginnings of life. . . ."[58] Atkinson's interpretation sounds strikingly similar to discussions of earlier works such as *Sanctuary*. Similarly, *Dragonseed* calls to mind earlier works of Abstract Expressionism and the interest in the dragon as an archetype of Jungian philosophy. *Dragonseed* fuses Jung's dragon with the germinal force of plant growth.

Lipton gravitated toward nature, growth, and the life cycles in his constructed metal forms. Sam Hunter assessed Lipton's works and themes and contended that "the principal themes and sources of his urgent sculptural imagery are some of the great commonplaces of human and natural existence, man's search for identity, the mystery of birth and death, the unfolding drama of nature."[59] As a theme, nature provided Lipton with subjects that satisfied his creativity for approximately fifty years of sculptural production.

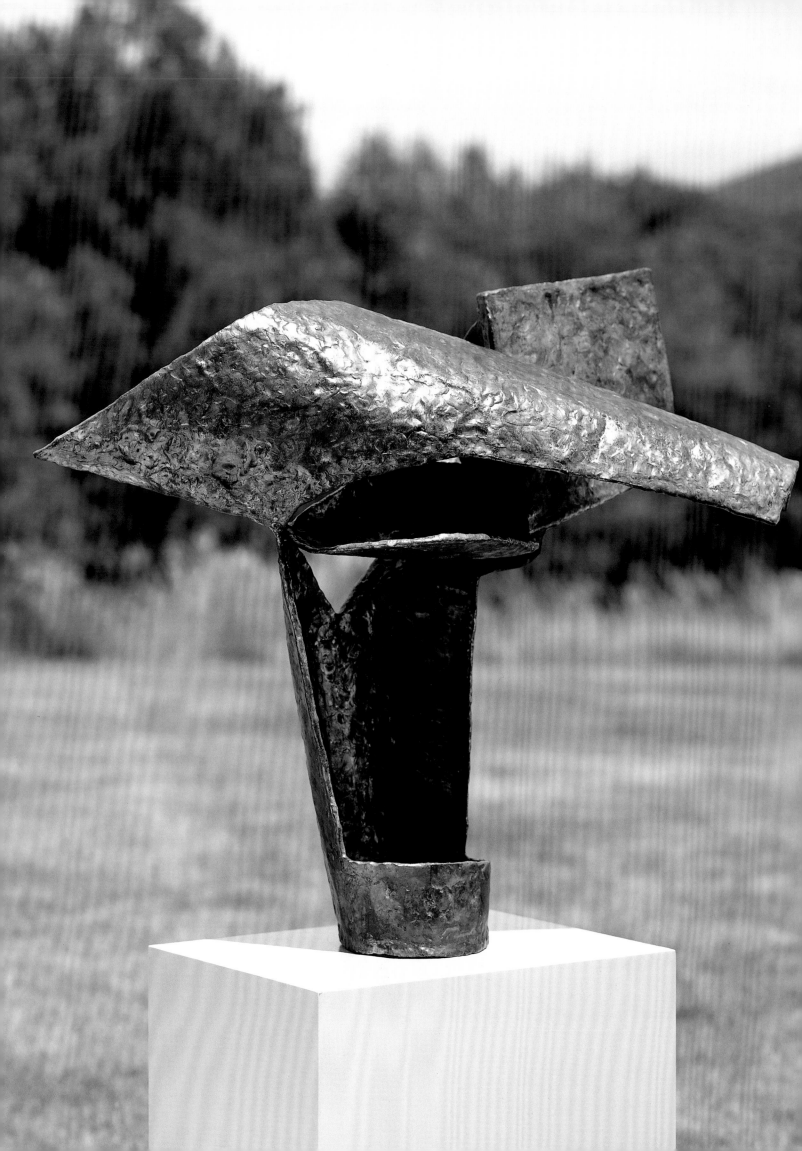

THREE

Avian Imagery

above
Untitled drawing (possible study for *Prehistoric Bird*), ca. 1945, black ink, 11¹³⁄₁₆ × 8⅞ in. (30 × 22.5 cm), *cat. no. 53*

opposite
Icarus, 1983, nickel silver on Monel metal, 34 × 36½ × 15 in. (86.4 × 92.6 × 38.1 cm), *cat. no. 35*

"The aerial force is part and parcel of a general mood I have felt about our time, and in nature . . . art is fundamentally the language of the spirit," wrote Lipton of his dedication to avian subjects.[1] A proud member of the Audubon Society, he was personally fascinated by birds and by flight. During an interview with Sevim Fesci in 1968, Lipton recalled his childhood interest in aviation: "I made an airplane which flew a bit—this was very exciting. I still have the propeller I carved for it."[2]

Avian imagery plays a significant role in the history of American sculpture. From the direct carvers to the Postmodernists, sculptors have frequently addressed the theme of flight. Lipton's comment about the aerial force, though specific to the postwar period, can also be applied to the entire modern era for American artists.

In the early decades of the twentieth century, direct carvers such as John Flannagan, Chaim Gross, and William Zorach produced avian forms in both wood and stone. For instance, Flannagan's *Triumph of the Egg* (1937, granite) presents a newborn bird as it is liberated from the egg. The direct carvers inspired other artists both formally and in their attention to images of flight, even as many of them moved from carving in wood to working in metal.

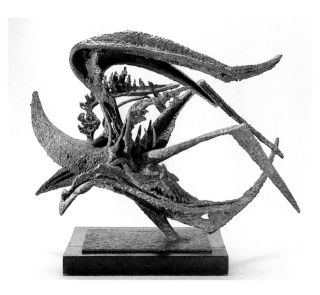

Theodore J. Roszak, American (b. Poland, 1907–1981), *Firebird,* 1950–51, iron brazed with bronze and brass, 31 × 41 × 27 in. (78.8 × 114.1 × 68.5 cm). The Metropolitan Museum of Art, Gift of Muriel Kallis Newman in memory of the artist, The Muriel Kallis Steinberg Newman Collection, 1982. © Estate of Theodore Roszak/Licensed by VAGA, New York, NY

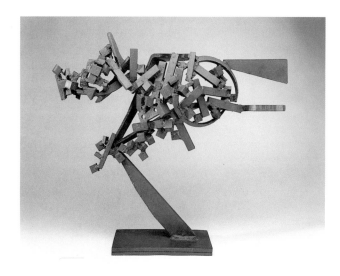

David Smith, American (1906–1965), *Raven IV,* March 14, 1957, steel, 28⅛ × 32⅜ × 13¼ in. (71.5 × 82.3 × 33.7 cm). Hirshhorn Museum and Sculpture Garden, Smithsonian Institution, Gift of Joseph H. Hirshhorn, 1966. © Estate of David Smith/Licensed by VAGA, New York, NY. Photo by Lee Stalsworth

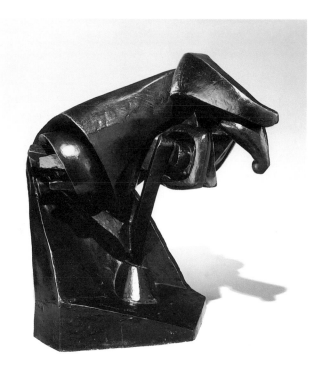

Raymond Duchamp-Villon, French (1876–1918), *Horse,* 1914 (cast 1954–63), bronze, 17¼ × 15¼ × 11¾ in. (43.8 × 38.8 × 29.9 cm). Hirshhorn Museum and Sculpture Garden, Smithsonian Institution, Gift of Joseph H. Hirshhorn, 1966. Photo by Lee Stalsworth

Throughout the 1940s, 1950s, and 1960s, artists sculpted avian forms in both realistic and abstract styles. Henry Moore, for example, often considered avian imagery, and produced works such as *Bird* (1960, bronze). Leonard Baskin created sculptures based on the bird in various materials throughout the 1950s and 1960s, including *Owl* (1958, bronze), *Dead Crow* (1964, bronze), and *Caprice* (1963, bronze). Alexander Calder's famous mobiles hover overhead and move gracefully in space like birds in flight. Avian imagery also inspired, for example, Calvin Albert's *Aggressive Bird* (1954, constructed metal), John Chamberlain's *Johnnybird* (1959, welded steel) and *Redwing* (1959, welded steel), and Richard Stankiewicz's *The Golden Bird Is Often Sad* (1957, steel). In images of birds and flight, Abstract Expressionist sculptors found a subject with which to treat many prominent themes of the period, including prehistory, contemporary literature, and renewal. Theodore Roszak's extensive list of sculptures dedicated to flight imagery includes *Jurassic Bird* (1945, steel), *Night Flight* (1958, steel, related to Antoine de Saint-Exupery's book *Vol de Nuit*), *Raven* (ca. 1947, steel), *Firebird* (1950–51, iron brazed with bronze and brass), *Firebird* (1951, steel and copper), *Skylark* (1950–51, steel), and *Great Moth* (ca. 1955, steel). Specifically, both *Firebird* sculptures and *Great Moth* refer to renewal and regeneration, as both creatures experience a life transformation. Similarly, many of David Smith's works are avian in concept, including *Prehistoric Bird* (1945, welded metal), *Royal Bird* (1947–48, welded metal), and the "Raven" series.

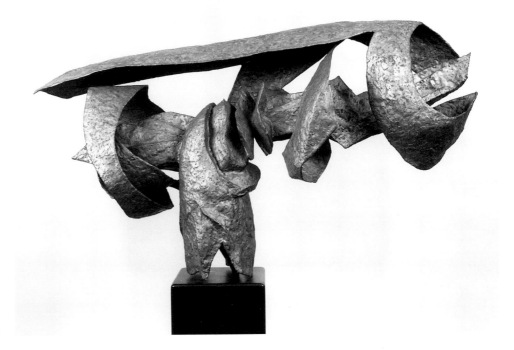

Storm Bird, 1955, nickel silver on steel, 20 × 35¾ × 11 in. (50.8 × 90.8 × 27.9 cm). Collection of Drs. Thomas and Marika Herskovic. Photo by Geoffrey Clements

Like his contemporaries, Lipton looked to the bird for inspiration, and in the late 1940s began to create avian sculptures in metal. In images inspired by birds and flight, Lipton explored various themes that compelled him: the union of the natural and the mechanical; the horrors of World War II; the tension created by polarities; and the promise of rebirth—all subjects significant to the artists of the New York School.

Nature and Machine

Lipton has said that his sources included "biologic nature, technological forms, and aspects of past art traditions." In numerous works, he explores the juxtaposition of nature and the machine. The concept of uniting the organic with the mechanical in sculpture was established early in the century in works such as Raymond Duchamp-Villon's *Horse* (1914, bronze). Sam Hunter described Duchamp-Villon's work:

> The mastery of the Cubist idiom attained an epic power in the *Horse, a striking representation of machine and animal imagery in a synthesis utilizing the contemporary language of abstract mass, movement, and suggestive symbol. At that time, the obsession with machines, speed and motion effects was very much under discussion . . . combining fragments of an identifiable horse's anatomy—head, neck, and hoof—with machine forms, the compact, dynamic design suggests both straining, muscular animal energy and the piston thrusts of an engine.*[3]

For the Cubists and more importantly for the Italian Futurists after World War I, the machine was an exciting and positive advancement, and they encouraged the machine aesthetic in art. But by the Second World War, the machine was no longer merely a sign of progress but also could be synonymous with evil. Lipton described Duchamp-Villon's work as "an angry aesthetic solution to western technological society: a joining of horse and locomotive in expressive, twisted power."[4] Lipton revived this fusion in his avian sculptures at mid-century. For him, the joining of elements from opposing sources was a means of creating the tension that he thought could emerge from polarities. *Storm Bird* (1955, nickel silver on steel) demonstrates the issue of polarity and relates to Duchamp-Villon's *Horse.* Both works employ machine forms juxtaposed with organic ones. As *Horse* combines legs with gears, *Storm Bird* combines angular wings with the structure of a spring or spiral. *Horse* is both equine and trainlike, *Storm Bird* is avian and aeronautical. Lipton described his piece as showing

> the wings and body of a dragonfly at rest, in terms of an airplane and spiral staircase. They seem far apart in meaning but for me when I first made the Storm Bird, *they grew together, very simply. Each became part of an ambiguously felt surging aerial force. Each in itself was incomplete. But together formally simplified and coordinated they became elements of a new unity.*[5]

Lipton's understanding and implementation of the machine aesthetic proved fundamental to his avian constructions. As evidenced by *Storm Bird,* fusing forms was imperative to Lipton, who worked with dualities like nature and the machine throughout his career.

> The drive I have felt these past few years is toward an organization of many such varied polar opposites. I have looked for an interplay of tensions: of lines, planes, forms, spaces and suggested meanings to

develop energy, and to evoke the mystery of reality. To attain impact, all this must grow as a materialization in the physical medium out of concretely felt, thought about and sharply observed aspects of reality.[6]

Lipton's avian forms demonstrate that interplay of tensions that occurs throughout his work.

Freedom and Imprisonment

Birds, with their ability to fly away, are of course associated with freedom. Lipton discussed the connection: "The simple polished form was a brilliant invention adequate to and strongly countered by the suggestion of a bird in swift flight. Here is a world of resolved freedom, alluded to for the life of man."[7]

Avian forms also reflected American popular culture and its obsession with airplanes and automobiles. The introduction of the television set, which brought visual information about faraway places into the living room, resulted in an increased interest in airplane travel. In addition, the "road experience" became a popular and romantic notion during the postwar period. American car manufacturers presented the public with glamorous new car models named for birds, such as Skylark, Firebird, and Thunderbird. David Halberstam has suggested that these names for automobiles relate to Americans' newly found freedom, a free spirit derived from driving the open road.[8] Lipton, along with other sculptors, selected similar avian titles for their work. *Firebird* and *Thunderbird* both evoke freedom of spirit.

David Smith, American (1906–1965), *Star Cage,* 1950, welded metal and paint, 44⅞ × 51¼ × 25¾ in. (114 × 130.2 × 65.4 cm). Collection Frederick R. Weisman Art Museum at the University of Minnesota, Minneapolis, John Rood Sculpture Collection Fund. © Estate of David Smith/Licensed by VAGA, New York, NY

Alberto Giacometti, Swiss (1901–1966), *The Palace at 4 a.m.,* 1932–33, construction in wood, glass, wire, and string, 25 × 28¼ × 15¾ in. (63.5 × 71.8 × 40 cm). The Museum of Modern Art, New York. Purchase. Photo © 1999 The Museum of Modern Art, New York

Prisoner, 1948, copper, lead solder with steel base, 78 × 15 × 15 in. (198.2 × 38.1 × 38.1 cm), *cat. no. 12*

At the same time, Abstract Expressionist sculpture revived certain aspects of Surrealism, including the cage as a formal element. A symbol of Surrealist constructions, the cage form was widely used by that movement's sculptors. The enclosed form dominates Alberto Giacometti's *Cage* (1931, wood) and *The Palace at 4 a.m.* (1932–33; construction in wood, glass, wire, and string).[9] Giacometti revealed the disturbing nature of Surrealism and his sculpture through his description of *The Palace at 4 a.m.*:

> *Again and again, I am captivated by constructions which delight me, and which live in their Surreality. . . . Once the object is constructed, I tend to see in it, transformed and displaced, facts which have profoundly moved me, often without my realizing it; forms which I feel quite close to me, yet often without being able to identify them, which makes them all the more disturbing.*[10]

The Palace at 4 a.m. embraces the confinement of the Surrealist cage, addresses the nightmarish imagery of the period, and embarks upon a new stage in the development of modern sculptural form.

One of the unsettling motifs of Surrealism, the cage provided a formal starting point for many Abstract Expressionist sculptors. Containment forms are evident in David Smith's *Star Cage* (1950, welded metal and paint), the assembled boxes of Louise Nevelson including *Sky Cathedral* (1958, wood), Ferber's roof sculptures, and Lassaw's dripped metal cages.

Lipton used the cage to express his own artistic concerns and those of the postwar era. The caged bird epitomizes Lipton's interest in polarities; an image of freedom is changed to one of bondage. For Lipton, the cage relates to the imprisonment of the Second World War, suggesting Nazi concentration camps. The prominent suggestion of enclosure in his avian sculptures recalls the loss of freedom suffered by so many during the war. Lipton included the cage in his early Surrealist-inspired metal sculptures such as *Prisoner* (1948; copper, lead solder with steel base; cat. no. 12) and *Imprisoned Figure* (1948, wood and sheet lead, cat. no. 11). Both of these constructions contain an abstract figural form with winglike extremities placed within the confines of a barred structure.

In the 1950s, Lipton overtly applied the cage to his avian pieces, as evident in *Thunderbird* (1951, bronze on steel). Lipton commented:

> *My work is not a direct abstract from nature. The essential feeling of a bird is not arrived at by study of bird forms, rather the creative direction is unpredictable, sporadic—but organically causal. Since I am concerned at present with curving, overlapping forms*

Thunderbird, 1951, bronze on steel, 36½ in. long (92.7 cm). Collection of Whitney Museum of American Art, New York. Purchase, with funds from the Wildenstein Benefit Purchase Fund, 53.18. Photo © 1999 Whitney Museum of American Art

> *to engulf space, this idea was one of the possible starting points in the creative drive involving the* Thunderbird. *For me, experiences of movement, flight, strength, space, air, tensions, etc. For example, the large, cage-like form in this piece calls tensionally for a mass within it.*[11]

For Lipton, the caged construction provided the tension that creates the imposing power of the piece.

Storm Bird, too, has a metal shield or covering reminiscent of the Surrealist cage. Lipton described *Storm Bird* as having "the quality of a twisting, turning lathe and a mood of ominous power attained thru machine-like yet organic spherally movements under a cover of brooding protection and enclosure."[12]

Prehistoric Birds and Predators from the Air

For many artists of the period, the nature of avian imagery was violent, associated with birds of prey and prehistoric raptors. Science fiction and horror films featuring rapacious, predatory birds were prevalent at the time,[13] and the bird as a symbol of the apocalypse was tragically timely in American society in the 1950s. As the war introduced the idea that connections to the end of the world might come from above, like the bomb falling from the sky, the apocalypse was associated with horror creatures of the air. Lipton and his contemporaries, as we have seen, frequented natural-history museums; David Smith, for example, arrived at the forms for his *Prehistoric Bird* and *Royal Bird* after viewing fossils of prehistoric birds at the American Museum of Natural History. Leonard Baskin said, "birds of

prey flutter ominously through my oeuvre . . . their essential meaning in my work is as raptors, carrion devourers, and as swift and startling bolts of death."[14] Prehistoric forms were influential for Lipton—"the dinosaur and its bones have come alive to me"[15] and his interest in violent, primeval birds is evident in *Prehistoric Birds #1* (1946, bronze) and *Predator* (1947, lead). Lipton described his subjects as "birds of evil, prehistoric birds."[16] The undulating and uncontrolled formal aspects of the wings and torso of both pieces show the unrestrained qualities of raptors and the mystery associated with prehistory's fowl.

This fascination with prehistoric birds of prey relates, no doubt, to the postwar image of airplanes as agents of destruction. Herbert Read, in the catalogue for the exhibition *Britain at War* in 1941, described the fighter plane as "a monstrous bird threatening humanity from the skies."[17] In art, the bombers that had reduced parts of Europe to rubble, the fighters that could destroy an entire warship, were transformed into mechanical raptors. Such violent war images appear in Lipton's sculpture, resulting in works that could be best described as beastly, ferocious, and predatory.

This was also a time when a real fear of nuclear war with the Soviet Union existed. In the nation's schools, air-raid drills sent children diving beneath desks. Citizens prepared survival kits and built fallout shelters. As the public perceived a threat of destruction from the sky, Lipton responded with "cruel forms [that] should certainly convey an artist's reaction to an age of upheaval."[18]

Myths of Renewal and Transformation
As postwar artists sought ways to express their search for rebuilding and renewal, they looked to mythology, folklore, and tribal cultures. Certain renewal myths concern birds possessed of unfathomable powers, particularly that of rebirth. The phoenix and the firebird became subjects for Jacques Lipchitz and Theodore Roszak, as well as Lipton, who produced *Firebird #2* (1947, bronze), *Firebird #1* (1948, bronze), and *Phoenix* (1953, bronze).

Lipton's *Phoenix* derived from the ancient myth of a bird's miraculous rebirth: Rising from the ashes of extinction, the phoenix triumphs over death. It is an evident symbol of strength and rebirth, relating to the postwar sensibility in America. The form of *Phoenix* is also reminiscent of the mushroom cloud of the atomic bomb, a form so prevalent in the minds of members of postwar society. Perhaps the sculpture's title alludes to a hope that a rebirth can exist even after near total devastation.

As the Abstract Expressionists studied ancient myths and tribal legacies, they became fascinated with the rites and rituals of the Native Americans.[19] Lipton's own interests in natural history and past civilizations extended to the study of the art forms of various Native Americans tribes. In addition to the American Museum of Natural History, he frequently visited the Museum of the American Indian and the Heye Collection and was an avid reader of *National Geographic* and *Natural History* magazines. He commented that a "major influence of my early work stems from my interest in primitive art—especially Northwest Indian and Oceanic."[20]

The ceremonies and related art forms and artifacts of Native American culture frequently referred to birds. In particular, eagles, ravens, crows, and thunderbirds often appeared in ceremonies and as ritual objects for various Native American tribes. Masks depicting eagles, ravens, and thunderbirds were widely incorporated into transformation ceremonies. Lipton was especially drawn to these Native American transformation rituals. In the ceremony, a mask in the form of a thunderbird or other bird is prepared, and as the ceremony progresses, the mask changes to portray human features. There are various versions of the thunderbird myth, but, each maintains the element of supernatural transformation. A widely accepted version is as follows:

> *The man, Namukusto'lis, began to build a house but the beams were too heavy for him. A Thunderbird flew down and perched on a large rock nearby. The man wished for the bird to help him. The bird, a supernatural creature, knew the man's wish and the bird lifted his face revealing a human face. He helped the man lift the beams. The work finished, the bird removed his bird skin and threw it into the air. As the Thunderbird flew away, he said, "You will only cause thunder and lightning when one of the people in this place dies."*[21]

Lipton's *Thunderbird* is clearly influenced by such rituals. Lipton said *Thunderbird* "suggests a giant, ominous bird, with the drive of additional forms toward a great threatening bird as possibly suggested by American Indian myths."[22]

Late-Career Avian Images
Variations on the avian form appeared throughout Lipton's mature and late career. In the 1960s, he abandoned the prehistoric quality of his avian forms, reducing the fossil, skeletal, and nightmarish properties of these pieces, and produced simple yet elegant abstractions dealing with images of flight. These new works included *Arctic Bird* (1960, nickel silver on Monel metal, cat. no. 25) and *Archangel* (1963–64, nickel silver on Monel metal). The visually enticing sculptures *Angel* (1975, nickel silver on Monel metal) and *Bird* (1975, nickel silver on Monel metal, cat. no. 33) both produced in 1975, and the late-career works *Icarus* (1983, nickel silver on Monel metal, cat. no. 35) and *Storm Pilot* (1984, nickel silver on Monel metal) revisit the theme of flight.

Arctic Bird is a straightforward composition of a bird in the abstract. With two vertically oriented wings, a rounded body, and a defined spherical head, the sculpture indicates the bird's implied power and strength and captures the essence of flight. At the same time, its firm base indicates the bird's ability to orient itself to the ground. As it suggests the flexibility of birds native to northern territories to feed from the ground as well as to take flight, the sculpture once again reflects Lipton's dedication to portraying polarities in art.

Archangel, a sculpture for Lincoln Center's Avery Fisher Hall, couples Lipton's interest in flight with a spiritual form. Although *Archangel* and *Angel* do not depict birds, they both relate to flight and the free spirit. They are among the most interesting and visually successful works of Lipton's career. *Bird,* meanwhile, captures the feeling of flight and acts as a virtual metaphor of flight. In 1975 Lipton indicated that while making *Bird,* "I immediately had a sense of flight and airiness."[23]

Although Lipton produced comparatively few forms dedicated to the avian theme in the final phase of his career, he did return to his interests in flight and mythology in *Icarus,* inspired by the story of the boy whose wax wings melted as he flew too close to the sun. *Storm Pilot,* produced only two years before his death, showed the power of aviation technology and mechanical advancement, personal interests for Lipton.

As a major Abstract Expressionist, Lipton's avian forms derive from common aesthetic and contextual sources. While they explore the formal considerations of his era, the avian pieces are also grounded in themes prevalent in postwar society: prehistory, rebirth, transformation, and mythology.

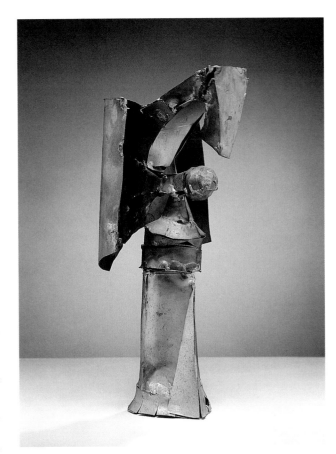

Maquette: Angel, 1975, Monel metal, 13⅞ × 6⅜ × 5¾ in. (35.4 × 16.3 × 14.7 cm), *cat. no. 49*

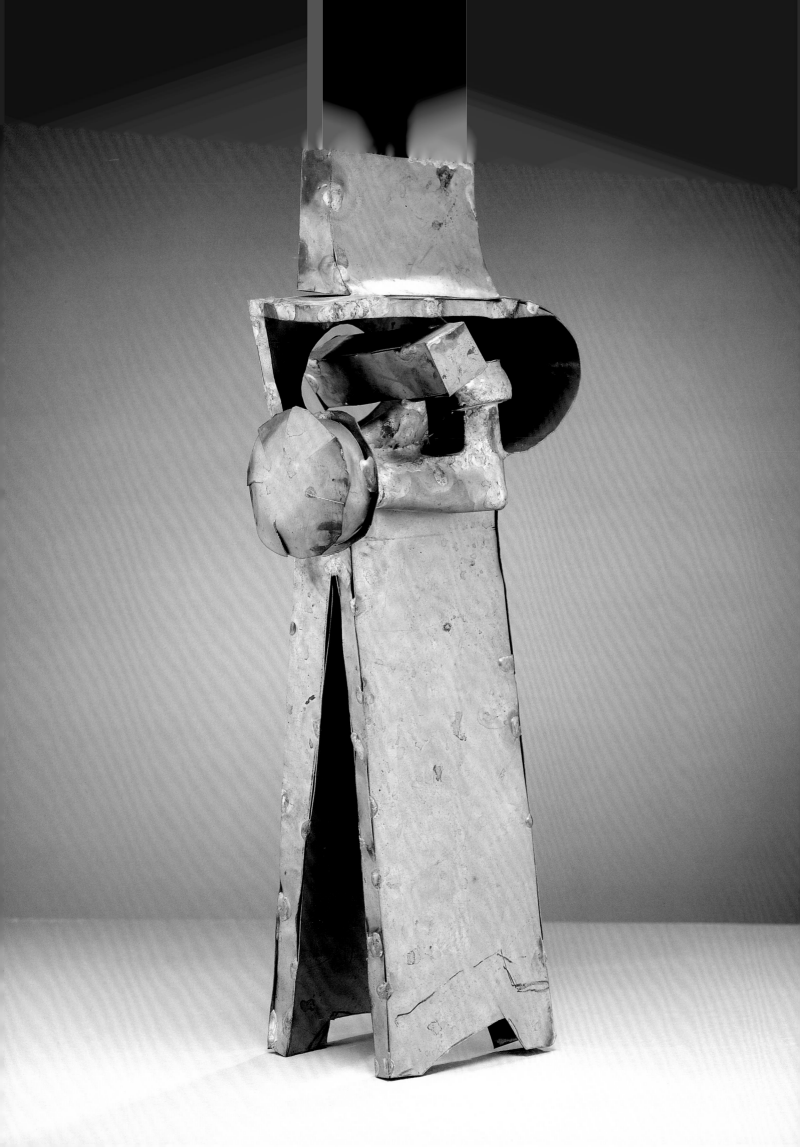

FOUR

Hero Sculpture

above
Drawing after Hero, 1957, black conté
crayon, 11 × 8½ in. (27.9 × 21.6 cm),
signed lower right: "Lipton '57."
Collection of James R. and Barbara R.
Palmer

opposite
Maquette: Defender, 1962, Monel metal,
14½ × 5¾ × 4⅛ in. (37.0 × 14.7 × 10.6 cm),
cat. no. 43

Whether Lipton's sculptures take the form of plants, birds, or ma-
chines, in their essence they always refer to man and to the human
condition. The painter Will Barnet commented on this aspect of
Lipton's career:

> He never destroyed the line of figurative work no matter how
> abstract he got. Lipton continued the great line of figurative
> sculpture which dominated through the history of art. He
> continued the tradition in a very fresh and inventive way,
> whereas a lot of sculptors had destroyed the idea of figurative
> sculpture in order to do something else. The concept of no-
> imagery was very much in the air at that time. In some ways,
> it was felt that to deal with a figurative idea, was like going
> against the grain. But Sy maintained that concept of the
> figure—his ideal—all the way through.[1]

In his figural sculptures, he used the human figure to express
his preferred thematic issues, strength, and the bonds common to
all people. He stated:

> Basically "man" concerns me in all the various things I make.
> I find "inner spaces" of man in things outside of himself; in
> the sea, under the earth, in animals, machines, etc. . . . Man

was primary. This is true for me in such an apparently remote thing from man as Earth Loom. *For me this work involves the forces of energy, of potential, of the subconscious, operating and weaving patterns of experience that may later become overt and conscious. . . . This is true throughout nature, but most directly, I feel its application to man even though the work suggests a botanical machine form. Whether or not I use the gesture of man, or forms other than man, all the works in a fundamental way concern human life.*[2]

As he explored the figural tradition, he embarked upon a major theme within his work and a vital subject of the postwar era: the hero. Lipton's hero sculptures, like all of his work, deal with the essentials of life and the basics of human existence.

Early Hero Images

Early in his career, Lipton produced sculptures that concentrated on people or events that exemplified the traits associated with heroism. In his direct carvings, Lipton showed heroism through subject matter such as the athlete, the soldier, the common man, and the oppressed, employing straightforward interpretations. In *Football Players,* two strong, intertwined bodies act as one figure as the players tackle each other in an effort to secure the football. As they strive to overcome their opponent and attain victory, these athletes become heroes of the playing field.

In *Wounded Soldier* (1940, oak), Lipton moves from playing field to battlefield. Here the partial figure with its worn and taxed face represents a war hero suffering from a fatal wound. Depicted with obvious references to Cubist sculpture, such as the geometric forms serving to denote

eyes, nose, and clenched fists, the sculpture is strikingly evocative of sacrifice and pain. This figure, a soldier who has given his life, serves to represent all members of the armed forces. The piece arouses sympathy in the viewer as well as making a statement about the far-reaching impact of the war.

Lipton focused on the oppressed, sculpting nameless and faceless figures that characterize the great numbers of people who have been mistreated throughout history: people of color and minority groups, the poor, and slaves. Examples include *Lynched, Cotton Picker* (1940, sabicu wood), and *John Brown and the Fugitive Slave.* Realistic and heartwrenchingly accurate, *Lynched* captures the hardship, suffering, and humiliation of the bound figure. The sculpted figure is shown in a dynamic yet contained fetal position, emphasizing an attempt at protection from harm. With knees to chest, this poignant pose conveys the suffering of the beautiful form and captures the emotion associated with racial injustice and inequality. A related piece, *Cotton Picker* is more abstract, yet conveys a similar theme. Here, the form highlights the backbreaking work of the Southern laborer. Lipton shows the figure bending over, with its entire body in motion. Again, a single figure represents the many people who encounter similar obstacles. With *John Brown and the Fugitive Slave,* Lipton considers the plight of the oppressed and the valor of those who try to help them. As in *Football Players,* two partial figures become one as the abolitionist attempts to free the slave. All of these works remain grounded in the hero theme.

The Universal Hero

These early works address the theme of the individual hero, but by the postwar years, Lipton's sculptures began

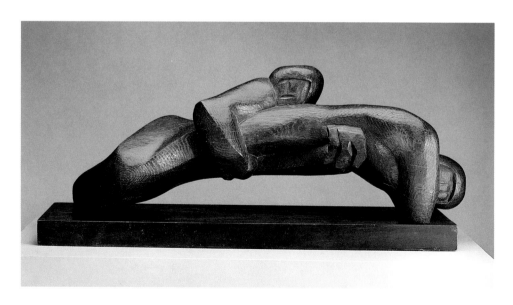

Football Players, 1936, oak, 15 × 39 × 13 in. (38.2 × 99.0 × 33.0 cm), *cat. no. 2*

to reflect a broader concept of the universal hero. Heroes were a frequent subject for writers and artists of the time, reflecting the Abstract Expressionists' interest in mythology, the influence of contemporary literature and philosophy, and the postwar notion of reviving the universal qualities of art. Barnett Newman maintained that the idea of the hero was a simple concept to grasp, as "each man is, or should be, his own hero."[3] The works of Jung, Joseph Campbell, and Ayn Rand proved particularly inspirational for the Abstract Expressionists and, for Lipton, crystallized his own concepts of the hero. While hero sculptures can be found throughout the art of Abstract Expressionism, for Lipton the hero represented an integral part of his thematic agenda.

The Hero as Archetype
Jungian philosophy was a prominent source for understanding the unconscious and collective archetypes. Jung described the concept of the "collective unconscious" as a "psychic system of a collective, universal, and impersonal nature which is identical in all individuals. This . . . does not develop individually but is inherited. It consists of pre-existent forms, the archetypes, which can only become conscious secondarily and which give definite form to certain psychic contents."[4]

Joseph Campbell, in his great work *The Hero with a Thousand Faces,* published in 1949, reveals the hero as an archetype, elucidating the universality of this character and his odyssey. Stephen Polcari described Campbell's theories regarding the hero myth and their relationship to Abstract Expressionism.

> *Myth is best represented by a universal pattern, the advent of the hero. The hero is for Campbell a figure who symbolizes the group's problems, struggles and triumphs in his own actions. The hero has a journey that should be familiar to us by now: he ventures forth from the everyday into a region of supernatural wonder and conflict; he wins the conflict, gains new power, and bestows it on his fellow man. Rites of passage . . . symbolize the pattern of what Campbell called the monomyth.*[5]

Lipton embraced the symbol of the hero and specifically identified with the notion of the heroic in Everyman. He explained, in a discussion of his work *Herald* (1959, cast aluminum), that his sculptures deal with "the hero concept in Everyman. Each human being is struggling in some way to encompass and transcend his own limitations."[6] This was the concept Lipton wanted to express even in the early figural sculptures such as *Wounded Soldier* and *Lynched.*

As the subjects of his figural works moved from the specific to the universal, Lipton found inspiration in

Campbell's book. According to Albert Elsen, *The Hero with a Thousand Faces* paralleled Lipton's own thoughts about sculpture. It maintained, Elsen said, "that the essential mystery today lies in man himself, but also presented the challenging problem facing the artist who would seek to extend into modern times the traditional artist's role of imaging the heroic."[7] Lipton himself acknowledged the connection in a discussion of *Cloak:*

> *Cloak is one of a series of hero pieces, each one presenting an experience in the life of a hero as I have seen, and felt, and experienced it. Before, I mentioned that the business of the hero is somewhat related to a book which I read a couple of years ago by Campbell called* The Hero with A Thousand Faces *which is quite well known and which I found extremely fascinating.*[8]

Lipton was also stimulated by the Objectivist theory and the writings of Ayn Rand. Rand introduced her philosophy of Objectivism in two groundbreaking novels, *The Fountainhead* and *Atlas Shrugged.* She stated that "my philosophy, in essence, is the concept of man as a heroic being, with his own happiness as the moral purpose of his life, with productive achievement as his noblest activity, and reason as his own absolute."[9] *The Fountainhead* won critical and popular acclaim shortly following its publication in 1943. This best-selling novel, the story of a modernist architect named Harold Roark who espouses the supremacy of the individual, influenced many of the Abstract Expressionists. Lipton responded so strongly to this book that he produced a work directly based upon it. Like Rand's book, Lipton's sculpture *Fountainhead* (1958, nickel silver on Monel metal), with its formal references to the activity of the human brain, places emphasis on the human mind and individual will. For Lipton, the hero was the individual who faced and dealt with the problems and struggles of humanity:

> *The problem of mankind today . . . is precisely the opposite to that of men in the comparatively stable periods of those great coordinating mythologies which are now known as lies. Then all meaning was in the group, in the great anonymous forms, none in the self-expressive individual; today no meaning is in the group—none in the world; all is in the individual. But there, the meaning is absolutely unconscious.*[10]

In discussing *Pioneer* (1957, nickel silver on Monel metal), a work contemporary with *Fountainhead,* Lipton summarized the underlying spirit of his hero series. Although the word "pioneer" suggests an individual who breaks new ground, Lipton viewed this sculpture as representing the process of history. He characterized this work,

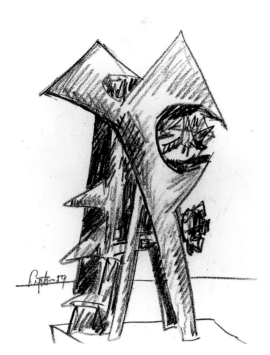

Study for Prophet, 1959, black conté crayon, 11 × 8½ in. (27.9 × 21.6 cm), *cat. no. 69*

Untitled drawing (related to *Sentinel*), 1958, black conté crayon, 10¹⁵⁄₁₆ × 8½ in. (27.8 × 21.6 cm), *cat. no. 68*

and all of his hero sculptures, as depictions of bravery. About *Pioneer,* Lipton said:

> There is always a pioneering of the human spirit that goes on in time—in the processes of history. Always rebirth, always death, but transfiguration into new life . . . this is the way I feel about life. Life is as final as death, and life is real, it's an adventure, it's a struggle, it is the human hero. The hero is the force in man of courage, of the effort to not succumb to the adversaries of life but to struggle and fight them. And I made a whole series of works which are related to the various episodes and aspects in the life of man, which very well could be called a hero series.[11]

Lipton's "Hero" sculptures deal with the recurring issues of his artistic and thematic process: the figure, struggle, rebirth, renewal, and the human spirit.

Nature, Renewal, and Survival
Lipton's hero series allowed him to reprise his chosen themes of nature, renewal, and rebirth. For example, in the sculpture *Prophet* (1959, nickel silver on Monel metal), Lipton incorporates botanical forms into the figural work. With the suggestion of a head with hood, torso, and legs, *Prophet* evokes the form of a great strider while budding plant forms are apparent in the rear leg extensions and the facial area. According to Andrew Ritchie, here Lipton "sets in play a magnificent series of skeletal and plant forms bringing into noble resolution many of the themes he has worked on in recent years."[12] Thus, the plant form remains vital to Lipton's art, and the combination of figure and flora suggests an interplay of two major themes for the sculptor: the hero and nature. This confluence recurs in *Sentinel*

(1959, nickel silver on Monel metal), a hero sculpture that revisits the motif of the life cycle. He described it as "one of a series of hero figures. The hero in mythology stems symbolically from the life cycle in nature—of birth, struggle, growth, death and rebirth."[13] He explained the manner in which *Sentinel* began as Everyman does—within the womb—and then, later is transformed into a hero or guardian figure:

> I remember first I was very concerned with the use of the human pelvis as a basis for work in the '40s, the womb, the pelvis, the business of how man is born. The pelvis is real, it's as real as the crib or the bed—more real. This is the image which has been used and developed into the hero series. So that I could make various kinds of sculpture related and suggesting and expressing the life of man. For example . . . Sentinel looks like a kind of figure of a visored knight and it has an arm which seems to go through the body and around the body, but the suggestion . . . is that it has a kind of presence of a guardian spirit. Well, this is part of the life of the hero, the business of guarding against ogres, against adversaries, and going out into the battle of life.[14]

Like many of the hero works, *Sentinel* demonstrates the fact that battle, struggle, and survival remain primary to Lipton, for as he said, "for me, the hero is that aspect of Everyman thru which he struggles to transcend himself."[15]

As Lipton defined the manner in which *Sentinel* satisfied various aspects of the hero theme, he also described how the sculptural process related to the overall thematic presence of the work:

From the very beginning, while drawing the schematic sketch for this work, I was concerned primarily with brooding power and great calm. The effort also involved the search for new areas of sculptural experience within the frame of the human gesture and spirit. I tried to arrive at these ends thru the use of jagged, continuous and discontinuous forms. Square, elongated forms interpenetrating a vertical box like frame were surmounted by an armor like hood.

In the process of working for spatial and dramatic counterplay, the solid square forms, flat curved forms and the rounded fist like element came into being. The effort was for barest economy to convey a complex experience—all toward a gothic simplicity. I tried to concentrate on achieving an image that would shock yet paradoxically attain a classical pose.[16]

Conveying great power and confidence, *Sentinel* is an outstanding example of the hero sculptures. Elsen viewed it as "a landmark in Lipton's odyssey. . . . The artist's aim was for complexity achieved with economy through which to convey brooding power and demonic force. *Sentinel* is Lipton's character of the awesome mystery of inner life, its alternation between calm and wildness contained as he terms it within an emotional coat of arms."[17]

Non-Western Inspirations

Campbell, along with Jung, Zimmer, and Ananda Coomaraswami, introduced the beliefs and imagery of non-Western and tribal cultures to a broader audience. Like many modern artists, Lipton incorporated the formal elements of non-Western art, and specifically African art and the Shona sculpture of Zimbabwe, into his early carvings. These influences continued as he created figural works in the abstract:

In the 20th century, we find that the anatomical representation of the human figure seems to have taken a change toward more primitive resolutions. New attitudes of formal organization or presentation of the life of man seem to be greatly influenced by primitive sculpture. This has led to a preoccupation . . . with more metaphysical, less representational and less realistic, presentations of the experience of man. This has interested me very greatly. I am concerned with, and have been interested in a non-anatomical humanism, a non-anatomical anatomy, a non-representational anatomy, a new anatomy, new dimensions. New dimensions of experience become possible through the avoidance of the strictures and limitations of accurate logical anatomy.[18]

This interest in the formal aspects of tribal art coincided with his intentions for the "Hero" series.

Also evident in formal attributes of his work is Lipton's curiosity about Asian art. Scholars noted that *Sentinel* "stems directly from a Chinese written symbol yet his interest in Asian culture remains evident through other sculptures as well."[19] *Earth Bell* (1964, bronze on Monel metal) is another product of Lipton's fascination with Asian art forms. Lipton often noted his interest in Chinese bronzes and Asian philosophy, and in his papers on deposit at the Archives of American Art, Lipton discussed his particular interest for Zhou (1100–771 B.C.) and Han (206 B.C.–A.D. 8) dynasty bronzes. His knowledge was extensive on the subject of iron and metal sculpture dating back as far as the Middle Ages in the West and the ancient period in the East. Lipton's technique related to his desired concept of image and content. David Clarke discussed the Asian attitude toward the creative process by equating it with the Abstract Expressionists' interest in cosmology. Clarke writes, "just as in the oriental cosmologies, [for the Abstract Expressionists] form is seen as arising from the Void, so thoughts are regarded as being born from an inner emptiness, and thus the cultivation of a state of silence prior to working is seen as a natural strategy for attuning oneself to the source of creativity."[20] According to Lipton's former studio assistant, Luis Jimenez, the sculptor rarely tolerated extensive conversation or unnecessary chatter within the studio. His pensive and disciplined personality paralleled his production method.

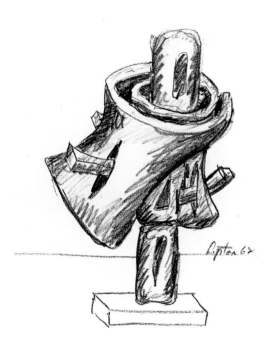

Study for Earth Bell, 1962, black conté crayon, 11 × 8½ in. (27.9 × 21.6 cm), *cat. no. 76*

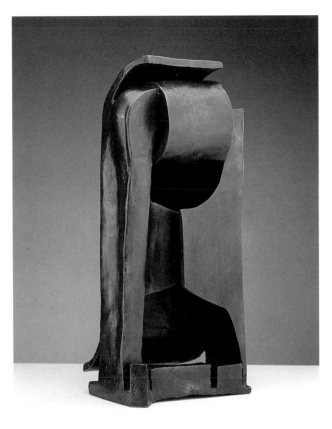

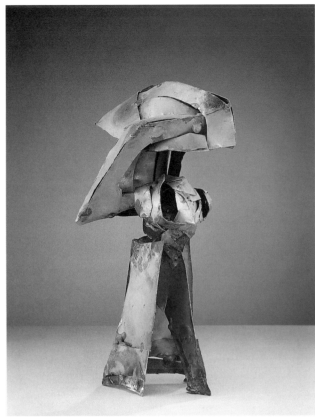

Inquisitor, 1965, bronze, 18 × 8 × 6½ in. (45.8 × 20.3 × 16.5 cm).
Collection of James R. and Barbara R. Palmer

Maquette: Explorer, 1963, Monel metal, 12 × 6⅝ × 4⅜ in.
(30.7 × 17.0 × 11.3 cm), *cat. no. 44*

Late Hero Images

Lipton continued his "Hero" series in the later part of his career. As in his earlier work, he looked to contemporary references, dealing with prominent individuals and issues of the day. *Guardian* (1964, nickel silver on Monel metal), like the airport in which it is housed, is a tribute to Fiorello LaGuardia, the popular mayor of New York City who championed social reforms, for his efforts on behalf of others. Lipton called the sculpture "a beacon" and described his vision for the work:

> It seeks to convey the spirit of illumination projected through the life of this man through the strong light he shed on the problems of his fellow citizens. The name followed naturally from LaGuardia's resolute defense and protection of the rights of man, and not from his actual name. The austere dignity, yet warmth, of the image also suggested the name Guardian. The symbolism of the sculpture evolved around a mood of a human presence looking out on these things. The upper element suggests a head as a great eye. The eye shape is also a decorative echo of the ground plan where the fountain is placed in front of the building. The idea of a beacon is also congruent with the mood . . . of an airport—a guiding light.[21]

Lipton gave instructions about siting the sculpture to ensure that the location of the work remained true to its theme and subject. He advised: "appropriately, a light should be reflected on the sculpture at night."[22]

Like other Americans in the 1960s, Lipton found new examples of heroic figures in the astronauts of the nation's space program. Both *Defender* (1962, nickel silver on Monel metal) and *Explorer* (1963–64, nickel silver on Monel metal) refer to space exploration and to the need for heroic individuals in contemporary society. Lipton presented these works to denote figures, real or artistic, who are willing to confront the dangers of the unknown. Both exemplify strength and determination.

Explorer has also been characterized as another exposition of the idea of the struggling hero. Specific elements reinforce this interpretation: The hand shape recalls a shield or a clenched fist. The hooded form, seemingly moving through air, suggests a swift, forceful movement through space, the courageous striding motion of a person confidently confronting a foe. *Defender* and *Explorer* are both figural striders in the tradition of *Prophet* and *Sentinel,* but these two works demonstrate Lipton's notion of the hero as it evolved over the years. With similar aesthetic forms, Lipton connects the traditional hero concept with the typical figures of the postwar, the cold war, and the space race.

Another guardian or hero figure, *Conquistador* (1968, nickel silver on Monel metal) refers to the Spanish conquerors of Mexico. Lipton employed his highly developed abstract language to convey an image of ancient soldiers,

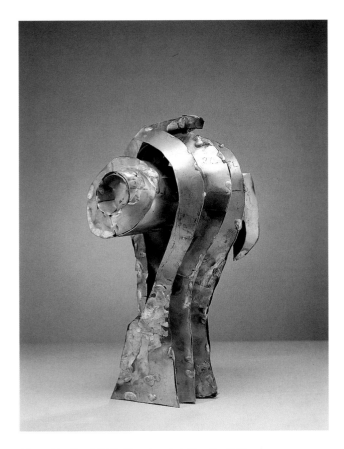

Maquette: Bond, 1986, Monel metal, 10 × 6 × 5⅛ in.
(25.6 × 15.4 × 13.2 cm), *cat. no. 52*

warriors, and of course, heroism. He constructed *Conquis-tador* using the typical armature format of sheets of Monel metal with brazed nickel-silver rods. However, the torso of the figure is severed by a columnar form suggesting the warrior's weapon or club. This protruding form presents a strong reference to the pain associated with battle and the inner strength and valor of the hero.

Angel marks a point of thematic unification for Lipton's sculpture. Its commanding presence relates to Lipton's powerful hero works, while its elegant expansive wings and flared columnar body indicate a flying, spiritual figure. In *Angel,* the hero takes flight, and the confluence between hero and angel creates an evident symbol of hope. In addition, *Angel's* form evolves from Lipton's lifelong interest in non-Western sculpture and the totemic images of his oeuvre. According to Harry Rand, "*Angel* is one of the most successful works of Lipton's career; it is a true totem, not just a gesture toward the totemic." [23]

Lipton characterized his "Hero" series as having its origin in primitive art in the archetypes common to all societies:

> [the] dominant use of the human figure in sculpture in primitive societies probably occured because of the innate habit of the mind to create an imaginary world of living beings to represent the incorporeal forces of nature. For example, gods, giants, and heros were hu-

man beings controlling the destiny of reality. The representation of these forces of the cosmos as human or animal is the very soul of mythmaking and nearly all poetry. [24]

From his earliest work through his final sculptures, Lipton's dedication to the human form is evident. He appropriately summarizes his feelings about his late-career hero pieces, especially his final work, *Bond* (1986, nickel silver on Monel metal), in a statement entitled "Sculpture and the Human Form":

> The human figure has always and everywhere been almost synonymous with sculpture. It's a thing the complex fears and reverance for ancestors involved in both magical and religious societies, were also responsible for the continued preoccupation with the human figure. Man has been the exclusive subject for sculptors in every society. He has shaped his gods in his own image. . . . Man and his destiny do not lose stature thru the recognition that man is a single element among millions in a world that was not made for his exclusive use. In this recognition, I believe man gains in dignity, strength, humility and understanding. This is a broader humanism—is a wider view of man and reality. It is the reorientation of man in a world of relativity, of organic process, of evolution and of cosmic mystery. [25]

The human form was for him a medium through which to express the ideas that compelled him: struggle, nature's renewal, and eventually Everyman's realization of the heroic. Drawing on contemporary philosophy, ancient and tribal art, current events and prominent personages, and above all, the war and its aftermath, Lipton created a group of works based on the human figure that embodies his beliefs. The "Hero" series can be viewed as a process, a continuum, in terms of his work: from straightforward carvings during the 1930s of figures characterizing struggle and oppression, to postwar works that intimate man's transcendence of his own limitations, to the late work that became figural symbols of progress and hope. As he expressed it:

> The tragic feeling of the early forties, the stories of the terrible disaster of man, the primordial struggles of man . . . —that man is still an animal. This was shown to us in the past, but the war showed it up more definitely more clearly. I used all the means at my disposal . . . to find images of horror. Subsequently, however, I came to feel that Hell below wasn't the whole story, that man had hope. [26]

Read First →
→

The result is crudely suggested in These diagrams - as a crown of light, with lines of force pointing upwards and outwards expanding toward heaven; with a mysterious illuminated interior.

The quiet dignity of eternality is achieved from The strength of classical coherence; yet The maintaining a movement of shafts of light and interplay of wings.

note: The forms of The "Eternal light" evolved from my discussions with Percival Goodman. based on The symbolism of The Mercy Seat - two sets of The crossed wings of cherubim set over The two tablets.

To maintain coherence with The ark below, the work developed along lineal, angular symmetrical lines. also -

The direction of emphasis was toward a work internally consistent in forms. and not bottom heavy. Literal symbolism was avoided and plastic symbolism stressed.

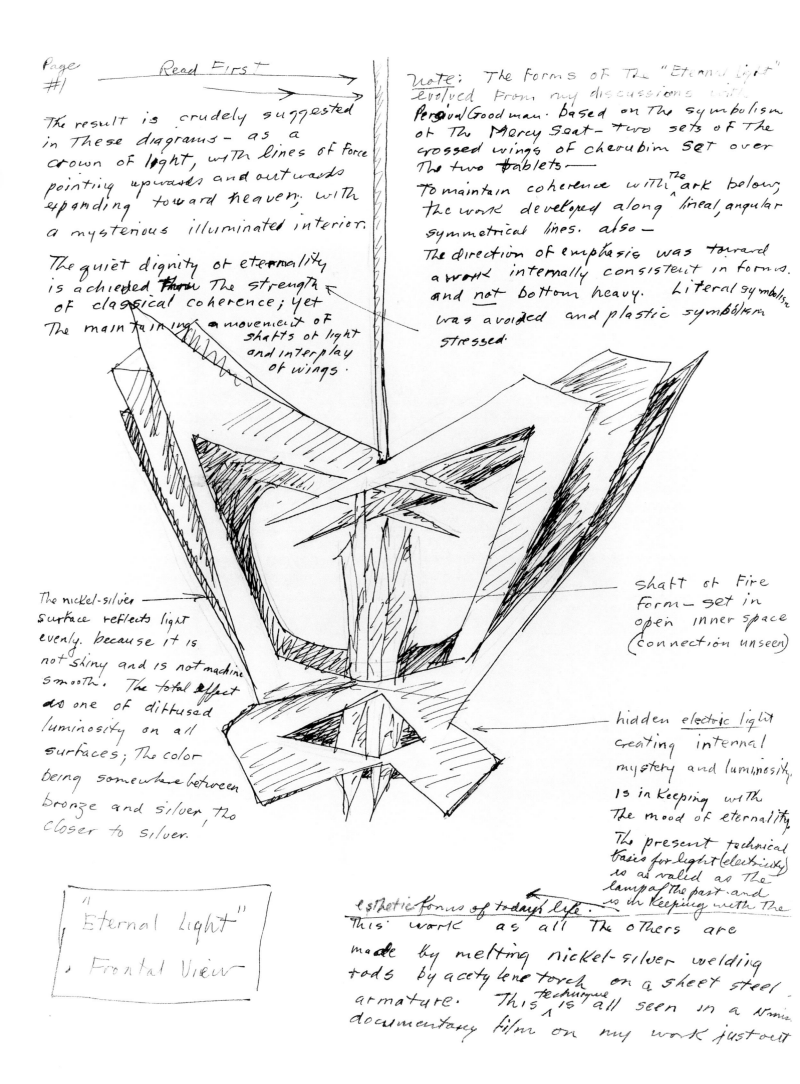

The nickel-silver surface reflects light evenly. because it is not shiny and is not machine smooth. The total effect is one of diffused luminosity on all surfaces; The color being somewhere between bronze and silver, tho closer to silver.

Shaft of Fire Form - set in open inner space (connection unseen)

hidden electric light creating internal mystery and luminosity, is in Keeping with The mood of eternality.

The present technical basis for light (electricity) is as valid as The lamps of the past. and is in Keeping with The esthetic forms of today's life.

"Eternal Light"
Frontal View

This work as all The others are made by melting nickel-silver welding rods by acetylene torch on a sheet steel armature. This technique is all seen in a documentary film on my work just out

FIVE

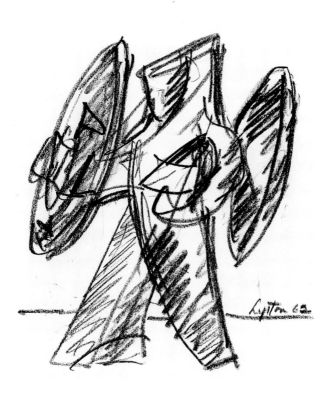

Drawings and the Sculptural Process

above
Study for Archangel, #7, 1962, black conté
crayon, 11 × 8½ in. (27.9 × 21.6 cm),
signed lower right: "Lipton 62." Collec-
tion of James R. and Barbara R. Palmer

opposite
Study for Eternal Light, 1953, black
ink and pencil, 13¾ × 10¹⁵⁄₁₆ in. (34.9 ×
27.8 cm), *cat. no. 65*

Seymour Lipton commented, "the drawing is the first excitement."[1]
This statement gives insight into the important role that works on
paper played in his sculptural process. His drawings are works of
art in their own right, but they also provide information about his
method for creating large-scale metal sculptures. The drawings
serve a vital purpose within the sculptural process. Most of them
are preliminary studies or design revisions for metal sculptures.
Lipton sometimes produced as many as one hundred sketches for a
single sculpture.[2]

The majority of Lipton's drawings are oil crayon (black conté
crayon) on 8½ × 11 inch sheets of bond paper. Although Lipton was
a talented draftsman, he viewed drawing as a means toward
achieving his sculptural goals. He maintained, "I'm interested in
sculpture; I'm not interested in illustrating anything."[3] For him,
drawing was integral to the sculptural process. He discussed the
obstacles inherent in working in metal and the utility of preliminary
drawings:

*Working in direct metal, working in physically cumbersome
materials that are not easily manipulated, you have the prob-
lem of trying to remove the possibility of ultimate failure by
giving thought and preparation to what will ultimately be*

made, and that is the reason why I make so many drawings and so many models in my conception, my image conception, will be fairly well crystalized.[4]

Once a specific image sparked an idea for a sculpture, Lipton would work toward producing a useful drawing to serve as a study:

My initial images are developed into drawings. There is always the problem of translation into the third dimension. I always make a base on the drawing so that it is a schema for a sculpture, never just a graphic conception. By making the drawing that way and putting a horizon line behind it, it sets it off into space and helps me visualize it three dimensionally. It helps me also to formulate tentatively the rear of the work. In some way, I begin to get a sense of the posterior orientation, even though it is not present in the drawing.[5]

After he arrived at the desired aesthetic form, he used the drawings as points of reference, pinning them up in his studio. He then began to translate the drawings into three dimensions, constructing a ten-inch metal model. After completing the maquette, shaping its sheet metal forms using pliers and spot welding, Lipton returned to the drafting table. New drawings would be introduced as he reworked the model. He made measurement notations relating to specific areas of the sculpture to attain the precise proportions in order to enlarge the maquette. The drawings would also change in this process, as Lipton indicated: "all through the process up to the very end, I find myself making changes, sometimes even serious changes."[6] He viewed the transitory nature of the preparatory process as a vital aspect of his work:

My life as an artist, my understanding of the history of sculpture, my search for newness, my total drive becomes involved in a series of drawings. From these models, I will accept or reject, alter or refine images. The drawings are only a suggestion for the model. The model is very frequently an exact model for the large thing [large scale sculpture], or it may merely be a suggestion for one [a sculpture].[7]

Influences and Sources for Drawings

Lipton's drafting began early, and as a youth, he drew constantly. He recalled:

I loved drawing. I remember eight or nine o'clock at night after we'd finished dinner at the old round table. We had an old oak table and everybody would be sitting around talking and playing cards, and I'd be sitting copying an old master. I was about twelve years old. My mother used to say, "Go to bed, you'll hurt your eyes, don't draw." But I used to draw because I liked it.[8]

Happily, Lipton disregarded his mother's well-intentioned warnings and executed thousands of drawings throughout his career. His artistic promise was recognized and he re-

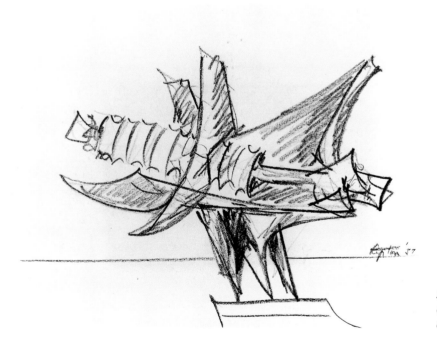

Study for Glowworm, 1957, black conté crayon, 8⅜ × 11 in. (21.4 × 27.9 cm), *cat. no. 66*

membered the support of art teachers and of his family: "When we were very small, [my father] took us to the Metropolitan Museum of Art, and my sister drew before me, I had an uncle who painted, and I had a cousin, several cousins who painted."[9] As we have seen, he continued to visit museums as a mature artist and he drew much of his imagery from works seen at these institutions. As Will Barnet recalled, "We used to go to museums and I think he [Lipton] was very much involved with art history and . . . anthropology."[10] Lipton often sketched the objects on exhibit. Drawings inspired by his museum outings were quickly executed, filed away, and reconsidered later for use in the production of his sculpture. Lipton kept records of his drawings and referenced his file cabinets. Often he resurrected earlier drawings and used them or forms from them.

Abstract Expressionist Drawings

Lipton's drawings, in subject matter and approach, reflect his place within the Abstract Expressionist movement. He explained, "my drawings occur spontaneously. I don't know what will be my next."[11] The drawing phase of Lipton's meticulously planned sculptural process defines a spontaneous approach of his work.

The spontaneity characteristic of Abstract Expressionism is evident, for example, in the gesture paintings of Jackson Pollock and Willem de Kooning, but it is difficult to detect spontaneity in sculpture, with its restrictions of slow production time, costly materials, and the need for extensive planning for large-scale works. In their drawings, however, sculptors of the New York School including David Smith, Theodore Roszak, Herbert Ferber, and Lipton could be freer and more impulsive. Lipton drew whenever the inspiration struck him, whatever the time or place. Whether working in the studio or commuting by train, he drew. Quick sketches and drawings appear on the reverse side of handbills distributed on the city street, on traditional cotton bond typing paper, and even on pieces of gallery letterhead from his art dealer, Betty Parsons. The large-scale constructed metal sculptures required careful planning, yet the direct, quick, and freely executed drawings provide a clear connection with the emotional side of Abstract Expressionism.

The Drawing Process

Drawings also helped Lipton take into consideration the eventual site for a sculpture. Drawing a horizon line gave "the illusion of an object standing on the ground."[12] The study for the sculpture *Earth Mother* (1951, conté crayon on paper) is an early example of the use of this instructive sight line.

For large-scale works, Lipton drew the sculpture's surroundings in the early stages of production. For example,

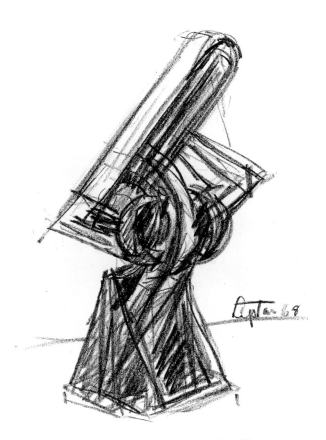

Study for Laureate, 1968, black conté crayon, 11 × 8⁹⁄₁₆ in. (27.9 × 21.7 cm), *cat. no. 80*

Laureate (1968, nickel silver on monel metal) at the Marcus Center for the Performing Arts, Milwaukee, was created after Lipton considered the architectural site plan and incorporated its forms into his preliminary drawings. Lipton commented:

Thinking back to how I felt on seeing the plans for the building project, it seemed to me at the time, in view of the essentially boxlike, flat, cream-colored building and general layout of the grounds, that a dark vertical, dramatic work was called for with a sharp silhouette, because it would be seen against the open sky. I began to feel in terms of hands for the imagery—hands working with tools, the creative craftsman. But beyond that I thought of hands as man's spiritual vector reaching out toward the cosmos. I soon began drawing although no signed agreement was certain. Perhaps forty to fifty drawings emerged from this initial effort.[13]

He traced the evolution of *Laureate* through the drawings,

The first drawings were dramatic verticals, the second dealt with musical instruments and ideas related to the harp, the fist, struggle and music. The third idea was a light beacon from a lighthouse on the island of Tobago. In addition, ideas of the strong fist bending iron forms, [and] elemental egg for emerging as a life force.[14]

A combination of these ideas and varied forms produced the final work.

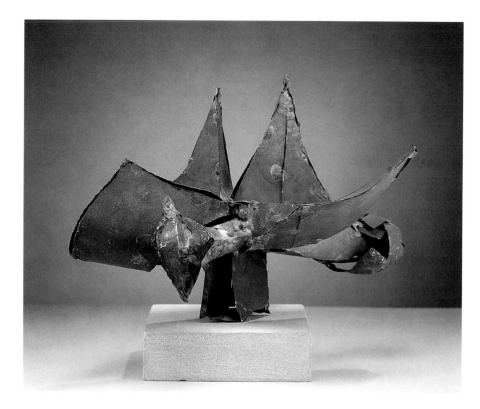

Maquette: Arctic Bird, 1960, Monel metal, 8¾ × 13 × 7⅞ in. (22.4 × 33.2 × 20.2 cm), *cat. no. 39*

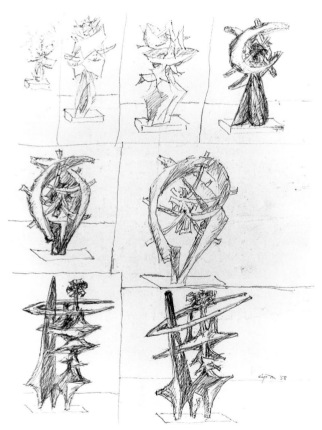

Eight studies, including two for Sorcerer, 1958, blue ballpoint pen, 11 × 8½ in. (27.9 × 21.6 cm), *cat. no. 67*

Preliminary drawings also allowed him to rework—or reinvent—his ideas. One of Lipton's most important pieces, *Archangel,* constructed for Lincoln Center's Avery Fisher Hall, was completed only after numerous changes in the drawing stage. Lipton worked with the building's architect, Max Abramovitz, on the proper form of the piece, and he described the exchange in his essay "The Making of *Archangel*":

> *I felt it should be a vertical piece to repeat the column qualities that were around it. I told him [Abramovitz] that I would go home and make drawings and I'd get in touch with him. I made about 150 drawings with crayon on typing paper and from that I made a small armature model about ten inches high and I studied it for a while and I didn't like it. I discarded it. I made another one and discarded that. I went through my drawings again and finally saw one drawing which gave me an idea for a new piece. And from that drawing I made a series of new drawings. Finally I arrived at a drawing from which I felt I should make a model.[15]*

According to Roberta Tarbell, Lipton initially produced 175 drawings and two models for *Archangel.*[16]

Sometimes the idea for a sculpture resulted from combining shapes and thoughts from several sketches. For instance, *Guardian* developed from many preliminary drawings and unused forms. Lipton admitted, "there was no original drawing for *Guardian.* It was a composite of some odds and ends. A lot of my pieces are made like this. I keep a graveyard of discarded forms."[17] Once he had composed *Guardian* from organizing and piecing together forms created for other drawings and sculptures, Lipton still worked through the drawing process. The vertical emphasis and

strong figural form of the final sculpture were achieved with the aid of numerous drawings.

The late-career work *Bird* is also a combination of various earlier drawings. Lipton described the way ideas might linger in his memory for years until they became the basis of a sculpture and elaborated on the conception of this piece:

> *Bird is based on a drawing which I made in which there are two wings which are not wings which are sort of little compartments all built up like pigeon-holes. And in the middle of this set of technological paraphernalia a bird's beak emerged. I had this drawing for many years. It's been sitting around for ten years. Certain drawings, even though I made them a long time ago, haunt me . . . as suggestions for a sculptural idea.*[18]

Lipton's drawings allowed him to take advantage of spontaneous, creative sparks. The drawing process provided an opportunity for Lipton to experiment with many forms and then to translate them into a successful sculptural form. Lipton maintained, "although the inspiration for a piece of sculpture may come from many sources, the artist first translates these ideas into a working drawing."[19] These drawings certainly possess a presence and a visually stimulating artistic existence. As preparatory studies or individual art works, Lipton's drawings are fine examples of the masterful talent of this sculptor.

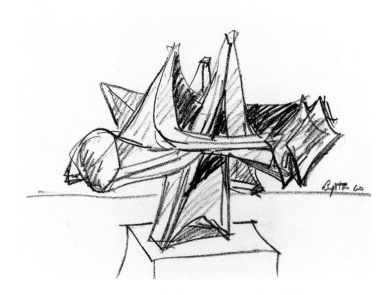

Study for Arctic Bird, #3, 1960, black conté crayon, 8½ × 10¹⁵⁄₁₆ in. (21.6 × 27.8 cm), signed lower right "Lipton 60." Collection of James R. and Barbara R. Palmer

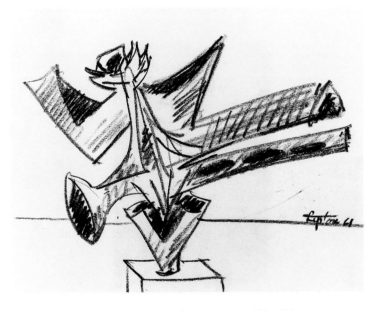

Study for Chinese Bird, #1, 1961, black conté crayon, 8½ × 11 in. (21.6 × 27.9 cm), signed lower right "Lipton 61." Collection of James R. and Barbara R. Palmer

Notes

Chapter 1: Seymour Lipton and Postwar American Sculpture

1. Ibram Lassaw, "Waldorf Sculpture Panel," *It Is: A Magazine for Abstract Art* 2 (February 17, 1965): 64.

2. Stephen Polcari, *Abstract Expressionism and the Modern Experience* (New York: Cambridge University Press, 1991), 33–40.

3. Seymour Lipton, "Notes," Seymour Lipton papers, Archives of American Art, Smithsonian Institution, Washington, D.C. (Hereafter referred to as Lipton papers), December 18, 1962.

4. Frank O'Hara, "Seymour Lipton," *The United States Pavilion—Lipton, Rothko, Smith, Tobey: XXIX Biennale Venezia* (exh. cat., The Museum of Modern Art, 1958).

5. Albert Elsen, *Seymour Lipton* (New York: Harry N. Abrams, Inc., 1970), 28.

6. Similarly, Herbert Ferber used a new material called Modalloy, which was developed by Calvin Albert.

7. *Seymour Lipton* (exh. cat., Marlborough Gallery, New York, 1974), 21.

8. For more information on the process of welded sculpture, see Nathan C. Hale, *Welded Sculpture* (New York: Watson-Guptill, 1968).

9. Lisa Phillips, *The Third Dimension: Sculpture of the New York School* (exh. cat., Whitney Museum of American Art, New York, 1984), 2–3.

10. Herbert Read, *Modern Sculpture* (London: Thames and Hudson, 1964), 247.

11. Phillips, *The Third Dimension,* 2–4.

12. Stephen Polcari, interview by the author, May 11, 1993, New York City.

13. Herman Cherry, "Seymour Lipton's Sculpture," *Arts Digest* 29 (November 15, 1954), 105.

14. "Reviews: 10 Best Shows," *ArtNews* 53 (November 1954), 61.

15. "Awards in Arts Are Made to 20," *The New York Times,* April 30, 1958, I, 31.

16. After the 1950s, Lipton's long-time dealer Betty Parsons closed her gallery. Also, prominent dealers such as Samuel Kootz and Charles Egan did not sell in the same active manner as they had in previous years. For more information on the New York art scene, see Wade Saunders, "Touch and Eye: '50s Sculpture," *Art in America* 70 (December 1982), 90–104.

17. Harry Rand, "Notes and Conversations: Seymour Lipton," *Arts Magazine* 50 (February 1976), 64.

18. Elsen, *Seymour Lipton,* 14.

19. "The Irascible 18" was the title given to eighteen American painters and sculptors who signed an open letter to Roland L. Redmond, president of The Metropolitan Museum of Art, that described the artists' decision to refrain from participating in a national exhibition at the museum scheduled for December 1950. The artists described the award juries as "notoriously hostile to advanced art." The letter also stated that the museum director, Francis H. Taylor, had "publicly declared his contempt for modern painting." This statement served as an example of the unity and strength of the artists working in New York at the time. See "18 Painters Boycott Metropolitan; Charge Hostility to Advanced Art," *The New York Times,* May 22, 1950.

20. Will Barnet, interview by the author, October 8, 1993, New York City.

Chapter 2: Nature's Forms

1. Polcari, interview by author.

2. Polcari, interview by author.

3. Quoted in Jonathan Fineberg, *Art Since 1940: Strategies of Being* (Englewood Cliffs, New Jersey: Prentice Hall, 1995), 93.

4. Polcari, *Abstract Expressionism and the Modern Experience,* 53.

5. John I. H. Baur, "Artist's Comments," *Nature in Abstraction: The Relation of Abstract Painting and Sculpture to Nature in 20th Century American Art* (exh. cat., Whitney Museum of American Art, New York, 1958), unpaginated.

6. See Robert C. Hobbs and Gail Levin, *Abstract Expressionism: The Formative Years* (Ithaca, New York: Cornell University Press, 1978).

7. Ibram Lassaw, "Statement," *Sculptural Expressions: Seven Artists in Metal and Drawing 1947–1960* (exh. cat., Sarah Lawrence College Art Gallery, Bronxville, New York, 1985), 15.

8. Lipton, "Life Attitudes," Albert Elsen papers, Archives of American Art, Smithsonian Institution, Washington, D.C., May 18, 1962.

9. Albert Elsen, "Seymour Lipton: Odyssey of the Unquiet Metaphor," *Art International* 5 (February 1, 1961), 39.

10. Andrew Carnduff Ritchie, "Seymour Lipton," *Art in America* 44 (Winter 1956–57), 17.

11. Cherry, "Seymour Lipton's Sculpture," 25.

12. Lipton, interview by Sevim Fesci, Lipton papers, 1968.

13. Margaret Rigg, "Seymour Lipton: Sculptor," *Motive* 20 (April 1960), 29.

14. Lipton, interview by Dorothy Seckler, Lipton papers, April 28, 1964.

15. Read, *Modern Sculpture,* 255.

16. Polcari, *Abstract Expressionism and the Modern Experience,* 52–53.

17. Phillips, *The Third Dimension,* 24.

18. Jack Burnham, *Beyond Modern Sculpture: The Effects of Science and Technology on the Sculpture of This Century* (New York: George Braziller, 1968), 62.

19. Henry Moore quoted in Herbert Read, *Unit One: Sculpture* (London: A. Zwimmer, 1934), xxxi.

20. Lipton papers, May 18, 1962.

21. Lipton quoted in Dorothy C. Miller, *12 Americans* (exh. cat., The Museum of Modern Art, New York, 1956), 10.

22. Lipton papers, "Group III, Notes—Poems, c. 1920–1969."

23. Lipton papers, interview by Seckler, April 28, 1964.

24. Terree Grabenhorst Randall described the Abstract Expressionists as "searching for forms of expression that would break through individual boundaries of experience in order to create a humanistic art out of the source of the collective life of human species." See *Jung and Abstract Expressionism: The Collective Image Among Individual Voices* (exh. cat., Lowe Gallery, Hofstra University, Hempstead, New York, 1986), 4.

25. For a discussion of Heinrich Zimmer and his impact on American society, see Margaret Case, ed. *Heinrich Zimmer: Coming Into His Own* (Princeton, New Jersey: Princeton University Press, 1994). For Joseph Campbell's discussion of Jung, see Joseph Campbell, *The Portable Jung,* trans. by R. Hull (New York: The Viking Press, 1971).

26. Randall, *Jung and Abstract Expressionism,* 4.

27. Lipton papers, interview by Seckler.

28. Elsen, *Seymour Lipton,* 37.

29. Jung quoted in Evan R. Firestone, "Herman Melville's *Moby Dick* and the Abstract Expressionists," *Arts* 54 (March 1980), 122.

30. Lipton papers, "Dragon Bloom."

31. Lipton papers, "Notes," no date.

32. Albert Elsen, "Odyssey of the Unquiet Metaphor," 38–44.

33. Lipton papers, "Notes," no date.

34. Lipton papers, "Notes," no date.

35. H. H. Arnason, "Theodore Roszak," *Art in America* 44 (Winter, 1956–57), 63.

36. See, for example, Harry Bertoia's *Dandelion* (1958, steel), John Chamberlain's *Wildroot* (1959, steel), David Slivka's *Young Flower* (1958, bronze), Richard Stankiewicz's *Flower* (1956, steel), and David Smith's *Rose Garden* (1955–56, bronze).

37. See Polcari, "Propaedeutics: Intellectual Roots of Abstract Expressionism," in *Abstract Expressionism and the Modern Experience,* 35–50.

38. Walt Disney Productions, *Nature's Half Acre,* True Life Adventure Series, 16 mm, MTI Teleprograms, Inc., Deerfield, IL, 33 minutes, 1953.

39. Alan Lipton, interview by the author, March 18, 1995, Bethesda, Maryland. Lipton's son discussed his father's fascination with air-raid drills and bomb shelters.

40. Lipton papers, "Notes," November 24, 1958.

41. Lipton papers, "Notes," November 24, 1958.

42. Lipton papers, "Group III, Notes—Poems, c. 1920–1969."

43. Elsen, *Seymour Lipton,* 37.

44. Thomas B. Hess, "Peter Agostini: The Sea and the Sphere," *Art News* 58 (March 1959), 35.

45. In 1976, the tall ships were among the attractions celebrating America's Bicentennial and may have inspired the seafaring theme for Lipton in his late career.

46. Lipton papers, interview by Fesci.

47. Lipton papers, "Notes," no date.

48. Lipton papers, interview by Fesci.

49. Albert Elsen, "Seymour Lipton's *Sea King,*" *Buffalo Fine Arts Academy Gallery Notes* 24 (Summer 1961), 7.

50. Martha Graham, *The Notebooks of Martha Graham* (New York: Harcourt Brace Jovanovich, 1973), 191.

51. Lipton quoted in Isamu Noguchi, *Isamu Noguchi: A Sculptor's World* (New York: Harry N. Abrams, Inc., 1968), 28.

52. Lipton papers, "Metaphor in Sculpture," no date.

53. Lipton papers, interview by Fesci.

54. There was a large and famous metal sundial on the campus of Columbia University, where Lipton attended dental school.

55. Lipton quoted in Ritchie, "Seymour Lipton," 15–16.

56. Polcari, interview by author.

57. Polcari, interview by author.

58. Tracy Atkinson, "Lipton's Recent Sculpture," *Art International* 20 (January/February 1976), 38.

59. Sam Hunter, *Seymour Lipton: Major Late Sculpture* (exh. cat., Babcock Galleries, New York, 1991), 14.

Chapter 3: Avian Imagery

1. Lipton papers, "Group III, Notes—Poems, c. 1920–1969."

2. Lipton papers, interview by Fesci.

3. Sam Hunter and John Jacobus, *Modern Art* (New York: Harry N. Abrams Inc., 1992), 147.

4. Lipton, "A Problem in Sculpture: The Question of Intensity and the Total Image," *The Register of the Museum of Art of the University of Kansas* 2 (April 1962), 16.

5. Lipton papers, "Group III, Notes—Poems, c. 1920–1969."

6. Lipton, "Experience and Sculptural Form," *College Art Journal* 9 (Autumn 1949), 52.

7. Lipton, "A Problem in Sculpture," 11.

8. See David Halberstam, *The Fifties* (New York: Villard Books, 1993), 118.

9. Giacometti's *The Palace at 4 a.m.* also demonstrates the interest in flying creatures of prehistoric times. Giacometti's sculpture includes a pterodactyl form within the caged structure.

10. Giacometti quoted in Carola Giedion-Welcker, *Contemporary Sculpture: An Evolution in Volume and Space* (New York: G. Wittenborn, 1961), 96–97.

11. Lipton papers, "Thunderbird."

12. Lipton papers, "Notes," no date.

13. For example, Alfred Hitchcock's *The Birds* went into production in the late 1950s. Lisa Phillips cites the movie *Rodan* (1956) by Toho Studios, which features pterodactyls as another example of America's interest in prehistory and avian imagery. See *The Third Dimension,* 7. Disney's animated film *The Black Cauldron* of 1950 also featured winged monsters.

14. Leonard Baskin, "Of Roots and Veins: A Testament," *Atlantic Monthly* 214 (September 1964), 66. Irma Jaffe discusses Baskin's owls and ravens as symbols of desolation. In the Old Testament, these birds were associated with evil, darkness, and mystery. The artists' Jewish background would have made this point well known to Baskin and Lipton. See *The Sculpture of Leonard Baskin* (New York: Viking Press, 1980), 97–125.

15. Lipton papers.

16. Lipton papers, "Group III, Notes—Poems, c. 1920–1969."

17. Herbert Read, *Britain at War* (exh. cat., The Museum of Modern Art, New York, 1941), 10.

18. Howard Devree, "Abstract Survey," *The New York Times,* January 28, 1951, 10.

19. For more information pertaining to the Abstract Expressionists' interest in Native American forms, see W. Jackson Rushing, *Native American Art and the New York Avant Garde* (Austin: University of Texas Press, 1995).

20. Lipton papers, "Notes." Like Lipton's early works, most Native American ceremonial masks were carved from one piece of wood.

21. Aldona Jonaitis, *Chiefly Feasts: The Enduring Kwakiutl Potlatch* (Seattle: University of Washington Press, 1991), 90.

22. Lipton papers, "Thunderbird."

23. Lipton quoted in Rand, "Notes and Conversations," 67.

Chapter 4: Hero Sculpture

1. Barnet, interview by the author.

2. Lipton quoted in Elsen, *Seymour Lipton,* 37.

3. Ann Gibson, "Retracing Original Intentions/Barnett Newman and Tiger's Eye." *Art International* 32 (Winter 1988), 17.

4. Carl G. Jung, *The Archetypes and the Collective Unconscious.* The Collected Works, vol. 9, part 1, paragraph 90 (Princeton: Bollingen Foundation, Princeton University Press, 1968): 43.

5. Polcari, *Abstract Expressionism and the Modern Experience,* 48.

6. Lipton papers.

7. Elsen, "Seymour Lipton: Odyssey of the Unquiet Metaphor," 44.

8. Lipton papers, interview by Seckler.

9. See Ayn Rand, *The Voice of Reason: Essays in Objectivist Thought* (New York: Meridian Books, 1990).

10. Elsen, "Seymour Lipton: Odyssey of the Unquiet Metaphor," 44.

11. Lipton papers.

12. Ritchie, "Seymour Lipton," 17.

13. Lipton papers, "Group III, Notes, Poems, 1920–1969."

14. Lipton papers, "Group III, Notes, Poems, 1920–1969."

15. Lipton papers, "Group III, Notes, Poems, 1920–1969."

16. Lipton statement, Registrar's Files, Yale University Art Gallery, New Haven, Connecticut, December 16, 1959.

17. Elsen, "Seymour Lipton: Odyssey of the Unquiet Metaphor," 39.

18. Lipton papers.

19. Lipton quoted in Rand, "Notes and Conversations," 67.

20. David Clarke, *The Influence of Oriental Thought on Postwar American Painting and Sculpture* (New York: Garland Press, 1988), 69.

21. Lipton papers, July 23, 1963.

22. Lipton papers, July 23, 1963.

23. Harry Rand, *Seymour Lipton: Aspects of Sculpture* (exh. cat., Washington, D.C.: National Collection of Fine Arts, Smithsonian Institution, 1979), 51.

24. Lipton papers, "Group III, Notes—Poems, c. 1920–1969."

25. Lipton papers, November 11, 1954.

26. Tal Streeter, "The Sculptor's Role: An Interview with Seymour Lipton," *The Register of the Museum of Art of the University of Kansas* 2 (April 1962), 29.

Chapter 5: Drawings and the Sculptural Process

1. Lipton papers, "Notes," April 28, 1964.

2. Rigg, "Seymour Lipton: Sculptor," 17.

3. Lipton papers, interview by Fesci.

4. Lipton papers, interview by Seckler.

5. Streeter "The Sculptor's Role," 29.

6. Streeter, "The Sculptor's Role," 29.

7. Streeter, "The Sculptor's Role," 26.

8. Lipton papers, interview by Fesci.

9. Lipton papers, interview by Fesci.

10. Barnet, interview by the author.

11. Streeter, "The Sculptor's Role," 26.

12. Lipton papers, "Notes," March 1, 1967.

13. Lipton papers, "Notes," no date.

14. Lipton papers, "Notes," no date.

15. Lipton papers, interview by Seckler.

16. Roberta K. Tarbell, interview by the author, August 24, 1993, University Park, Pennsylvania.

17. Rand, "Notes and Conversations," 66.

18. Rand, "Notes and Conversations," 67.

19. Lipton papers. "Group III, Notes—Poems, c. 1920–1969."

CATALOGUE

1. Lynched
1933
Mahogany
14 × 24 × 17 in. (35.6 × 61 × 43.2 cm)
Collection of James R. and Barbara R. Palmer

For his early sculptures, Lipton worked in the tradition of America's direct carvers. He rarely made preparatory sketches, and he utilized his knowledge of anatomy as he carved figures in oak, rosewood, and mahogany. *Lynched* exemplifies Lipton's mastery of carved wood.

Premiered in Lipton's first one-man show at the ACA Gallery in New York City in 1938, *Lynched* met with critical acclaim. The critics praised the dynamism of its strong composition and diagonal orientation. In addition to its powerful forms and masterly carving, its subject matter was also commended. Depicting a black man bound and constricted, his pain and anguish evident, *Lynched* was described as "the most humanly appealing and powerfully modeled piece of sculpture in his entire display."[1]

In early works like this one, Lipton demonstrated his interest in subjects such as the oppressed and the issue of struggle, also seen in works such as *John Brown and the Fugitive Slave* and *Cotton Picker.* Lipton viewed such Social Realist content as "noble and inspiring, making the beholder vow that the causes of such suffering shall cease."[2] These Social Realist themes recur in the direct sculpture of the 1930s and 1940s.

1. Elizabeth Noble, "Progressive Sculptors," *New Masses,* November 15, 1938, 31.
2. Lipton papers.

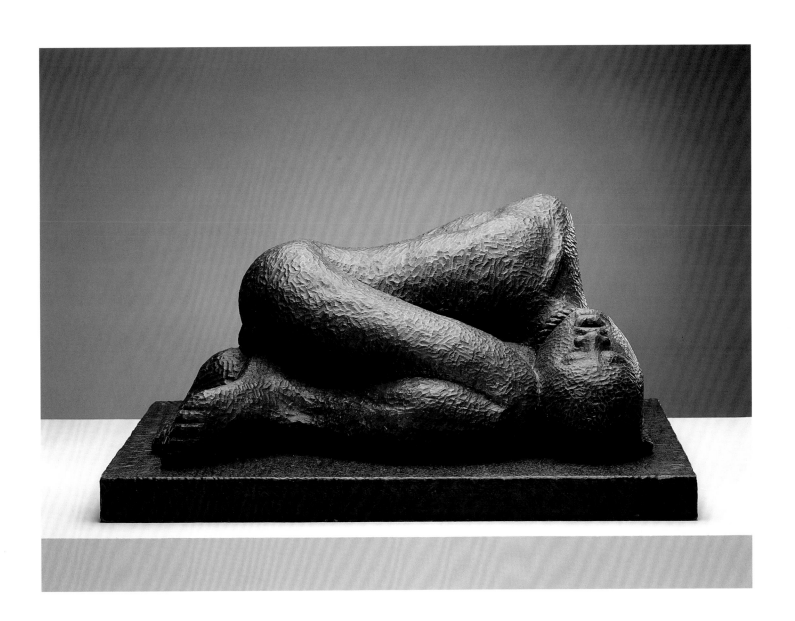

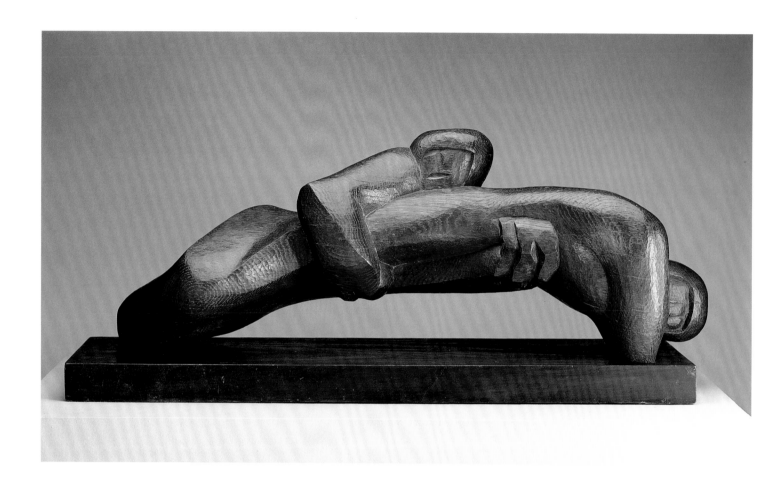

2. Football Players
1936
Oak
15 × 39 × 13 in. (38.2 × 99 × 33 cm)
Collection of James R. and Barbara R. Palmer

A self-taught sculptor, Lipton nevertheless produced some of his most powerful images in the early years of his long and prolific career. *Football Players* shows the young sculptor's keen understanding of balance and formal composition. Carved in oak, it incorporates two interlaced figures. As one player grasps at the lower torso and legs of the other, the forms of the two bodies create a semicircular lunette shape. This arch leads the viewer's eyes from one end of the piece to the other, and the curvilinear forms contrast with the abstract and even cubist elements of the figures' faces.

This composition reveals Lipton's mastery of both abstract and biomorphic forms. With this piece, Lipton began a departure from the straightforward and widely totemic compositions of the direct carvers. Similarly, he became less interested in carving full figures and began to concentrate on compositions based on the partial figure.

Football Players, also known as *Football Tackle*, was included in the exhibition at Galerie St. Etienne early in Lipton's career. In a review in the *New York Times*, Howard Devree noted that Lipton has "a distinctly abstract approach, yet his work is in the main representational and is best when he succeeds in blending the two strains."[1] Devree pointed to *Football Players* as an example of Lipton's success. In early 1943, Lipton also showed his abstract, directly carved pieces in the exhibition *American Sculpture of Our Time* at the Buchholz Gallery in New York.

1. Howard Devree, "Survey by Groups," *The New York Times,* October 16, 1949, X, 9.

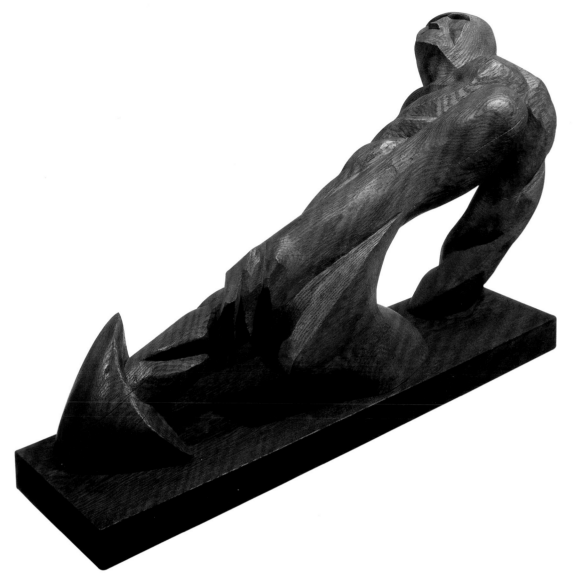

3. Sailor
1936
Oak
17 × 31½ × 10 in. (43.2 × 80 × 25.4 cm)
Collection of Whitney Museum of American Art,
New York
Gift of the artist
Photo © 1999 Whitney Museum of American Art

Maintaining his interest in forms that demonstrate physical struggle, Lipton here emphasizes the difficulty of a sailor's work. Utilizing a partial figure, he integrates a common attribute of the seaman—the rope—into the composition. The straining sailor pulls back on the tightly bound rope to complete the flowing composition. The figure, with squinting eyes and tensed muscles, projects power and physical strength as he tugs at the rope.

In the interrelated composition, there is complete visual and thematic unity. For instance, the figure's forearm and shoulder become one with the anchor and heavily braided rope. The sculpture first rises, then falls, as the anchor's form is echoed in the abstracted form of the sailor's body. Simultaneously, the rope supports the figure's head, which is positioned at the apex of the triangular and diagonal form of the piece. As the sailor's head is thrown backward in tension, his upper body and the rope become one continuous unit.

Formally, this work refers to totemic sculpture of non-Western art, such as the figures of the Senufo or the Lobi people of West Africa, the abstract and cylindrical dolls of the Mossi of Burkina Faso, or the Ibeji twin statuettes of the Yoruba of Nigeria. Exhibitions of tribal art such as The Museum of Modern Art's groundbreaking show *African Negro Art* in 1935 had a great impact on the direct carvers, both formally and thematically.

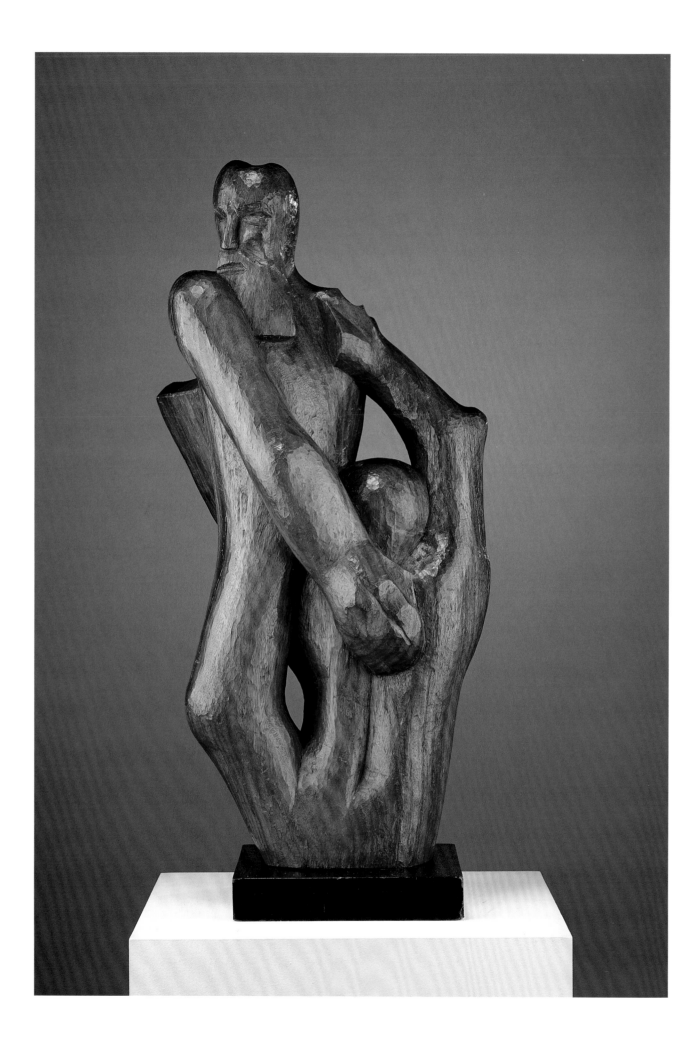

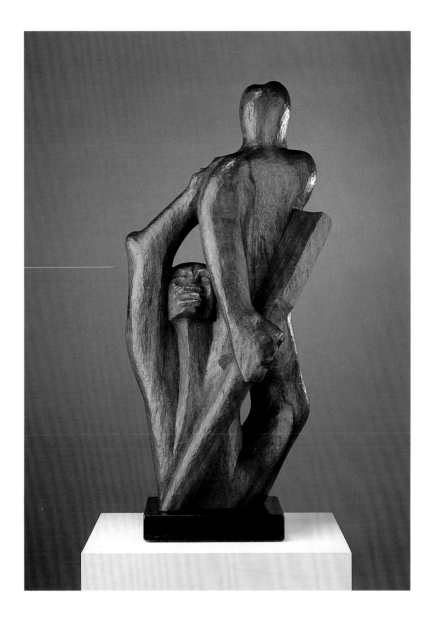

4. John Brown and the Fugitive Slave
1941
Sabicu wood with wood base
36 × 17 × 15 in. (91.4 × 43.2 × 38.1 cm)
Collection of James R. and Barbara R. Palmer

During the 1940s, Lipton achieved a command of the technique of direct carving, as evidenced in *John Brown and the Fugitive Slave*. He also continued to work with the themes of struggle and social justice and to examine the abstracted, partial figure. Specifically, Lipton focused on the theme of struggle for African-Americans and addressed the subject of slavery and racial injustice in American history. Like the artists of the muralist movement of the 1930s and 1940s, he found John Brown a compelling subject.

The sculpture depicts the abolitionist hero John Brown holding on to the slave, as if trying to pull him to freedom. It exemplifies the use of open yet interlocking forms found in Lipton's early sculpture, as the two bodies entwine to form one continuous shape. Lipton's choice of partial figural forms adds to the sculpture's dynamism. The figures merge as parts of each figure serve as components of the other. The most prominent example of this symbiotic relationship is the slave's arm, which reaches above his own head to grasp Brown's shoulder, and at the same time serves as a part of Brown's body. The work demonstrates Lipton's skill as a carver of interchangeable forms; a vital element of his later abstractions.

Rising from the base of the sculpture, the figure of John Brown provides an upward impression, both formally and metaphorically. Placed above the slave, John Brown protects and sustains him. Metaphorically, the figure rises above racism as well.

5. Argosy
1946
Bronze with wood base
16 × 29 × 11 in. (40.7 × 73.8 × 27.9 cm)
Collection of James R. and Barbara R. Palmer,
on loan to The Minneapolis Institute of Arts

As his sculptures took on new forms in the 1940s as a result of new industrial materials, Lipton produced abstractions based on historically rich themes such as mythology. Like his New York School colleagues, he used myths to address the postwar search for a method to rebuild society.

"Argosy" is the name for a large merchant ship or a fleet of ships and specifically refers to the epic voyage of Jason and the Argonauts in search of the Golden Fleece. Many years after *Argosy,* Lipton returned to the theme with his works for the IBM Watson Research Center entitled *Argonaut I* and *Argonaut II* (nickel silver on Monel metal) in 1961.

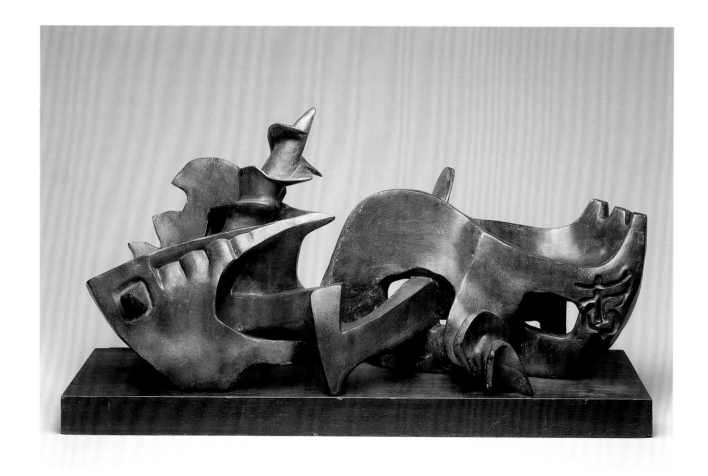

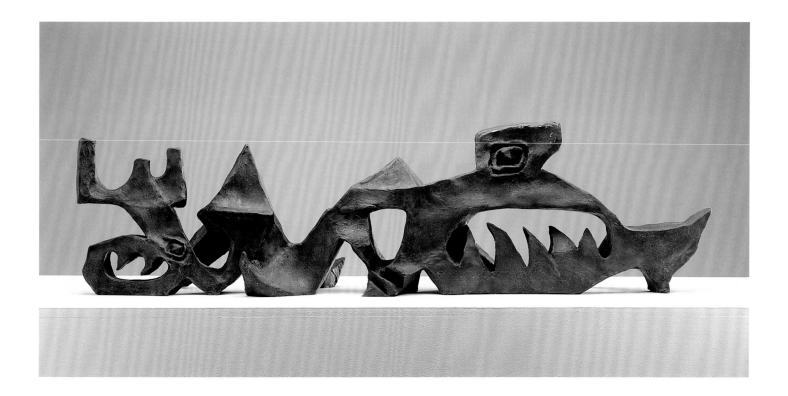

6. Exodus #1
1947
Lead construction
37 in. long (93.9 cm)
Estate of the artist, New York

Along with other works of the late 1940s, *Exodus #1* reveals
Lipton's experimentation with new materials. The sculpture
refers to World War II and its unfathomable atrocities. In
a horizontal format, *Exodus #1* includes abstracted fig-
ural forms that suggest the ruins of the war and evoke the
destruction caused by bombardment, and the suffering of
refugees.

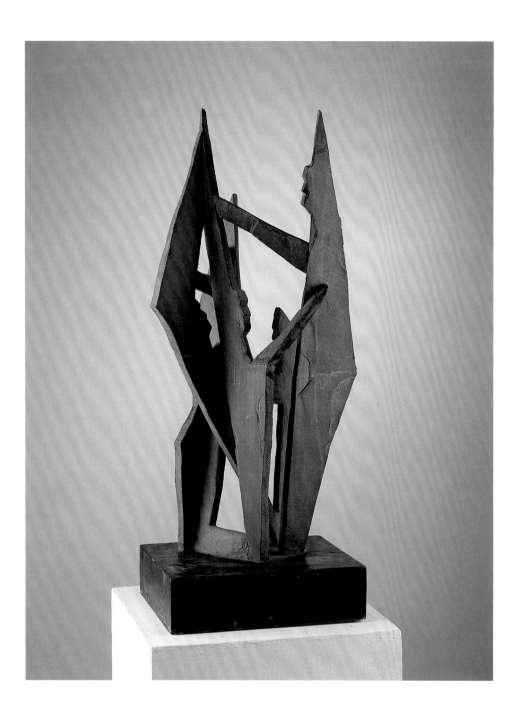

7. City
1947
Slate
26 in. high (66.1 cm)
Estate of the artist, New York

Lipton's works in slate reveal his expertise in carving varied materials. He employed slate in dynamic and dramatic sculptures such as *Night Rider* (1945, slate) and *City*. Although slate was an uncharacteristic material for him, *City* is a captivating and successful piece, showing his mastery of the new material and his diversity as a sculptor.

City was probably based on Lipton's hometown and the newly deemed center of the art world, New York City. Its upright forms evoke the height of New York's skyscrapers, while the slate's natural coloration conveys the sooty cast of the city. The vertical emphasis of the sculpture and the group of straight and diagonal lines refer to the web of buildings apparent in New York's postwar urban landscape. The angular composition projects a feeling of congested urbanism and suggests the impact that architecture can have on the human experience.

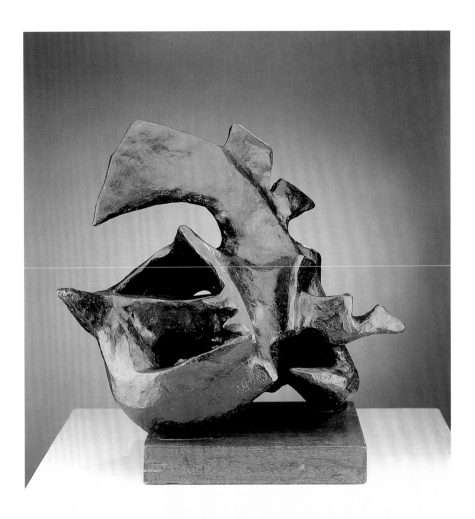

8. Moby Dick #2
1948
Bronze with wood base
16¾ × 18⅜ × 14 in. (42.6 × 46.7 × 35.6 cm)
Collection of James R. and Barbara R. Palmer

Herman Melville's epic novel *Moby Dick* had a tremendous impact on postwar society and art. Along with many of the other Abstract Expressionists including Sam Francis, Theodore Roszak, Theodore Stamos, William Baziotes, Barnett Newman, and Jackson Pollock, Lipton produced works inspired by the 1851 classic. Lipton held Melville's masterpiece in high regard. Roberta K. Tarbell, in a discussion of *Moby Dick #1*, explained:

> He feels that the book encompasses the whole human race and its problems, and believes that it is not just a tall tale about the sea. The element inside the lead sculpture is Moby Dick [the whale]. The outside form is Captain Ahab trying to engulf the dark interior of his being. Lipton's Moby Dick becomes an allegory for war. . . . [1]

Lipton addressed the beastly side of the great white whale in his art. He described the importance of the subject: "*Moby Dick* consumed my interest at the time, but only because it rang bells deep in my being. It was the symbol of destruction and . . . that evil is at the center of the universe."[2] Lipton found in *Moby Dick* an expression of his concerns with the horrors of conflict and man's struggle, making it an evident source for his sculpture.

1. Roberta K. Tarbell, "Seymour Lipton's Sculptures of the 1940s: Intellectual Sources and Thematic Concerns," paper presented at the Annual Meeting of the College Art Association, New York City, February 13, 1986.
2. Lipton quoted in Elsen, *Seymour Lipton,* 28.

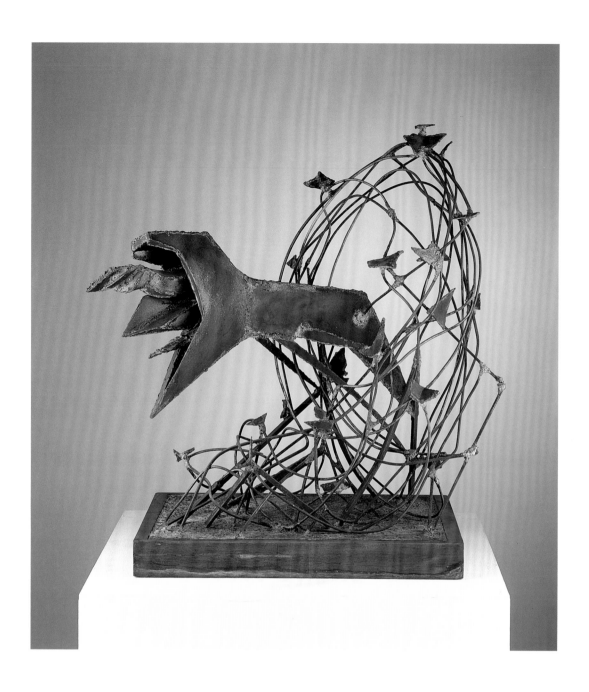

9. Genie
1948
Copper, lead solder with steel base
22¼ × 21½ × 13 in. (56.5 × 54.6 × 33 cm)
Estate of the artist, New York

In its assemblage approach of piecing together different metals and forms, *Genie* shows stylistic similarities with works such as *Pavilion* (1948). Its dynamism results from its use of diverse materials and the asymmetrical composition. *Genie* refers to the supernatural world, with stars and celestial forms on vertical metal rods, and considers the unknown beings of fairy tales and myths. The strong central shape indicates the genie, with its mysterious powers. Visually dramatic, *Genie* exemplifies the experimental phase of Lipton's career and his use of various metals and intriguing subject matter.

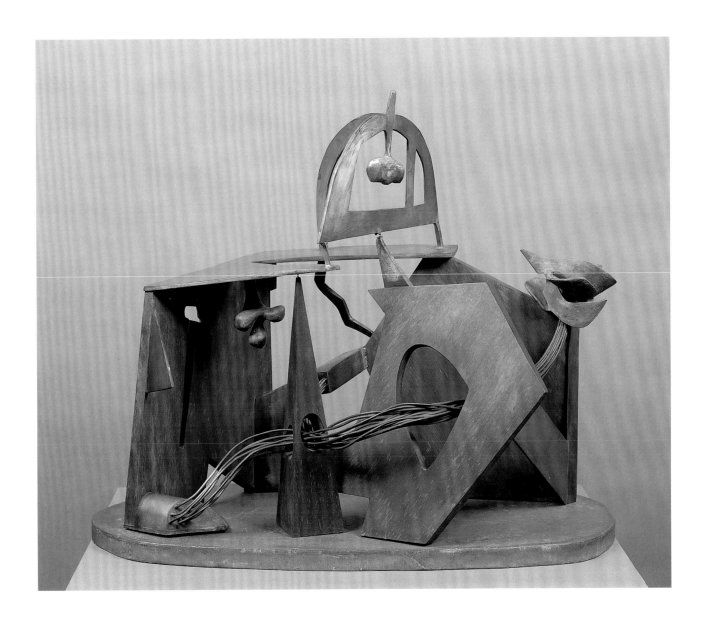

10. Pavilion
1948
Wood, copper, and lead
22 × 24 × 14 in. (55.9 × 61 × 35.6 cm)
Collection of Whitney Museum of American Art,
New York
Purchase, with funds from the Painting and
Sculpture Committee
Photo © 1998 Whitney Museum of American Art
Photo by Geoffrey Clements

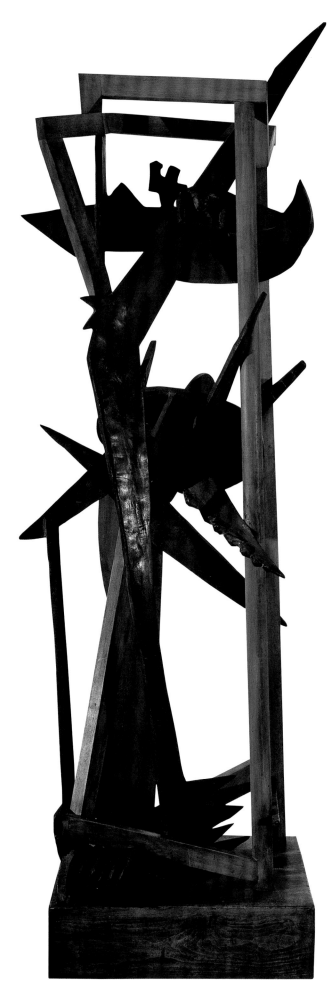

11. Imprisoned Figure

1948
Wood and sheet lead
84¾ × 30⅞ × 23⅝ in. (215.2 × 78.3 × 59.9 cm)
The Museum of Modern Art, New York
Gift of the artist
Photo © 1999 The Museum of Modern Art, New York

Along with *Sanctuary,* this work is possibly the most famous of Lipton's sculptures. *Imprisoned Figure* moves beyond his successful *Prisoner* in terms of dynamism. The figure within the cage is more defined and more dramatic in its movements. Its angular forms recount struggle in a manner unknown to *Prisoner,* as the confined figure attempts to break free. Activity commands *Imprisoned Figure* and suggests the attempts of the abstracted form to win control of the situation. Additionally, the juxtaposition of the sheet lead and the wood reveals Lipton's interest in the fusion of opposites, this time in materials of natural and manmade origins.

Lipton, like many of his contemporaries, participated in shows that dealt with prevalent issues of the day. One particularly interesting topic was paying tribute to the world's newest democracy by giving works of art to Israel or organizing exhibitions saluting the new nation. *Imprisoned Figure* was created for such an exhibition. *The New York Star* reported on January 1, 1949, that many artists, including Will Barnet, Byron Browne, Raphael and Moses Soyer, Milton Avery, William Baziotes and, of course, Lipton, not only offered pieces for the new government's cultural centers but "gave their best work."

12. Prisoner

1948

Copper, lead solder with steel base

78 × 15 × 15 in. (198.2 × 38.1 × 38.1 cm)

Collection of James R. and Barbara R. Palmer

By the latter part of the 1940s, Lipton had begun to experiment with various metals and direct welding. *Prisoner* marks a transitional stage in Lipton's career: Along with *Genie* and the pieces that follow, it demonstrates Lipton's new interest in constructed sheet metal.

The cage form of *Prisoner* derives from Surrealist imagery such as Giacometti's *The Palace at 4 a.m.* and *Cage.* The interior form, with its rounded head, spirals upward yet remains within the restraining bars and suggests a figure in captivity. The juxtaposition between the hopeful upward movement and the continued confinement is not unusual in Lipton's sculpture.

Lipton's imagery has been viewed as the most aggressive and violent of the Surrealist-inspired American sculptors in the postwar era.[1] While addressing new formal issues, *Prisoner* remains dedicated to the theme of war. With the issue of prisoners-of-war and the captives of the concentration camps ever present in the mind of the postwar world, its subject matter was timely.

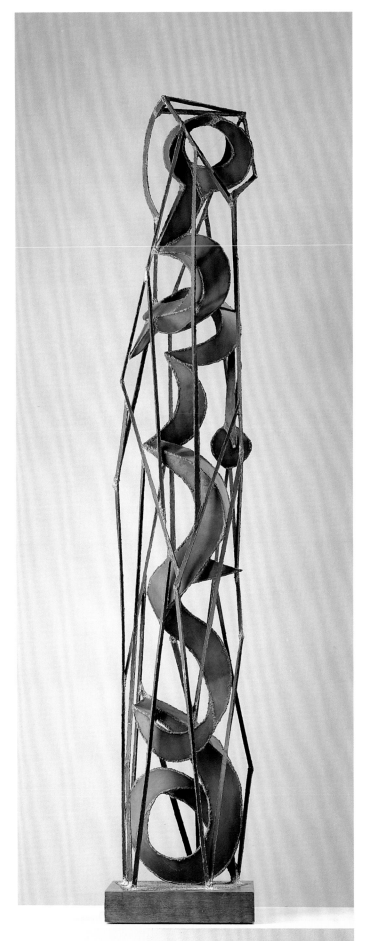

1. Wayne Anderson, *American Sculpture in Process: 1930/1970* (Boston: New York Graphic Society, 1975), 77.

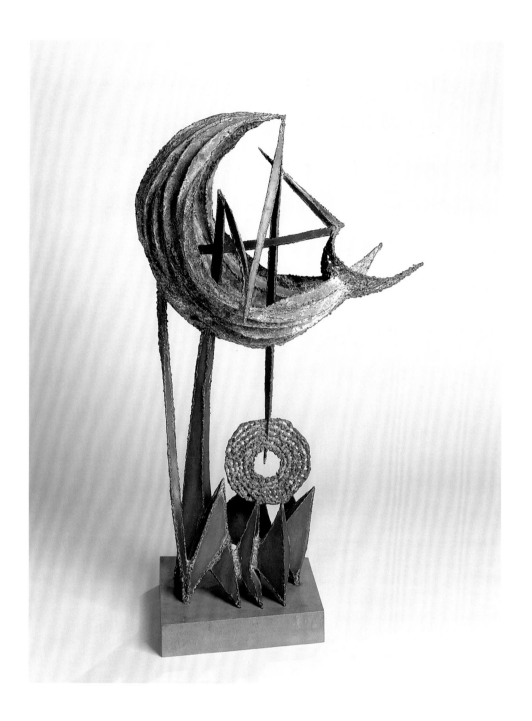

13. Equinox
1949
Bronze, lead, and wood
32 × 19¼ × 11 in. (81.4 × 48.9 × 28 cm)
Munson-Williams-Proctor Institute
Museum of Art, Utica, New York; 51.26

Equinox springs from Lipton's interest in astronomy, celestial beings, and the cyclical movements of heavenly bodies. During the late 1940s, Lipton continued to experiment with different types of metal to refine his sculptural technique. This sculpture is made from three different materials. Lipton focuses on the crescent moon shape and its relationship to earth and other celestial bodies, each comprised of different types of metals. Lipton makes the prominent symbol of the crescent-shaped moon easily recognizable because of its importance and central placement within the overall composition.

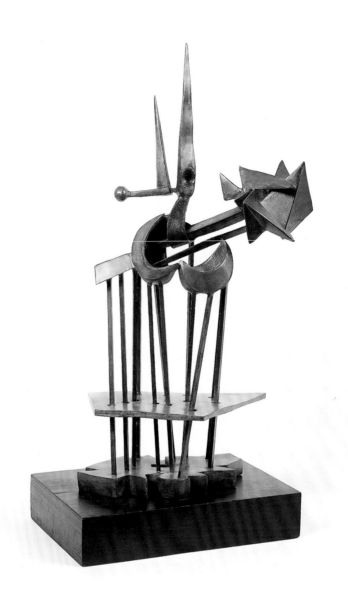

14. Moon Flower
1949
Brass and lead
19 in. high (48.3 cm)
Private collection of Elaine and Henry Kaufman

The theme of celestial bodies was prevalent in post-war sculpture. Herbert Ferber, Lipton's contemporary, created works such as *The Sun, the Moon, and the Stars II* and *Spheroid.* Lipton was certainly interested in science fiction and the mysterious forms of outer space. *Moon Flower* uses cast-metal cut-out pieces to depict celestial bodies. The base may represent the earth while the second level of the sculpture may recall the moon's surface upon which the flower grows and flourishes. The playful, almost childlike representations of the crescent moon and the cosmos juxtaposed against the abstract floral form are direct and appealing.

Again the uncertain, Surrealist tendencies emerge in Lipton's sculpture. He noted, and it is apparent in this piece, that "the surrealism underneath will always find its way into the imagery of art . . . the first half of the twentieth century was an investigation into the unconscious forces of art raised to a self conscious esthetic."[1]

1. Lipton papers, August 10, 1959.

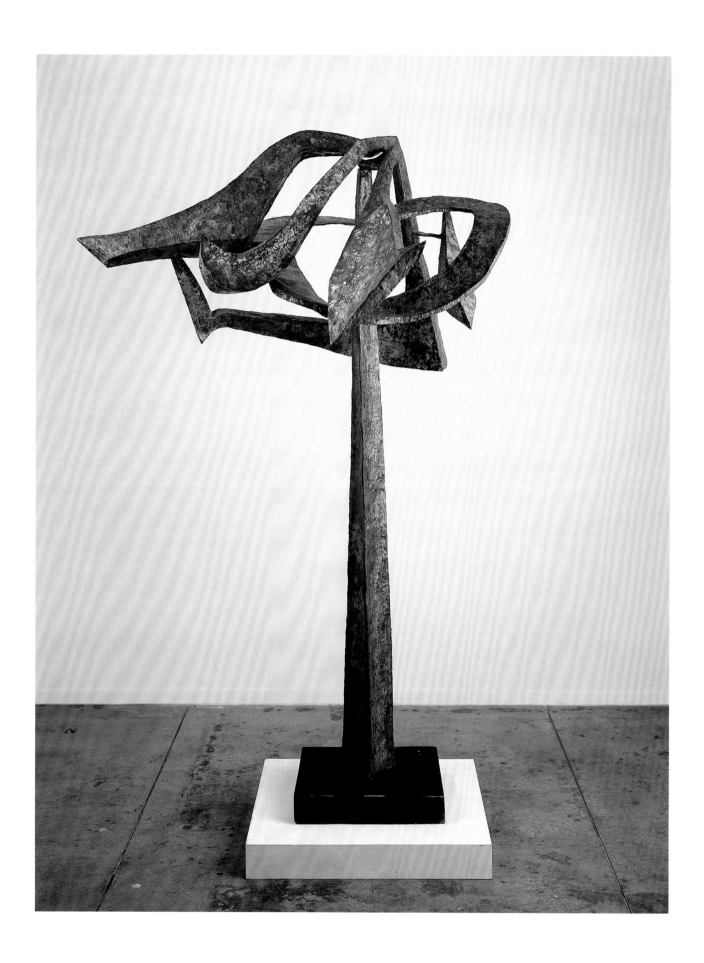

15. Spring Ceremonial
1951
Bronze and steel
72 in. high (183.4 cm)
Estate of the artist, New York

Spring Ceremonial embodies the hope and the magical transformations associated with the coming of spring and reflects feelings of anticipation that were well known to members of postwar society. Evident here is Lipton's interest in the recurring seasonal cycles and the elemental forces of life.

The dynamic vertical form rises triumphal, much like a blooming tree or a newly revived flower of springtime. The ribbonlike forms at the top call to mind a festive maypole and the traditional rituals and celebrations of the new season, and the sculpture serves as an expression of the gaiety of the *fête galante* with all of its art-historical and cultural associations.

Art of the postwar period frequently took on forms of renewal as society tried to come to terms with the Second World War. *Spring Ceremonial* helps to define Lipton's ideas of hope, rebirth, and growth as new life emerges after a dark winter or out of the chaos of tragedy.

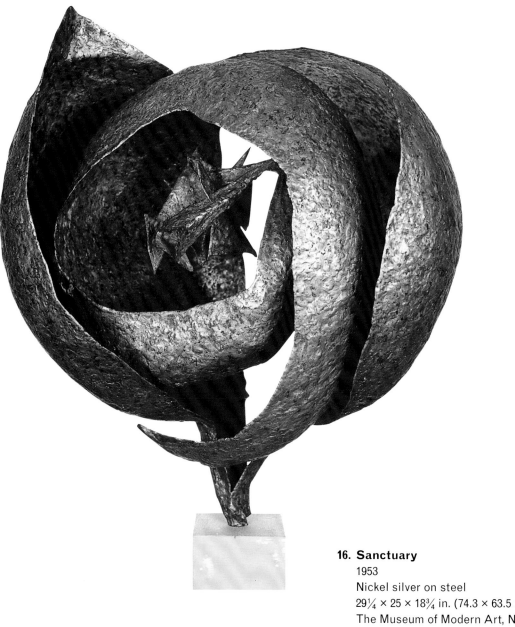

16. Sanctuary
1953
Nickel silver on steel
29¼ × 25 × 18¾ in. (74.3 × 63.5 × 47.8 cm)
The Museum of Modern Art, New York
Blanchette Rockefeller Fund
Photo © 1999 The Museum of Modern Art, New York

Sanctuary provides an example of Lipton's concentration in the 1950s on botanical and organic imagery and his dedication to Vitalism. For him, Vitalism meant that in art "the life of forms is the form of life; forms that are angry, bitter, lovely, searching; that intertwine, that reach out, that close back and inward. These are the stuff of everyday living."[1]

He looked to the mysterious growth pattern of plants and to their means of protection and survival. He examined and then sculpted plant forms from the interior in an attempt to capture the hidden processes of natural growth. *Sanctuary* stems from this fascination with the internal forms of nature and with the hidden secrets and places within those forms.

1. Lipton papers, May 18, 1962.

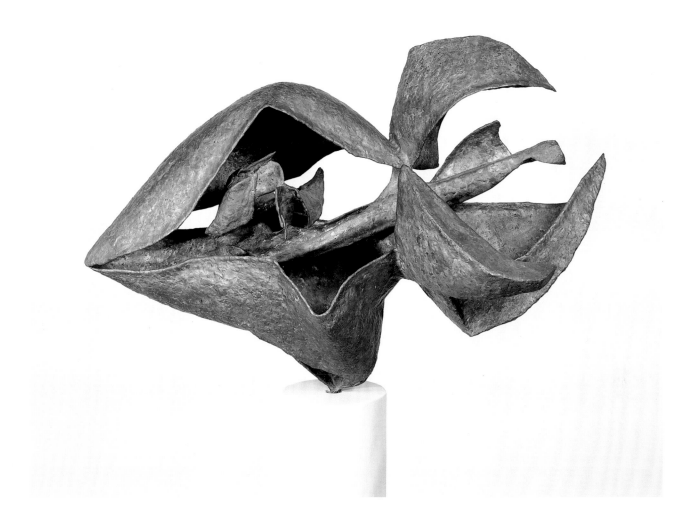

17. Jungle Bloom
1954
Bronze on steel
20½ × 31 in. (52.1 × 78.9 cm)
Yale University Art Gallery
Gift of Susan Morse Hilles

This work is the first of two pieces, *Jungle Bloom* and *Jungle Bloom #2,* dedicated to the subject of a jungle plant. One of the "Bloom" series, *Jungle Bloom* shows how Lipton's plant sculptures reflect Vitalism, nature, the life force, and struggle toward change.

A contrast is evident between the sculpture's interior and exterior forms. *Jungle Bloom* reveals its enclosed internal structure, but at the same time there is an outward, opening movement. The outer portion of the plant protects the seed and then, under appropriate conditions, opens up to allow growth. With its sensibility toward the movement associated with expansion and maturity, *Jungle Bloom,* like *Cloak, Carnivorous Flower, Sanctuary, Guardian,* and *Thorn* shows a protective covering that safeguards the inner growth process.

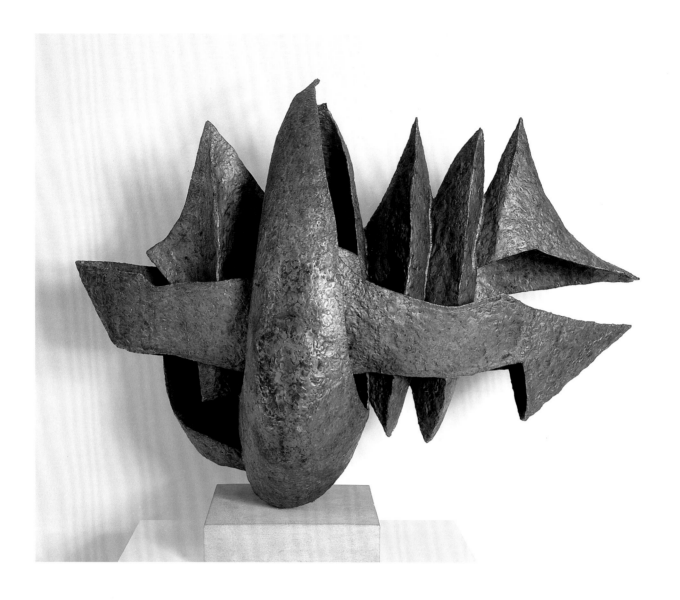

18. Sea King
1955
Nickel silver on Monel metal
30½ × 41¾ × 20 in. (77.5 × 105.1 × 50.8 cm)
Albright-Knox Art Gallery, Buffalo
A. Conger Goodyear Fund, 1956; 1956:6

Like painters, many sculptors looked to the ocean for subject matter, and Lipton maintained that the sea was an important theme within his work, as evidenced by *Sea King*. Lipton's proclivity toward the fusion of the natural and the mechanical is also apparent in this sculpture, which seems both powerful ship and dominant ocean creature. Its forms suggest a hull and sails, or perhaps the interior structure of a predatory fish. The budlike end forms join jagged elements to create formal tension and a sense of forcefulness. Lipton referred to *Sea King* as "the gesture of a ship,"[1] and it suggests a great boat moving through water. At the same time, *Sea King* reveals the internal intricacies of the marine world. Lipton continued to describe the work in the context of all of his sea pieces as showing "the dark side of things, the unseen aspects of reality; the internal anatomy as hidden truths, these things need a sculptural explanation. Such things as the opening of a bud, or the x-ray skeleton of a fish recorded a basis for a solution."[2]

1. Lipton papers, interview by Fesci.
2. Lipton papers, "Notes."

19. Odyssey
1957
Bronze on steel
27 × 38 × 22 in. (68.7 × 96.5 × 55.9 cm)
Collection of James R. and Barbara R. Palmer

Homer's timeless story of a wandering hero, *The Odyssey,* provides a point of reference for this work. The forms of the piece seem to wander in concert with the theme of Odysseus' journey. *Odyssey* also reveals a close connection to Surrealism and its visual responses to theories of the subconscious and to automatism and automatic drawing. It possesses much of the free-flowing linearity that was introduced into twentieth-century American art by Surrealists such as Max Ernst, André Breton, Alberto Giacometti, and Joan Miró. The intricate, all-over, and curving forms of Surrealist-inspired automatic drawings are evident here. Formally, *Odyssey* relates to Abstract Expressionist pieces such as David Smith's *Australia* (1951, painted steel) and *Hudson River Landscape* (1951, steel), which consider the idea of drawing in space in a manner similar to doodling, using metal.

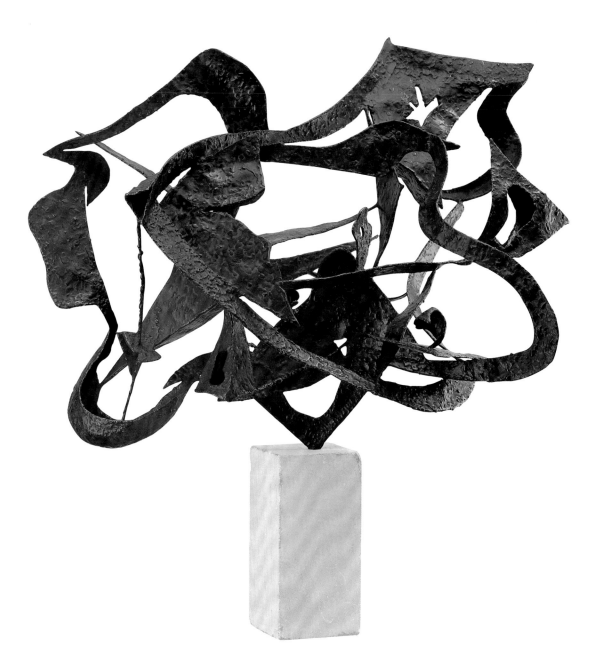

20. Winter Solstice #2

1957

Nickel silver on Monel metal

$18\frac{3}{4} \times 22\frac{1}{8} \times 15\frac{1}{4}$ in. (47.6 × 56.2 × 38.8 cm)

Hirshhorn Museum and Sculpture Garden

Smithsonian Institution, Gift of Joseph H. Hirshhorn, 1966

Photo by Lee Stalsworth

Originally planned as a sixteen-foot-tall, site-specific piece for the campus of the Massachusetts Institute of Technology, *Winter Solstice #2* was finally realized as a pedestal-size piece.[1] With its rounded, contained yet burgeoning form, this piece relates to the "Bloom" series. It also, of course, refers to the cycles of the solar system and the mysteries of the universe.

1. Elsen, *Seymour Lipton,* 43.

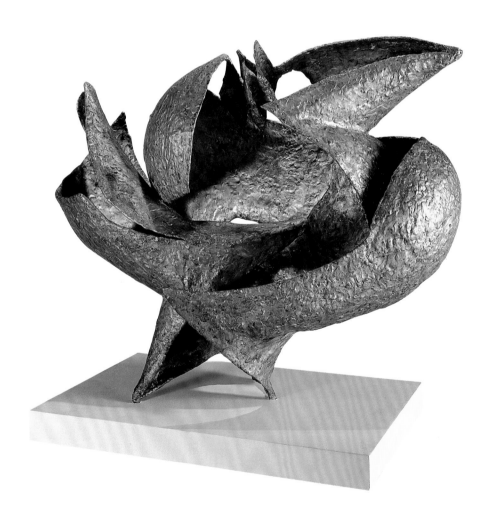

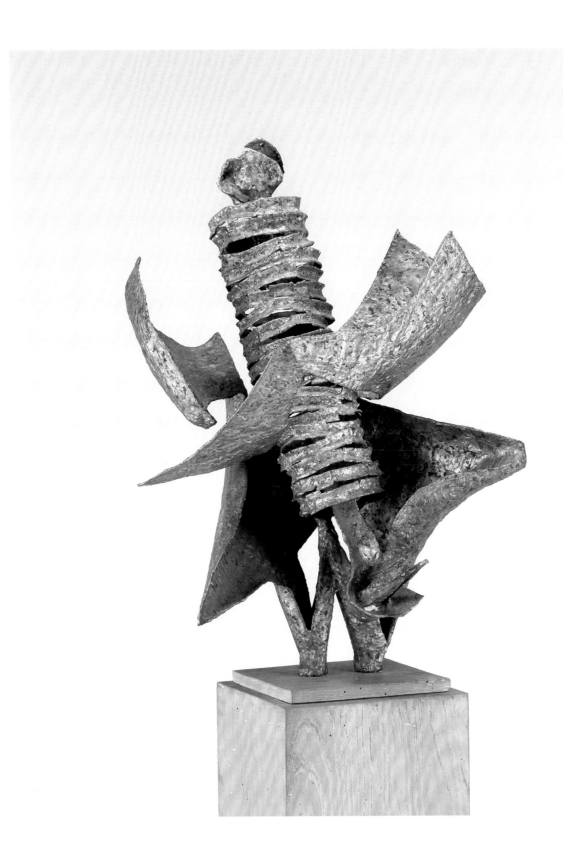

21. Glowworm
1957
Nickel silver on Monel metal
32 × 22 in. (81.3 × 56 cm)
Sheldon Memorial Art Gallery and
Sculpture Garden
F. M. Hall Collection
University of Nebraska-Lincoln

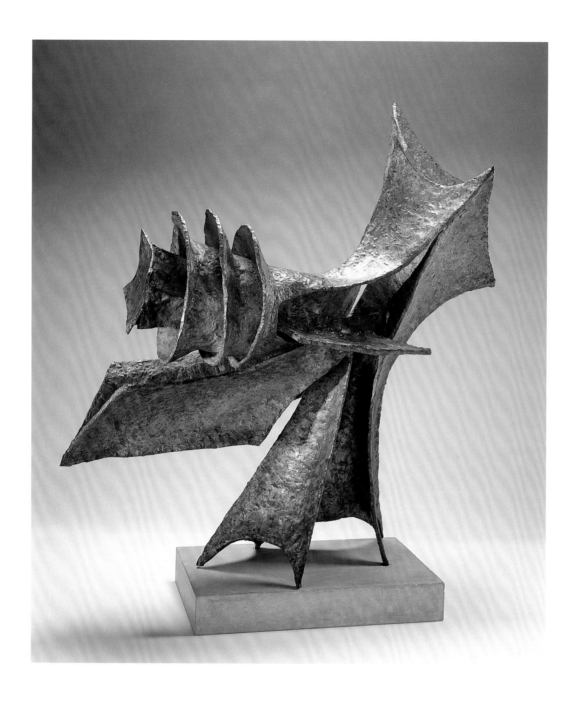

22. Mandrake
1958
Nickel silver on Monel metal
36 × 34 × 16½ in. (91.4 × 86.4 × 41.9 cm)
Hirshhorn Museum and Sculpture Garden
Smithsonian Institution
Gift of Joseph H. Hirshhorn, 1966
Photo by Lee Stalsworth

Mandrake combines Lipton's interests in the botanical world and the writings of Carl Jung. The mandrake is a poisonous plant from the Mediterranean region. The *drake* portion of the word comes from "dragon," a creature that signified the unconscious for Jung. The sculpture is clearly related to Lipton's thematic parameters: It is a plant abstraction grounded in natural history and a formal combination of lines and forms that deals with contemporary themes such as Jungian philosophy and thought.

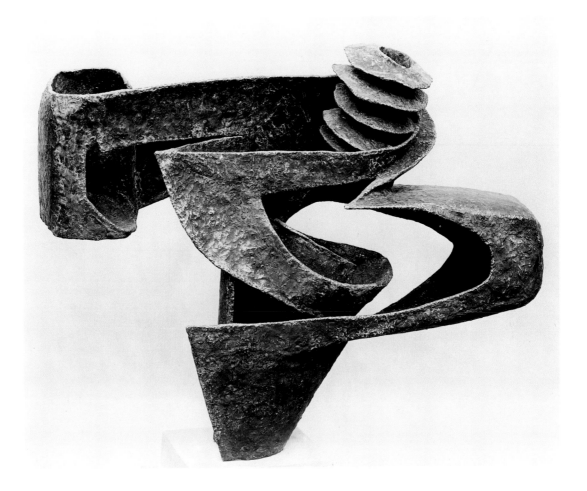

23. Earth Loom
1958–59
Bronze on Monel metal
28 × 32 in. (81.3 × 96.5 cm)
The Detroit Institute of Arts
Founders Society Purchase,
Friends of Modern Art Fund
Photo © The Detroit Institute of Arts

Albert Elsen described *Earth Loom* as "earth womb" or the combination of "a fan belt, revolving gear, and flower."[1] This mature work is among the many pedestal-sized works that represent Lipton's interest in combining forms from nature and industry.

It is one of a group of Lipton's sculptures that focus on subterranean themes. Appropriate for the postwar interest in bomb shelters, *Earth Loom* suggests protection through hiding. The composition also recalls large-scale farming equipment that burrows down toward the earth's core.

1. Elsen, *Seymour Lipton,* 40.

24. Sentinel

1959
Nickel silver on Monel metal
89¾ in. high (228 cm)
Yale University Art Gallery
University Purchase, Leonard C. Hanna Jr. Fund

Sentinel belongs to the series of hero sculptures based on the human form that Lipton executed in the mature phase of his career. An earlier work, *Hero,* shares a vertical orientation and figural emphasis, and it stresses the good, bright, and progressive qualities of a heroic being. *Sentinel,* on the other hand, with its hooded head and cloak form, indicates a more internally driven, introspective figure.

Lipton often made reference to *Sentinel* in his journals and lectures. The notion of the strong guardian figure ready to do battle was ever present for Lipton. He described it at the time of its completion:

> *The sense of a powerful guardian figure—an aspect of hero involvement—suggested the name* Sentinel. *The "name" I usually look for is suggested by the central presence of the work as I feel it within me; both to serve my own sense of identification and to help analyze attention to the viewer into this central vortex of experience.*[1]

This work derives from the history and tradition of Lipton's previous sculptures. Albert Elsen described the great importance of this sculpture:

> *Not only is* Sentinel *unsurpassed in American figural sculpture; it ranks with the best works of modern sculpture, indeed in the history of art. It contradicts the dogma . . . that inspiration from sources outside art, or nonsculptural references, inhibit formal excellence and true self-expression.* Sentinel *successfully challenges the pessimism of the dictum that the modern sculptor cannot say something meaningful about mankind without betraying the highest abstract formal demands.*[2]

For Lipton, *Sentinel* provided the "Hero" series with a strong work that demonstrated that captivating formal successes can be based on sources outside of the art world. This work remains a mainstay in the canon of postwar sculpture.

1. Lipton statement in Ritchie and Neilson, *Selected Painting and Sculpture from the Yale University Art Gallery,* 135.
2. Elsen, *Seymour Lipton,* 53.

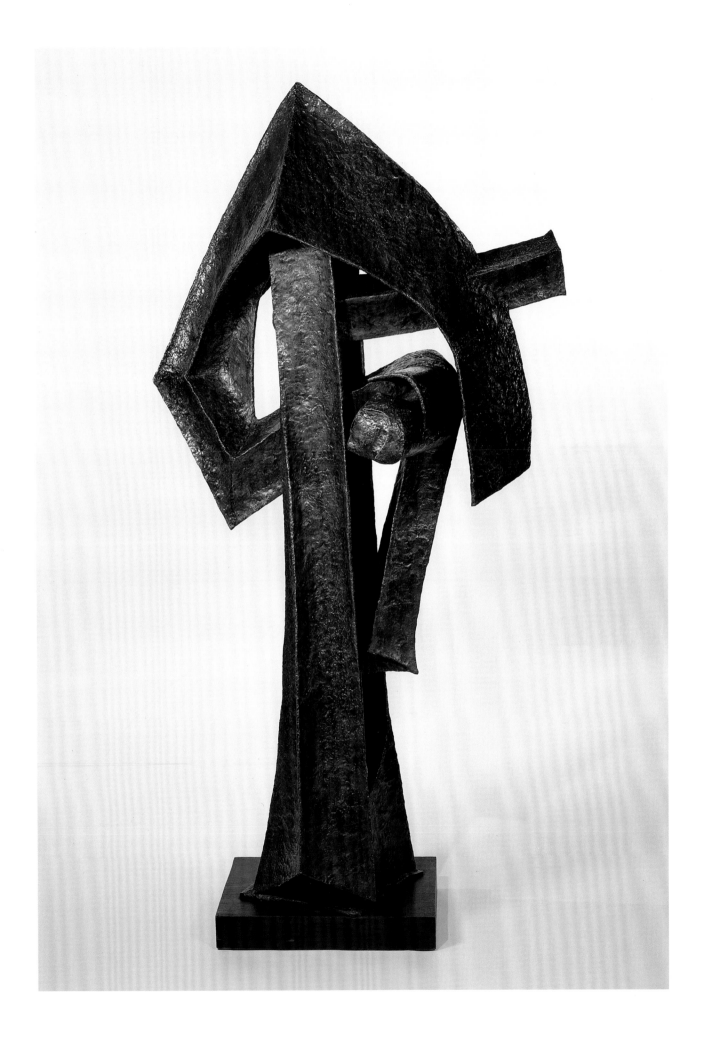

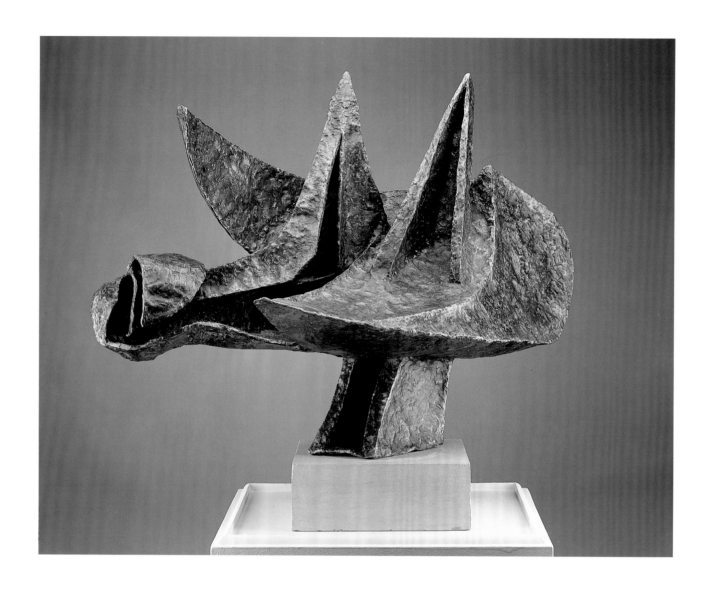

25. Arctic Bird

1960
Nickel silver on Monel metal
23½ × 33 × 20 in. (59.7 × 83.9 × 50.9 cm)
Collection of James R. and Barbara R. Palmer

The graceful and voluminous structure of *Arctic Bird* projects a sense of movement. Comprised of two vertical, inverted *V*-shaped wings, a small rounded head, and larger but similarly rounded back end, the sculpture has an overall simple flowing form from the horizontal front tip of the head to the tail. This sculpture conveys the simultaneous ability of birds to take flight and to remain grounded. It seems to be moving through space, but the strong, firm base—the bird's legs—creates the impression that it is standing still at the same time.

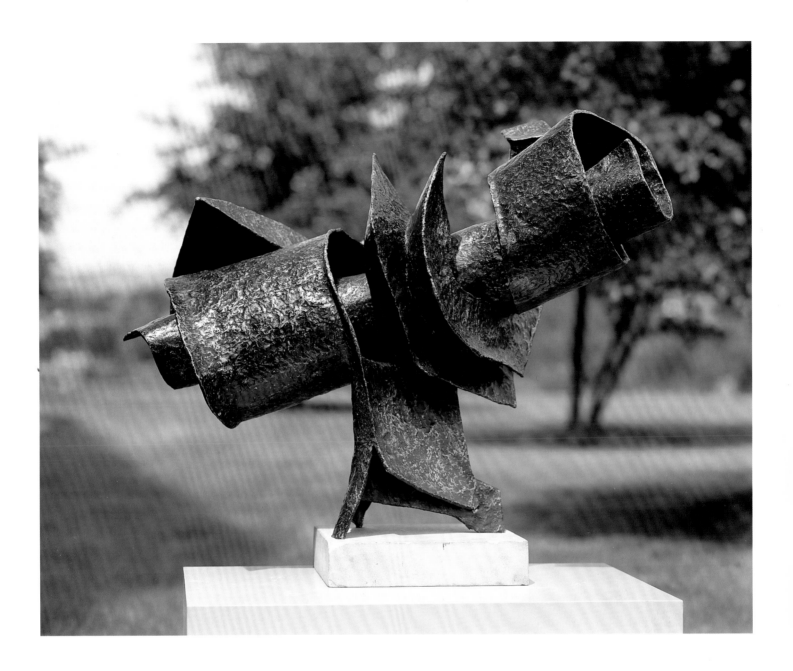

26. Scroll
1960
Nickel silver on Monel metal
29½ × 43 × 19 in. (75.0 × 109.2 × 48.3 cm)
Collection of James R. and Barbara R. Palmer

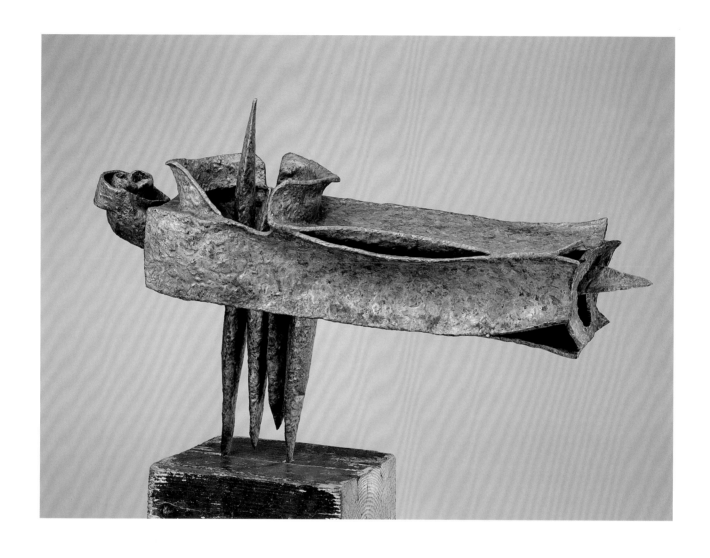

27. Séance
1961
Bronze on Monel metal
35 in. long (89.1 cm)
Estate of the artist, New York

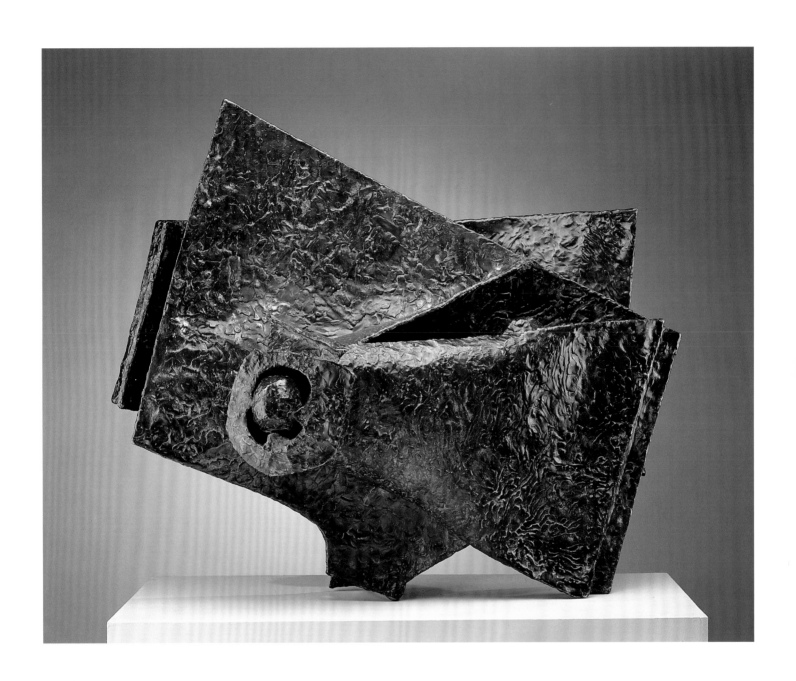

28. Labyrinth
1964
Nickel silver on Monel metal
37 × 44 × 27 in. (153.3 × 213.7 × 94.2 cm)
Collection of James R. and Barbara R. Palmer

29. Loom
1965
Nickel silver on Monel metal
70 in. high (177.8 cm)
Estate of the artist, New York

Lipton's mastery of constructed metal is evident in the lyrical and curvilinear forms of *Loom*. Referring to the grand object pieces of his mature career, it integrates the vertical forms of the "Hero" sculptures with the pods and interior plant forms of the "Bloom" series.

Loom demonstrates Lipton's expert ability to braze a uniform texture onto the sculpture's surface. Additionally, his interest in polarities is apparent in the play of negative and positive space, interior and exterior surface. The overlapping and interlacing qualities are familiar as they recall stylistic elements of his earlier works and simultaneously preface many of the striking pieces of his late career.

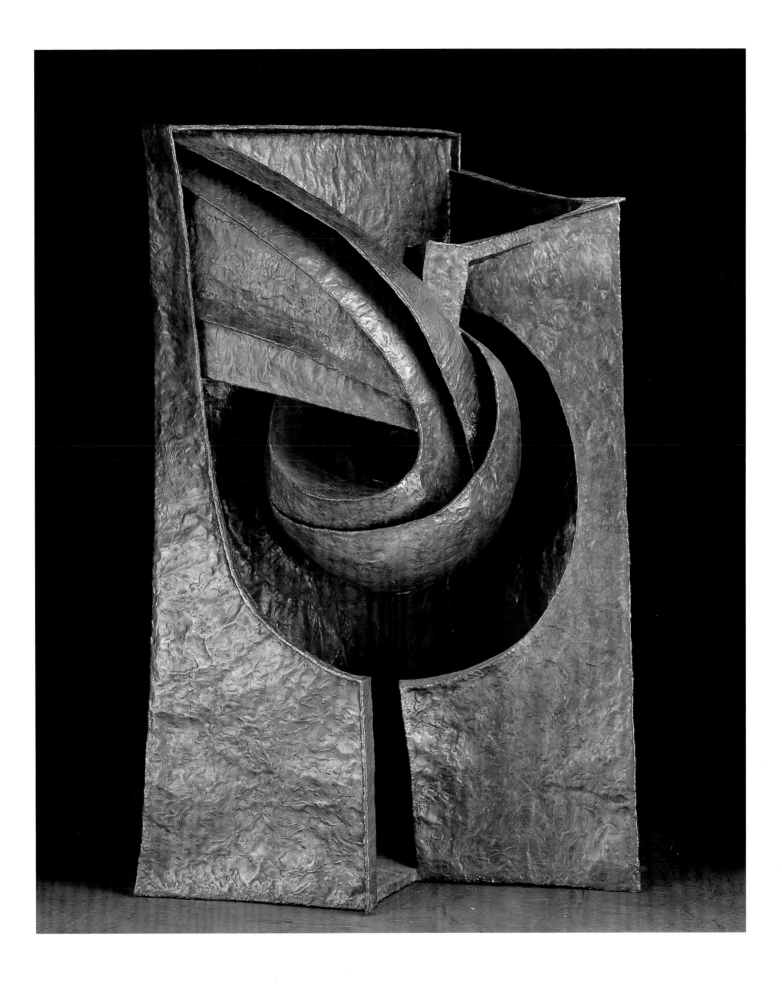

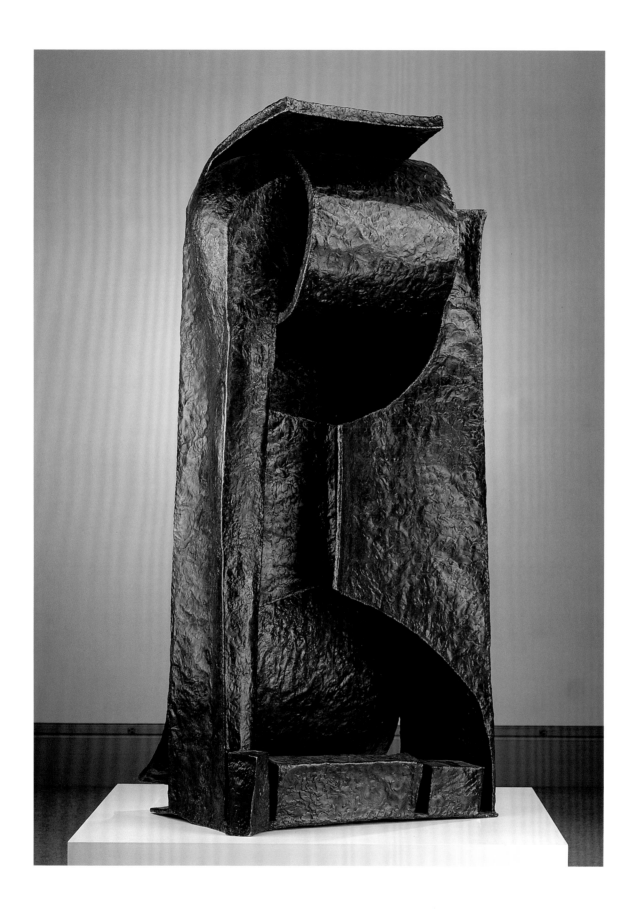

30. Inquisitor
1965
Nickel silver on Monel metal
81¼ × 35 × 35½ in. (206.4 × 88.9 × 90.2 cm)
Collection of James R. and Barbara R. Palmer

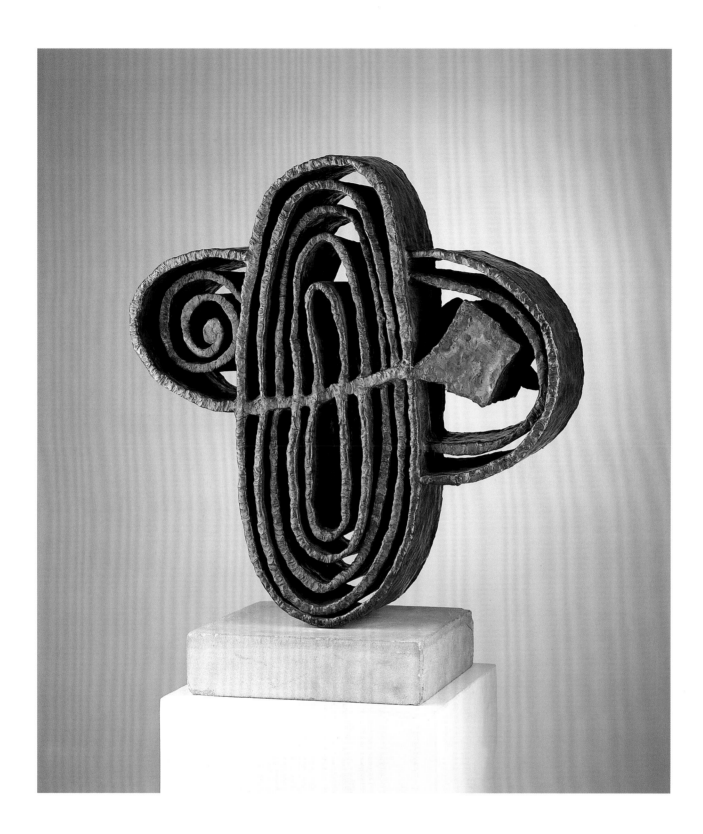

31. Brain of a Poet
1966
Bronze on Monel metal
23⁵⁄₁₆ × 22³⁄₈ × 8¼ in. (59.2 × 56.9 × 21 cm)
Estate of the artist, New York

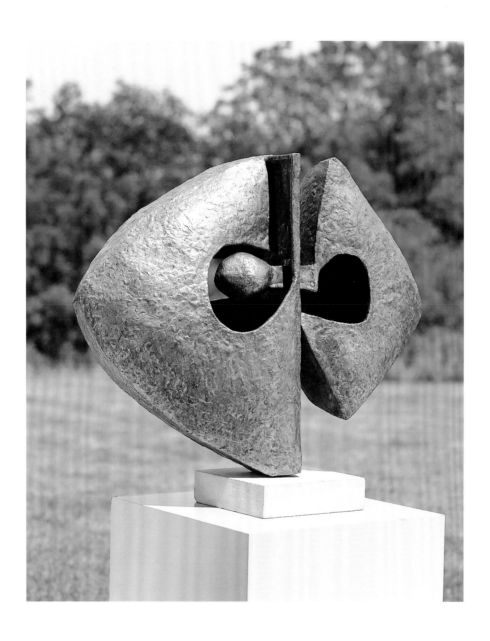

32. Winterseed
1968–74
Nickel silver on Monel metal
30 × 36 × 11 in. (76.3 × 91.4 × 27.9 cm)
Collection of James R. and Barbara R. Palmer

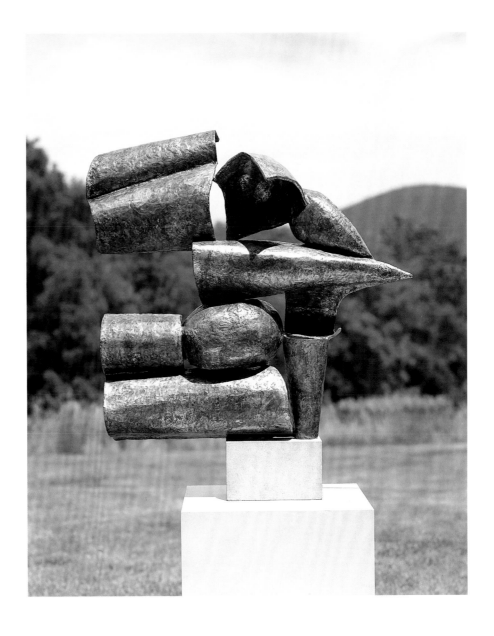

33. Bird

1975
Nickel silver on Monel metal
39 × 39 × 11 in. (99.1 × 99.1 × 27.9 cm)
Collection of James R. and Barbara R. Palmer

Bird is a work that projects the essence of flight. Lipton described the process of creating the sculpture:

> *I started to make this thing and I found it very dull to make these little compartments, one next to each other. It suddenly occurred to me, why not simplify it, just make a few, and use a basic thematic unit. I played around with it. With the beak vertical it looks static, so I turned it over on the side; as soon as I turned it over on its side I made it an elongated split-pipe form. I immediately had a sense of flight. . . .*[1]

Its streamlined and abstracted forms project the airiness and speed of a bird in flight. And the direct approach of welding and constructing metal give it a modern angularity and aesthetic. Lipton's "little compartments" remain individual units yet work in unison, as the small shapes are constructed to create the sculpture's form. The cumulative construction relates it to assemblage works of the postwar period.

1. Lipton quoted in Rand, "Notes and Conversations," 67.

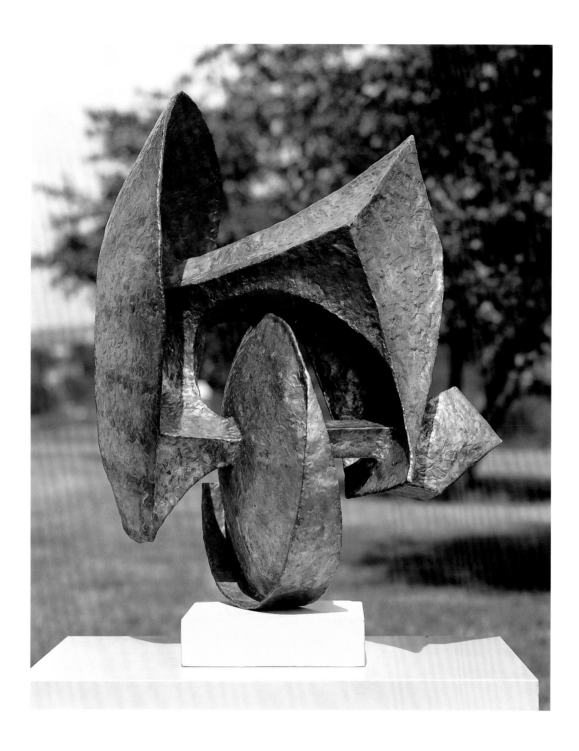

34. Thorn Mill

1975
Bronze on Monel metal
35 × 28 × 19 in. (89.0 × 71.2 × 48.3 cm)
Collection of James R. and Barbara R. Palmer

In the mid-1970s, Lipton revisited themes including those related to the war: "Those horror heads of the 1940s like *Moloch* and *Moby Dick* started an underlying idea of the killer or predator and rebirth from the 1950s to 1986 (as late as the 1980s), with works like *Scream.*"[1] *Thorn Mill* and related works such as *Apocalypse* and *Scream* demonstrate Lipton's working through one of the greatest fears of his time: the threat of the machine gone out of control.[2] These pieces derive from the fright surrounding technological advances such as the production of fighter planes and the testing of the atomic bomb.

1. Polcari, interview by author.
2. Harry Rand, *Seymour Lipton: Aspects of Sculpture*, 58–59.

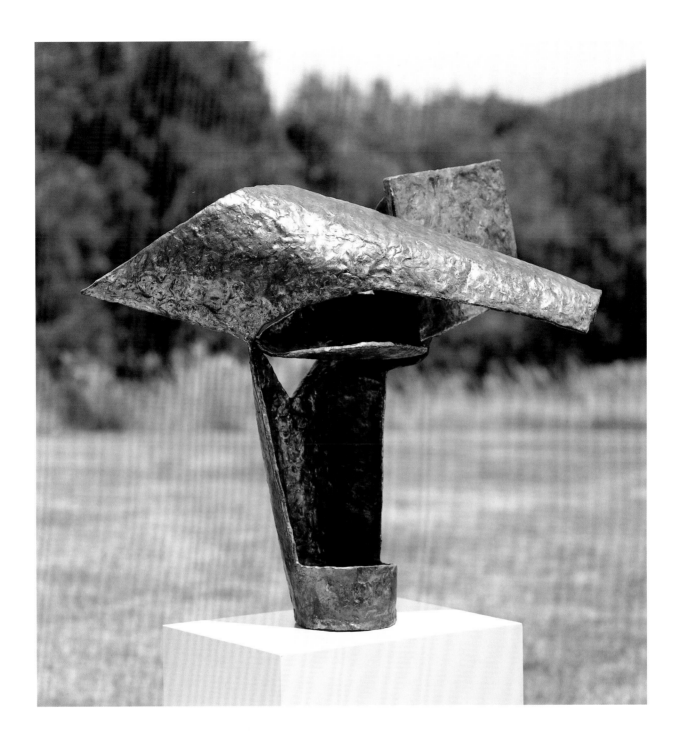

35. Icarus
1983
Nickel silver on Monel metal
34 × 36½ × 15 in. (86.4 × 92.6 × 38.1 cm)
Collection of James R. and Barbara R. Palmer

Lipton's interest in flight and mythology are both addressed in this late work. The story of Icarus—the boy whose wax wings melted as he flew too close to the sun—is the subject impetus for the work. *Icarus* demonstrates the sculptor's dedication to earlier themes such as avian imagery and mythology. Here, Lipton treats these themes in a straightforward manner by creating a fusion between myth and flight.

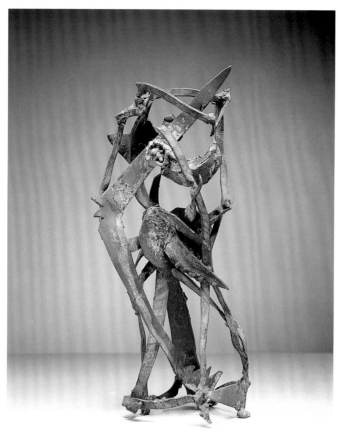

36. Maquette: Imprisoned Figure
1948
Lead
9½ × 3¾ × 5⅛ in. (24.3 × 9.7 × 13.2 cm)
Collection of James R. and Barbara R. Palmer

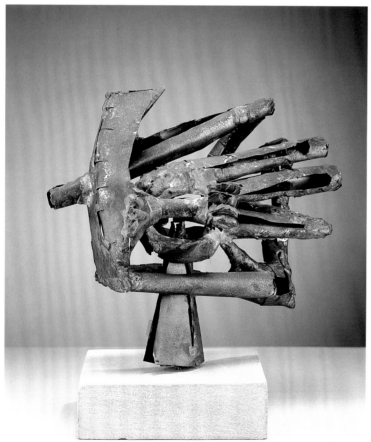

37. Maquette: Gauntlet
1959
Monel metal
8⅝ × 9⅝ × 8½ in. (22.1 × 24.6 × 21.8 cm)
Collection of James R. and Barbara R. Palmer

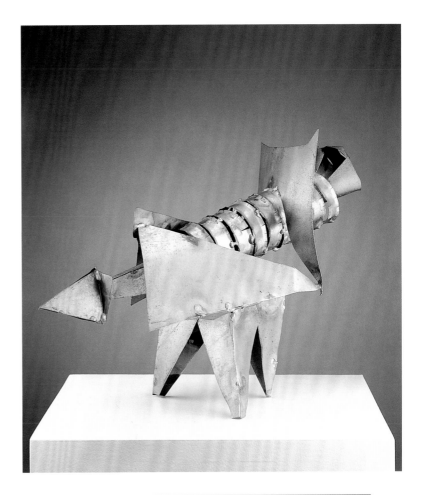

38. Maquette: Argonaut
1960
Monel metal
10½ × 15½ × 6⅞ in. (26.8 × 39.5 × 17.6 cm)
Collection of James R. and Barbara R. Palmer

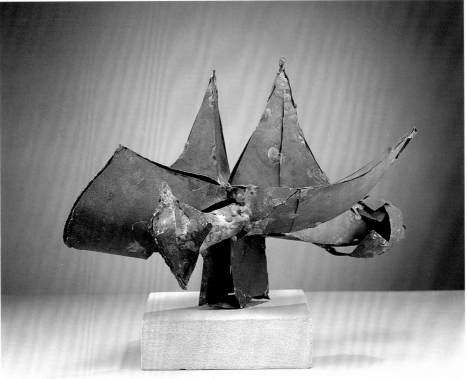

39. Maquette: Arctic Bird
1960
Monel metal
8¾ × 13 × 7⅞ in. (22.4 × 33.2 × 20.2 cm)
Collection of James R. and Barbara R. Palmer

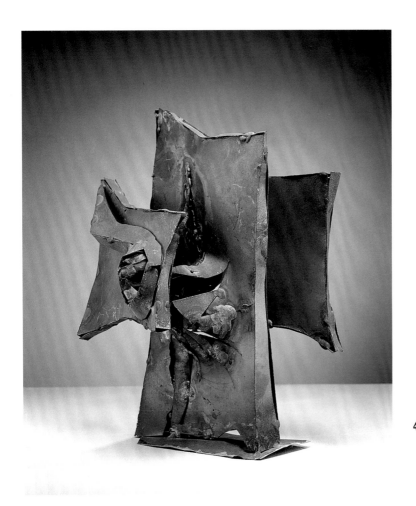

40. Maquette: Codex I
1961
Monel metal
12¼ × 10 × 7½ in. (31.3 × 25.6 × 19.2 cm)
Collection of James R. and Barbara R. Palmer

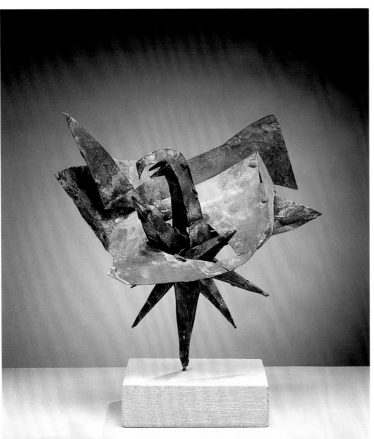

41. Maquette: Eagle
1961
Monel metal
11 × 11¼ × 5⅜ in. (28.2 × 28.8 × 13.8 cm)
Collection of James R. and Barbara R. Palmer

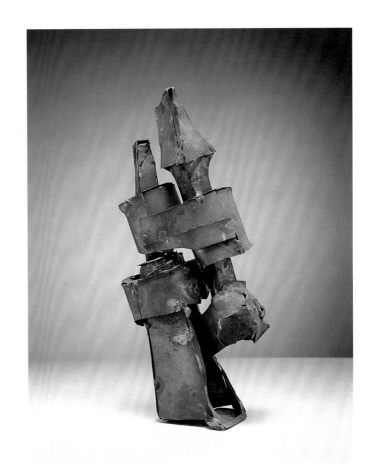

42. Maquette: Jouster
1961
Monel metal
12⅞ × 6 × 3⅛ in. (32.9 × 15.4 × 8.0 cm)
Collection of James R. and Barbara R. Palmer

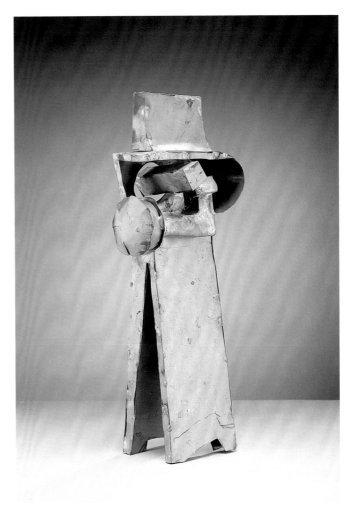

43. Maquette: Defender
1962
Monel metal
14½ × 5¾ × 4⅛ in. (37.0 × 14.7 × 10.6 cm)
Collection of James R. and Barbara R. Palmer

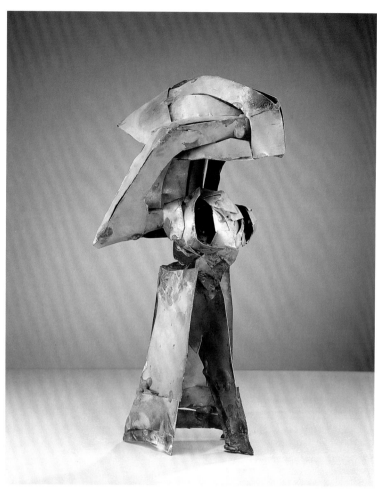

44. Maquette: Explorer
1963
Monel metal
12 × 6⅝ × 4⅜ in. (30.7 × 17.0 × 11.3 cm)
Collection of James R. and Barbara R. Palmer

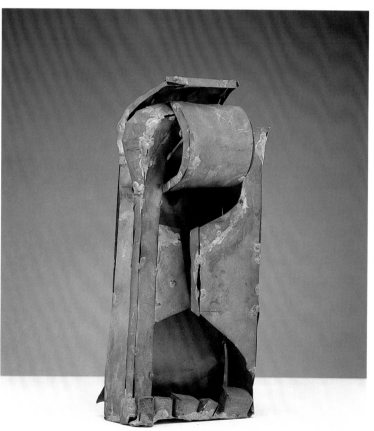

45. Maquette: Inquisitor
1965
Monel metal
11¾ × 5½ × 3⅛ in. (30.0 × 14.1 × 8.1 cm)
Collection of James R. and Barbara R. Palmer

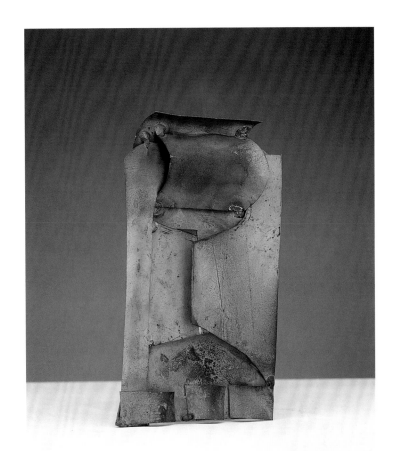

46. Maquette: Inquisitor
1965
Monel metal
7 × 4½ × ½ in. (17.9 × 11.6 × 1.4 cm)
Collection of James R. and Barbara R. Palmer

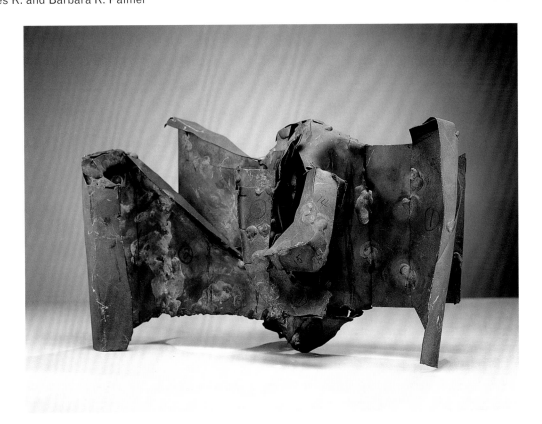

47. Maquette: Trap
1967
Monel metal
7⅝ × 13⅛ × 5⅞ in. (19.5 × 33.5 × 15.1 cm)
Collection of James R. and Barbara R. Palmer

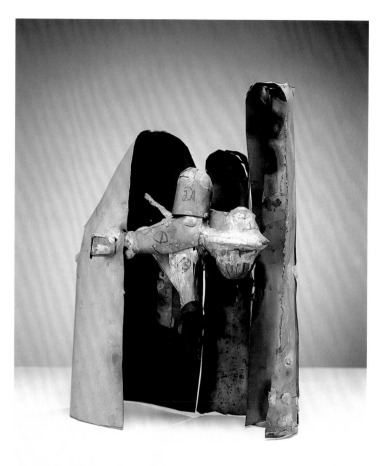

48. Maquette: Catacombs
1968
Monel metal
12¼ × 9¾ × 5 in. (31.3 × 24.9 × 12.8 cm)
Collection of James R. and Barbara R. Palmer

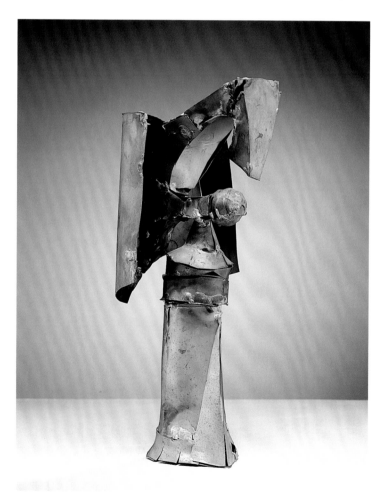

49. Maquette: Angel
1975
Monel metal
13⅞ × 6⅜ × 5¾ in. (35.4 × 16.3 × 14.7 cm)
Collection of James R. and Barbara R. Palmer

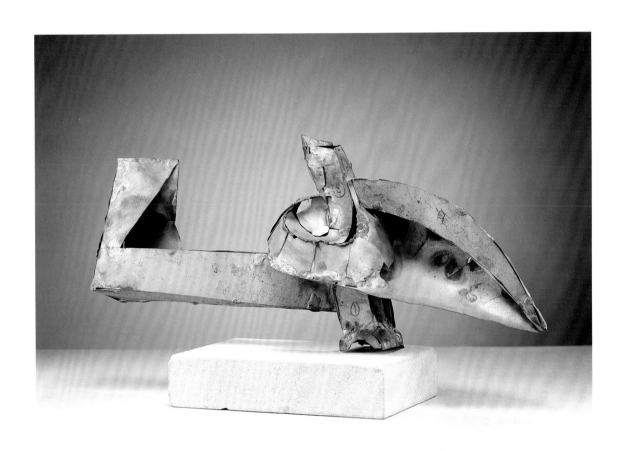

50. Maquette: Adventurer
1977
Monel metal
7 × 15 × 4⅛ in. (17.9 × 38.3 × 10.6 cm)
Collection of James R. and Barbara R. Palmer

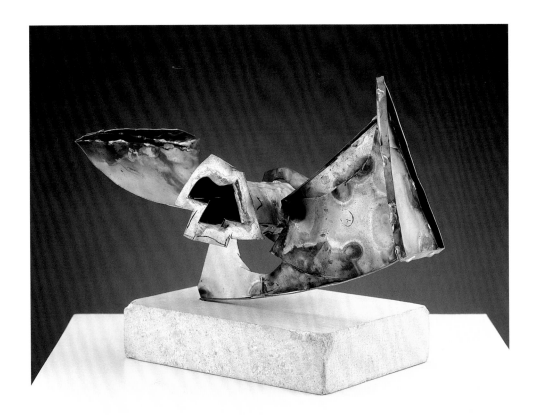

51. Maquette: Flying Dutchman
1985
Monel metal
7 × 9½ × 5⅛ in. (17.9 × 24.3 × 13.2 cm)
Collection of James R. and Barbara R. Palmer

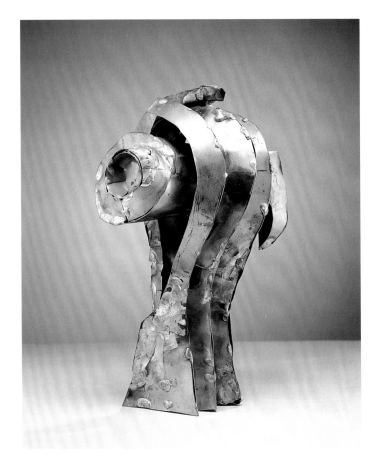

52. Maquette: Bond
1986
Monel metal
10 × 6 × 5⅛ in. (25.6 × 15.4 × 13.2 cm)
Collection of James R. and Barbara R. Palmer

53. Untitled drawing (possible study for
Prehistoric Bird)
ca. 1945
Black ink
11¹³⁄₁₆ × 8⅞ in. (30.0 × 22.5 cm)
Unsigned
Collection of James R. and Barbara R. Palmer

54. Untitled drawing (possibly related to
Diadem)
ca. 1945
Black ink and graphite
11 × 8⅞ in. (27.9 × 22.5 cm)
Unsigned
Collection of James R. and Barbara R. Palmer

55. Study for Argosy
ca. 1946
Black ink
8¹³⁄₁₆ × 11¹³⁄₁₆ in. (22.4 × 30.0 cm)
Unsigned
Collection of James R. and Barbara R. Palmer

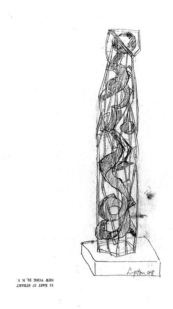

12 EAST 57 STREET
NEW YORK 22, N. Y.

PLAZA 3-3456

MODERN PAINTINGS
BETTY PARSONS GALLERY

56. Study for Prisoner
1948
Pencil
11 × 8½ in. (27.9 × 21.6 cm)
Signed lower center: "Lipton 48"
Collection of James R. and Barbara R. Palmer

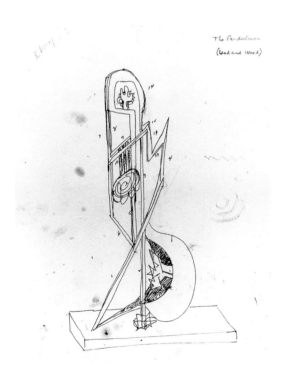

57. Study for Pendulum
ca. 1949
Black ink and pencil
11¹⁄₁₆ × 8½ in. (28.3 × 21.6 cm)
Unsigned
Collection of James R. and Barbara R. Palmer

58. Untitled drawing
ca. 1940s
Black ink
11 × 8½ in. (27.9 × 21.6 cm)
Unsigned
Palmer Museum of Art
Gift of Alan and Michael Lipton

7/20/51

59. Drawing after Predator
1950
Black ink
12¼ × 9⁵⁄₁₆ in. (31.1 × 23.7 cm)
Signed lower right: "Lipton '50"
Collection of James R. and Barbara R. Palmer

60. Study for Sargasso
1951
Pencil
11 × 8½ in. (27.9 × 21.6 cm)
Dated upper right: "7/20/51"
Collection of James R. and Barbara R. Palmer

61. Study for Sargasso
ca. 1951
Black ink and pencil
8⁹⁄₁₆ × 11 in. (21.7 × 27.9 cm)
Unsigned
Collection of James R. and Barbara R. Palmer

62. Study for Sanctuary
1951
Pencil
10¹⁵⁄₁₆ × 8½ in. (27.8 × 21.6 cm)
Signed lower right: "Lipton 51"
Collection of James R. and Barbara R. Palmer

63. Study for Sanctuary
1953
Pencil
10¹⁵⁄₁₆ × 8½ in. (27.8 × 21.6 cm)
Signed lower right: "Lipton 53"
Collection of James R. and Barbara R. Palmer

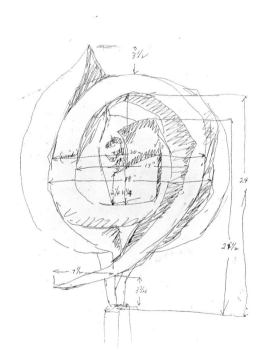

64. Study for Sanctuary
ca. 1953
Black ink
10¹⁵⁄₁₆ × 8½ in. (27.8 × 21.6 cm)
Unsigned
Collection of James R. and Barbara R. Palmer

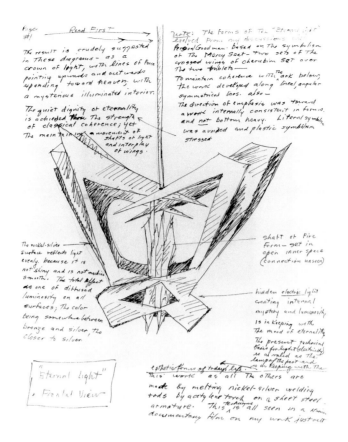

65. Study for Eternal Light
1953
Black ink and pencil
13¾ × 10¹⁵⁄₁₆ in. (34.9 × 27.8 cm)
Unsigned
Collection of James R. and Barbara R. Palmer

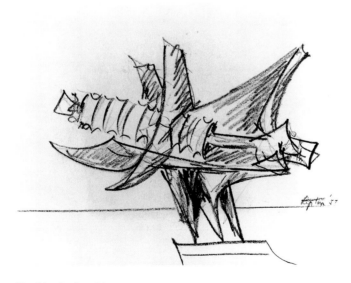

66. Study for Glowworm
1957
Black conté crayon
8⅞ × 11 in. (21.4 × 27.9 cm)
Signed lower right: "Lipton '57"
Collection of James R. and Barbara R. Palmer

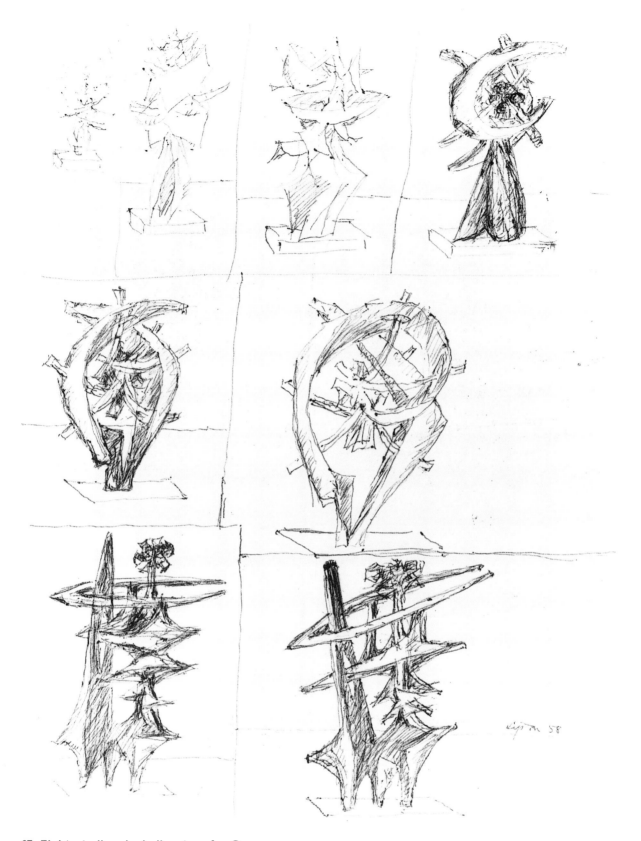

67. Eight studies, including two for Sorcerer
1958
Blue ballpoint pen
11 × 8½ in. (27.9 × 21.6 cm)
Signed lower right: "Lipton 58"
Collection of James R. and Barbara R. Palmer

68. Untitled drawing (related to **Sentinel**)
1958
Black conté crayon
10¹⁵⁄₁₆ × 8½ in. (27.8 × 21.6 cm)
Signed lower right: "Lipton 58"
Palmer Museum of Art
Gift of Alan and Michael Lipton

69. Study for Prophet
1959
Black conté crayon
11 × 8½ in. (27.9 × 21.6 cm)
Signed lower left: "Lipton 59"
Collection of James R. and Barbara R. Palmer

70. Untitled drawing (related to **Manuscript**)
1960
Black conté crayon
8⁷⁄₁₆ × 11 in. (21.5 × 27.9 cm)
Signed lower right: "Lipton 60"
Palmer Museum of Art
Gift of Alan and Michael Lipton

71. Study for Manuscript
1961
Black conté crayon
8½ × 10¹⁵⁄₁₆ in. (21.6 × 27.8 cm)
Signed lower left: "Lipton 61"
Collection of James R. and Barbara R. Palmer

72. Drawing after Argonaut
1961
Black conté crayon
8½ × 11 in. (21.6 × 27.9 cm)
Unsigned
Collection of James R. and Barbara R. Palmer

73. Study for Chinese Bird
1961
Black conté crayon
8⁹⁄₁₆ × 11 in. (21.8 × 27.9 cm)
Signed lower left: "Lipton 61"
Collection of James R. and Barbara R. Palmer

74. Study for Chinese Bird
1962
Black conté crayon
8⁹⁄₁₆ × 11¹⁄₁₆ in. (21.8 × 28.1 cm)
Signed center right: "Lipton 62"
Collection of James R. and Barbara R. Palmer

75. Study for Earth Bell
1961
Black conté crayon
11 × 8½ in. (27.9 × 21.6 cm)
Signed center right: "Lipton 61"
Collection of James R. and Barbara R. Palmer

76. Study for Earth Bell
1962
Black conté crayon
11 × 8½ in. (27.9 × 21.6 cm)
Signed lower right: "Lipton 62"
Collection of James R. and Barbara R. Palmer

77. Study for Altar
1963
Black conté crayon
8½ × 11 in. (21.6 × 27.9 cm)
Signed lower left: "Lipton 63"
Collection of James R. and Barbara R. Palmer

78. Study for Inquisitor
1965
Black conté crayon
11 × 8½ in. (27.9 × 21.6 cm)
Signed lower right: "Lipton '65"
Collection of James R. and Barbara R. Palmer

79. Untitled drawing
1968
Black conté crayon
8½ × 11 in. (21.6 × 27.9 cm)
Signed center left: "Lipton 68"
Collection of James R. and Barbara R. Palmer

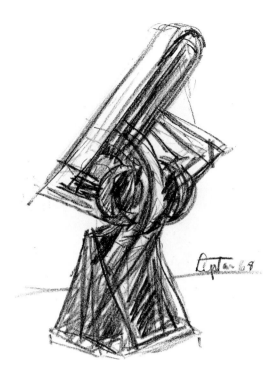

80. Study for Laureate
1968
Black conté crayon
11 × 8⁹⁄₁₆ in. (27.9 × 21.7 cm)
Signed lower right: "Lipton 68"
Collection of James R. and Barbara R. Palmer

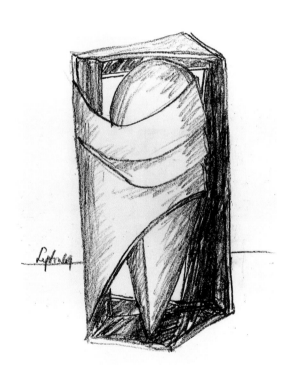

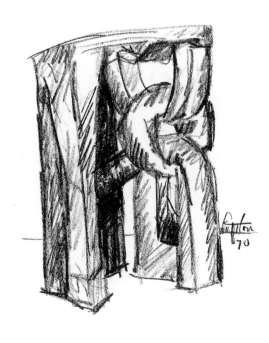

81. Drawing after Returning
1969
Black conté crayon
11 × 8½ in. (27.9 × 21.6 cm)
Signed lower left: "Lipton 69"
Palmer Museum of Art
Gift of Alan and Michael Lipton

82. Untitled drawing
1970
Black conté crayon
11 × 8½ in. (27.9 × 21.6 cm)
Signed lower right: "Lipton 70"
Collection of James R. and Barbara R. Palmer

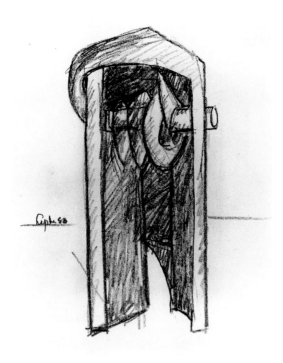

83. Untitled drawing (related to **Threshold**)
1983
Black conté crayon
11 × 8½ in. (27.9 × 21.6 cm)
Signed lower left: "Lipton 83"
Collection of James R. and Barbara R. Palmer

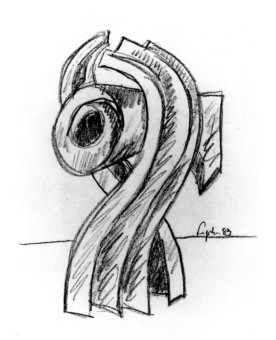

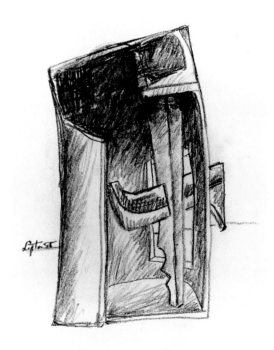

84. Study for Bond
1983
Black conté crayon
11 × 8½ in. (27.9 × 21.6 cm)
Signed lower right: "Lipton 83"
Collection of James R. and Barbara R. Palmer

85. Untitled drawing
1985
Black conté crayon
11 × 8½ in. (27.9 × 21.6 cm)
Signed lower left: "Lipton 85"
Collection of James R. and Barbara R. Palmer

BIBLIOGRAPHY

Books

Anderson, Wayne. *American Sculpture in Process: 1930/1970.* Boston: New York Graphic Society, 1975.

Burnham, Jack. *Beyond Modern Sculpture: The Effects of Science and Technology on the Sculpture of This Century.* New York: George Braziller, 1968.

Campbell, Joseph. *The Hero with a Thousand Faces.* Princeton: Princeton University Press, 1949.

Douglas, Frederic H. and René D'Harnoncourt. *American Indian Art.* New York: The Museum of Modern Art, 1941.

Elsen, Albert. *Seymour Lipton.* New York: Harry N. Abrams, Inc., 1970.

Giedion-Welcker, Carola. *Contemporary Sculpture: An Evolution in Volume and Space.* New York: G. Wittenborn, 1955.

Goldwater, Robert. *Primitivism in Modern Art.* New York: Belknap Press, 1938.

Gruen, John. *The Party's Over Now: Reminiscences of the Fifties—New York's Artists, Writers, Musicians, and their Friends.* New York: The Viking Press, 1967.

Guilbaut, Serge. *How New York Stole the Idea of Modern Art.* Chicago and London: University of Chicago Press, 1983.

Halberstam, David. *The Fifties.* New York: Villard Books, 1993.

Krauss, Rosalind. *Passages in Modern Sculpture.* New York: The Viking Press, 1977.

Mackie, Alwynne. *Art/Talk: Theory and Practice in Abstract Expressionism.* New York: Columbia University Press, 1989.

Marter, Joan. *Theodore Roszak: The Drawings.* Seattle: The University of Washington Press, 1992.

Norman, Dorothy. *The Hero: Myth/Image/Symbol.* New York: World Publishing Company, 1969.

Polcari, Stephen. *Abstract Expressionism and the Modern Experience.* New York: Cambridge University Press, 1991.

Rashell, Jacob. *Jewish Artists in America.* New York: Vantage Press, 1967.

Read, Herbert. *Modern Sculpture.* London: Thames and Hudson, 1964.

Rice, Pierce. *Man as Hero: The Human Figure in Western Art.* New York: W. W. Norton & Co., 1987.

Spengler, Oswald. *The Decline of the West.* New York: Alfred A. Knopf, 1932.

Exhibition Catalogues

Albany Institute of History and Art. *Art in Science.* Albany, New York: September 1965.

Albright-Knox Art Gallery. *Abstract Expressionism: The Critical Developments.* Buffalo, New York: September 19–November 29, 1987.

Babcock Galleries. *Seymour Lipton: The First Decade.* New York City: May 20–June 25, 1993.

Babcock Galleries. *Seymour Lipton: Major Late Sculpture.* New York City: October 29–December 22, 1991. Essay by Sam Hunter.

Battersea Park. *Sculpture in the Open Air.* London: May–September 1963.

Buchholz Gallery. *American Sculpture of Our Time.* New York City: January 5–23, 1943.

Maxwell Davidson Gallery. *Seymour Lipton: Sculptures, Maquettes and Drawings.* New York City: April 11–May 13, 1995.

Sid Deutsch Gallery. *Seymour Lipton Drawings.* New York City: April 26–May 21, 1986.

The Solomon R. Guggenheim Museum. *American Abstract Expressionists and Imagists.* New York City: October–December 1961.

The Solomon R. Guggenheim Museum. *American Drawings.* New York City: September 17–October 28, 1964.

Hillwood Art Gallery. *Seymour Lipton: Sculpture.* Greenvale, New York: December 12, 1984–February 1,1985.

Hodges/Taylor Gallery. *Seymour Lipton Drawings/Small Sculpture.* Charlotte, North Carolina: October 4–29, 1962.

The Jewish Museum. *Seymour Lipton Retrospective: Drawings and Sculpture.* New York City: November 1979–January 1980.

Herbert F. Johnson Museum of Art, Cornell University. *Seymour Lipton: Recent Sculpture 1964–73.* Ithaca, New York: 1973.

Lowe Gallery, Hofstra University. *The Coming of Age of American Sculpture: The First Decades of the Sculptors Guild: 1930s–1950s.* Hempstead, New York: February 3–March 18, 1990.

Lowe Gallery, Hofstra University. *Jung and Abstract Expressionism: The Collective Image Among Individual Voices.* Hempstead, New York: November 2–December 14, 1986. Essay by Terree Grabenhorst Randall.

Lowe Gallery, Hofstra University. *Seymour Lipton: A Retrospective.* Hempstead, New York: August 30–October 9, 1988.

Marlborough Gallery. *Seymour Lipton: Recent Works.* New York City: March 1971.

Marlborough Gallery. *Seymour Lipton.* New York City: 1974.

Marlborough Gallery. *Seymour Lipton: Recent Works.* New York City: January 31–February 21, 1976.

Marlborough-Gerson Gallery. *Seymour Lipton.* New York City: March 1965. Essay by Sam Hunter.

Milwaukee Art Center. *Decade of Recent Work: Creative Process.* Milwaukee, Wisconsin: September 14–October 26, 1969.

The Mint Museum of Art. *Seymour Lipton Sculpture.* Charlotte, North Carolina: October 3, 1982–January 2, 1983. Essay by Sam Hunter.

Munson-Williams-Proctor Institute. *Six Sculptors.* Utica, New York: January 7–29, 1951.

The Museum of Modern Art. *Abstract Painting and Sculpture in America.* New York City: January 23–March 25, 1951. Essay by Andrew Carnduff Ritchie.

The Museum of Modern Art. *12 Americans.* New York City: May 29–September 9, 1956. Essay by Dorothy C. Miller. Comments by Seymour Lipton.

The Museum of Modern Art. *The United States Pavilion—Lipton, Rothko, Smith, Tobey: XXIX Biennale Venezia.* New York City: 1958. Essay by Frank O'Hara.

The Museum of Modern Art. *Dada, Surrealism and Their Heritage.* New York City: March 27–June 9, 1968. Essay by William Rubin.

The Museum of Modern Art. *American Art Since 1945 from the Collection of the Museum of Modern Art.* New York City: 1975. Essay by Alicia Legg.

National Collection of Fine Arts, Smithsonian Institution. *Seymour Lipton: Aspects of Sculpture.* Washington, D.C.: March 16–May 6, 1979. Essay by Harry Rand.

Betty Parsons Gallery. *New Sculpture.* New York City: June 3–21, 1947.

Betty Parsons Gallery. *Seymour Lipton.* New York City: April 19–May 8, 1948.

Betty Parsons Gallery. *Seymour Lipton.* New York City: October 17–November 4, 1950.

Betty Parsons Gallery. *Ten Years.* New York City: December 19, 1950–January 14, 1951.

Betty Parsons Gallery. *Seymour Lipton.* New York City: October 1952.

Betty Parsons Gallery. *Seymour Lipton.* New York City: November 8–27, 1954.

The Phillips Collection. *Seymour Lipton: A Loan Exhibition.* Washington, D.C.: January 12–February 24, 1964.

Providence Art Club. *Critics' Choice—Art Since World War II.* Providence, Rhode Island: March 31–April 24, 1965.

Puma Gallery. *We Challenge War Art.* New York City: November 15–December 4, 1943.

Rutgers University Art Gallery. *Vanguard American Sculpture: 1913–1939.* New Brunswick, New Jersey: September 16–November 4, 1979.

Sarah Lawrence College Art Gallery. *Sculptural Expressions: Seven Artists in Metal and Drawing 1947–1960.* Bronxville, New York: October 8–November 17, 1985.

The Sculpture Center. *Exhibition: Welded Sculpture.* New York City: October 6–31, 1952.

Tampa Museum of Art. *Between Transcendence and Brutality: American Sculptural Drawings from the 1940s and 1950s.* Tampa, Florida: January 30–April 3, 1994. Essay by Douglas Dreishpoon.

The University of Illinois. *Contemporary American Painting and Sculpture.* Urbana-Champaign: February 27–April 3, 1955.

The University of Illinois. *Contemporary Painting and Sculpture.* Urbana-Champaign: Spring 1963.

The University of Minnesota Art Gallery. *A Selection of Contemporary American Sculpture.* Minneapolis: September 30–November 4, 1955.

Whitney Museum of American Art. *1951 Sculpture Annual Exhibit.* New York City: 1951.

Whitney Museum of American Art. *The New Decade—35 American Painters and Sculptors.* New York City: 1955. Dorothy C. Miller, ed.

Whitney Museum of American Art. *Nature in Abstraction: The Relation of Abstract Painting and Sculpture to Nature in 20th Century American Art.* New York City: January 1958–February 1959. Essay by John I. H. Baur.

Whitney Museum of American Art. *Eighteen Living American Artists Selected by the Friends of the Museum.* New York City: March 5–April 12, 1959.

Whitney Museum of American Art. *The Third Dimension: Sculpture of the New York School.* New York City: December 1984. Essay by Lisa Phillips.

Periodicals

Anderson, Wayne. "American Sculpture: The Situation in the Fifties." *Art Forum* 5 (Summer 1967): 60–67.

"The Art Galleries—The Grand Tour." *The New Yorker* 30 (May 28, 1955): 10.

Atkinson, Tracy. "Lipton's Recent Sculpture." *Art International* 20 (January/February 1976): 36–41.

Chaet, Bernard. "Direct Metal Sculpture: Interview with Seymour Lipton." *Arts* 32 (April 1958): 66.

Elsen, Albert. "Lipton's Sculpture as a Portrait of the Artist." *Art Journal* 24 (Winter 1964–65): 113–18.

———. "The Sculptural World of Seymour Lipton." *Art International* 9 (February 1965): 12–16.

———. "Seymour Lipton: Odyssey of the Unquiet Metaphor." *Art International* 5 (February 1961): 38–44.

———. "Seymour Lipton's *Sea King.*" *Buffalo Fine Arts Academy Gallery Notes* 24 (Summer 1961): 5–7.

"Exhibition at Marlborough-Gerson Gallery." *Art News* 64 (May 1965): 13.

Firestone, Evan R. "Herman Melville's *Moby Dick* and the Abstract Expressionists." *Arts* 54 (March 1980): 120–24.

Fitzsimmons, James. "Lipton on a Mythical Level." *Art Digest* 27 (October 15, 1952): 14.

"Fortnight in Review: Seymour Lipton." *Arts Digest* 29 (November 15, 1954): 25.

Getlein, Frank. "The Seriousness of Lipton." *The New Republic* (April 10, 1965): 24–27.

Goodnough, Robert. "Reviews and Previews." *Art News* 49 (October 1950): 49.

Guest, Barbara. "Reviews and Previews: Seymour Lipton." *Art News* 51 (November 1952): 47.

Hunter, Sam. "Seymour Lipton." *Kunstwerk* 20 (December 1966): 35–44.

"In the Galleries: Seymour Lipton." *Arts* 35 (May–June 1961): 86.

Kaufmann, Edgar. "The Inland Steel Building and Its Art." *Art In America* 45 (Winter 1957–58): 23–27.

Krasne, Belle, "Lipton Metals." *Art Digest* 25 (November 1, 1950): 17.

Kroll, Jack. "Reviews and Previews: Seymour Lipton." *Art News* 60 (April 1961): 11–12.

Kuh, Katherine. "Metaphor in Metal." *Saturday Review* (February 19, 1964): 24–25.

Lassaw, Ibram. "Waldorf Sculpture Panel." *It Is: A Magazine for Abstract Art* 2 (February 17, 1965): 64.

Lipton, Seymour. "Experience and Sculptural Form." *College Art Journal* 9 (Autumn 1949): 52–54.

———. "Extracts from a Notebook." *Arts Magazine* 45 (March 1971): 34–36.

———. "The Grotesque and the Classical in Sculpture." *Tracts* 1/2 (Spring 1977): 78–81.

———. "The Ides of Art: 14 Sculptors Write." *The Tiger's Eye* 4 (June 1948): 73–81.

———. "Some Notes on My Work." *Magazine of Art* 40 (November 1947): 264.

"Lipton Inside and Outside." *Art News* 53 (November 1954): 51.

"Lipton Teaches at New School." *Art Digest* 23 (December 15, 1948): 18.

Lowe, Jeannette. "Sculpture in Wood: A First Showing by S. A. Lipton." *Art News* 37 (November 5, 1938): 17.

"Monel in Art: Nickel-Copper Alloy Used in Direct Metal Sculpture." *INCO* 27 (February 1957): 22.

Noble, Elizabeth. "Progressive Sculptors." *New Masses* (November 15, 1938): 31.

"The Philadelphia Story on Sculpture." *Art News* 49 (October 1950): 49.

Rago, Louise Elliott. "A Visit with Seymour Lipton." *School Arts* 58 (May 1959): 33–34.

Rand, Harry. "Notes and Conversations: Seymour Lipton." *Arts Magazine* 50 (February 1976): 64–67.

Reed, Judith Kaye. "Two Modern Sculptors." *Art Digest* 22 (May 1, 1948): 14.

"Reviews: Seymour Lipton." *Art News* 49 (October 1950): 49.

Rigg, Margaret. "Seymour Lipton: Sculptor." *Motive* 20 (April 1960): 29.

Riley, Maude. "Lipton Exhibits." *Art Digest* 17 (January 15, 1943): 16.

Ritchie, Andrew Carnduff. "Seymour Lipton." *Art in America* 44 (Winter 1956–57): 17.

Rosenstein, Harris. "Lipton's Code." *Art News* 70 (March 1971): 46–47, 64.

Sandler, Irving. "Reviews and Previews: Seymour Lipton." *Art News* 56 (February 1958): 10–11.

Saunders, Wade. "Touch and Eye: '50s Sculpture." *Art in America* 70 (December 1982): 90–104.

Stokstad, Marilyn, et al. *The Register of the Museum of Art of the University of Kansas* 2 (April 1962).

Tarbell, Roberta K. "Seymour Lipton's Carvings: A New Anthropology for Sculpture." *Arts Magazine* 53 (October 1979): 78–84.

Verderame, Lori. "Assessing the Sculptor's Process: Drawings by Seymour Lipton." *The Picker Art Gallery Journal* 4 (1997): 12–19.

"Working Drawings for the Sculpture, *Sentinel.*" *Yale University Art Gallery Bulletin* 29 (April 1963): 38.

Newspapers

Adlow, Dorothy. "New Orientations in American Art—Innovations in Sculpture Developed in Use of Metal." *Christian Science Monitor,* November 27, 1954.

"Art: Acquisitions of Yale Gallery." *The New York Times,* January 10, 1961: I, 26.

"Art: Benign Shapes by Seymour Lipton." *The New York Times,* November 2, 1979: C, 19.

"Awards in Arts Are Made to 20." *The New York Times,* April 30, 1958: I, 31.

Braff, Phyllis. "A Master at Using Metal in Sculpture with Imagination." *The New York Times,* December 30, 1984: XXI, 13.

Canaday, John. "An 'Archangel' Adorns Philharmonic Hall." *The New York Times,* February 19, 1964: I, 56.

Devree, Howard. "Abstract Survey." *The New York Times,* January 28, 1951: 10.

———. "Americans in 'The New Decade' at the Whitney and Modern Surveys: Development Since 1920 Seen in Three Shows." *The New York Times,* May 15, 1955: II, 9.

———. "The Carnegie Annual Opens—Recent Work by Contemporary American Artists." *The New York Times,* October 16, 1949: II, 9.

———. "The Carnegie: 1950/Big International Resumes After Decade—Shows by O'Keeffe, Lipton, Reed." *The New York Times,* October 22, 1950: II, 9.

———. "Survey by Groups." *The New York Times,* October 16, 1949: X, 9.

———. "Transition Sculpture: Whitney Annual Reveals New Tendencies." *The New York Times,* March 21, 1954: II, 8.

James, George. "Seymour Lipton Dies; A Self-Taught Sculptor." *The New York Times,* December 7, 1986: I, 60.

"Manuscript by Seymour Lipton." *The New York Times,* August 29, 1965: II, 19.

"Modern to Ancient: American Art Today—Old Mexico." *The New York Times,* May 3, 1959: II, 21.

"Modern Sculpture Trio." *The New York Times,* August 19, 1965: X, 19.

"Powerful Imagery Evoked in Lipton Retrospective." *The New York Times,* October 2, 1988: XXI, 24.

"Prizes Are Given in Arts, Letters," *The New York Times,* May 22, 1958: I, 31.

"Seymour Lipton of U.S. Wins Sculpture Prize at São Paulo." *The New York Times,* September 18, 1957: I, 12.

Werner, Alfred. "Art and Artists: A Review of Jewish Interests." *Congress Weekly,* December 13, 1954.

"Will This Art Endure?" *The New York Times,* December 1, 1957: V, 48–49.

Films

Boxer, Nathan. *Sculpture by Lipton.* 15 mins., Film Images, 1954.

Cousteau, Jacques-Yves and Frederick Dumas. *The Silent World.* 19 mins., 1956.

Manucci, Mark. *Seymour Lipton.* Nassau County Museum, 1978.

Walt Disney Productions. *Nature's Half Acre.* 33 mins., MTI Teleprograms, Inc., 1953.

Archival Materials

Albert Elsen Papers: "Life Attitudes by Seymour Lipton." Archives of American Art, Smithsonian Institution, Washington, D.C.

Seymour Lipton Papers. Archives of American Art, Smithsonian Institution, Washington, D.C. The following citations are specific writings within the Seymour Lipton papers. Dates are provided where available. Microfilm D386, D385, N69-68.

"Group III, Notes—Poems, c. 1920–1969." 1920–69.

"Notes—Poems, c. 1920–1969." November 11, 1954.

"Symbolism of Steel in the Inland Steel Sculpture." April 1956.

"Notes." November 24, 1958.

"The Main Objective." June 16, 1959.

"Nature and Art." August 26, 1959.

"Statement." October 19, 1959.

"Forms and Substance." February 6, 1960.

"The Alcoa Lecture at RPI." December 1961.

"Statement." January 6, 1962.

"Statement." January 13, 1962.

"Notes." May 18, 1962.

"Notes." December 18, 1962.

"Notes." April 28, 1964.

"A Letter to a Friend." February 25, 1967.

"Notes." February 25, 1967.

"Notes." March 1, 1967.

"Notes." March 11, 1967.

"Dragon Bloom." no date.

"Metaphor in Sculpture." no date.

"The New and the Old." no date.

"Notes." no date.

"Organicism and Sculpture." no date.

"Suggestions on Metaphor." no date.

"Thunderbird." no date.

Interview by Dorothy Seckler, April 28, 1964.

Interview by Sevim Fesci, 1968.

Tarbell, Roberta K., "Seymour Lipton's Sculptures of the 1940s: Intellectual Sources and Thematic Concerns." Lecture at the annual meeting of the College Art Association, New York City, February 13, 1986 (transcript).

Dissertations

Buettner, Stewart. "American Art Theory, 1945–1970." Ph.D. diss., Northwestern University, 1973.

Dreishpoon, Douglas. "Theodore J. Roszak (1907–1981): Painting and Sculpture." Ph.D. diss., City University of New York, 1993.

Gibson, Ann. "Theory Undeclared: Avant-Garde Magazines as a Guide to Abstract Expressionist Images and Ideas." Ph.D. diss., University of Delaware, 1984.

Livingston, Valerie. "Herbert Ferber: Sculpture, Discourse, Content: 1930–60." Ph.D. diss., University of Delaware, 1989.

Verderame, Lori Ann. "The Sculpture of Seymour Lipton: Themes of Nature in the 1950s." Ph.D. diss., The Pennsylvania State University, 1996.

Interviews

Will Barnet. Interview by author, October 8, 1993. New York City.

John Driscoll. Interview by author, February 17, 1994, New York City.

Luis Jimenez. Interview by author, October 24, 1993, Hondo, New Mexico.

Alan Lipton. Interview by author, March 18, 1995, Bethesda, Maryland.

Stephen Polcari. Interview by author, May 11, 1993, New York City.

Lisa Scheer. Interview by author, August 15, 1993, University Park, Pennsylvania.

Roberta K. Tarbell. Interview by author, August 24, 1993, University Park, Pennsylvania.

INDEX OF WORKS BY SEYMOUR LIPTON

American (1903–1986)

INDEX OF WORKS BY OTHER ARTISTS